Woman / Image / Text

Woman / Image / Text
Readings in Pre-Raphaelite Art and Literature

Lynne Pearce

Lecturer in English
University of Lancaster, UK

UNIVERSITY OF TORONTO PRESS
TORONTO AND BUFFALO

© Lynne Pearce, 1991

First published in North America 1991 by
University of Toronto Press
Toronto and Buffalo

ISBN 0 8020 5980 5 (cloth)
 0 8020 6912 6 (paper)

First published in the United Kingdom by Harvester Wheatsheaf,
Hemel Hempstead
Printed and bound in Great Britian

Canadian Cataloguing in Publication Data
 Pearce, Lynne
 Woman / image / text: readings in pre-Raphaelite
 art and literature

 Includes bibliographical references.
 ISBN 0–8020–5980–5 (bound) ISBN 0–8020–6912–6 (pbk).

 1. Women in art. 2. Women in literature.
 3. Pre-raphaelitism – England. 4. Painting, English.
 5. Painting, Modern – 19th century – England.
 6. English poetry – 19th century – History and
 criticism. I. Title.

 X7630.P43 1991 759.2 091–094500–4

For Sarah

In memory of 22 May 1984 (or the day we didn't see Bob Geldof)

Contents

Plates

Preface

In the November of 1977, my friend and I travelled to London to celebrate my eighteenth birthday. It was the first time I had been to London since I was a child, and our visit to the Tate was most certainly my first encounter with High Art. I wish I could say that I experienced a profound aesthetic enlightenment, but I am afraid it is quite other things I remember.

The Pre-Raphaelites must have made an impression, however, because what I carried away with me was Andrea Rose's book, published earlier the same year (see Bibliography). I also remember Waterhouse's *Lady of Shalott* which then hung at the top of the stairs next to Gallery 19; and I remember us standing in front of one of Stanley Spencer's paintings and being revolted. At eighteen we did not have the feminism to explain either the attraction of the one, or the repulsion of the other. Yet even without the required *schemata*, our standing together, feeling the same, was its own feminist statement.

As Isobel Armstrong has observed, one's 'coming to consciousness' is an embarrassing thing to admit to, since it always appears to have started embarrassingly late (see Armstrong, 'Christina Rossetti: Diary of a feminist reading', in Sue Roe (ed.), *Women Reading Women's Writing*, Harvester Wheatsheaf, Hemel Hempstead 1987). To admit that one has not always been a feminist, despite the fact that one had the sense to say rude things about a Stanley Spencer, is unthinkable. It is also intensely difficult, looking back, to identify the moments at which things changed: Vera Brittain, Margaret Atwood, Michèle Roberts, Greenham Common (because we were children living in Cornwall in the 1970s; because we had never heard of Germaine Greer or Kate Millett).

Yet by the time we visited the Tate Gallery Pre-Raphaelite Exhibition of 1984, excuses were no longer necessary. Millett herself would have been proud of the way we rampaged through what seemed never-ending images of heart-sick, sex-starved women: damning the men who dared to create them, despising the public who continued to be duped. And it was out of the still-smouldering ashes of this first, raw anger that this project was born. While the terms of my

engagement have refined and qualified themselves immeasurably since, I have to admit that it was not love, but anger, ridicule, frustration, contempt – the defiant joy of having at last *seen through* – that fuelled this project: sent me back to teach courses in which I refused to let students simply *enjoy* Pre-Raphaelite paintings.

To anyone who reads this Preface *after* she has read the main text, its crudity of motivation will appear surprising, if not shocking. Because this is spoken outside official academic discourse, I have made statements, admitted feelings, that would, in theoretical terms, appear risible in their simple-mindedness. Although I occasionally make use of the personal pronoun to communicate my experience as the teacher of a particular text, 'I' as a full biographical subject have no place in the pages which follow; neither has Rossetti 'the man', nor the lives of the women he painted. The war there is waged in quite other terms; amongst texts whose sexism is engaged, disengaged and re-arranged bloodlessly, using theories that shift and re-shift the parameters of power so that artist, painting, viewer, society, all take their turn in shouldering responsibility for what we secretly liked about *The Lady of Shalott*, what we openly hated.

Yet, as students of post-structuralism will be aware, the human subject, like the text, lives among a myriad of discourses, none more or less real than the other. The genesis of this book, like most, has been a profound coincidence of chance, of expediency, of commitment, or sentiment. If, as an aspiring academic and sincere feminist, I should say I wrote this book to fill a gap in existing inter-disciplinary criticism, I should also admit that I wrote it to fulfil something that 22 May 1984 began. Either way, Pre-Raphaelite paintings have played a significant part in my life so far: so much so that when Bob Geldof and Paula Yates walked past us, we failed to see them.

Acknowledgements

As the Preface testifies, my involvement with Pre-Raphaelite art is of long standing, and this book owes its existence to the many people who made the different stages of that involvement possible.

Martin Hobba, my history teacher at school, was responsible for my first encounter with the study of art history. To him I owe my choice of this subject as a subsidiary to my main undergraduate degree (in English), and my subsequent place on the Lampeter MA course, 'The word and the visual imagination'. It was while I was at Lampeter that I began my first proper research on Pre-Raphaelite art and its related literature, and a special acknowledgement must be made to Alcuin Blamires, at whose seminar many of the texts included in this book were seen by me for the first time. From the Lampeter years, I wish also to remember the friendship provided by my fellow post-graduate students; in particular, Janet Pimblett, Paul Poplawski, Marvin Lansverk and Christine Torney. Christine's own MA thesis on Keats's illustrators has provided me with much useful scholarly information.

It was as a consequence of my teaching, however, that the proposal for this book was born, and I wish to thank Lucy-Anne Hunt and all the staff at the University of Birmingham School of Continuing Studies for providing me with so much employment over the years. My most considerable debt, however, is to all the students who attended my course on 'The representation of women in Victorian art and literature' (and its various off-shoots); they contributed more to the development of my ideas than they will ever know, despite my occasional attempts at acknowledgement in the chapters which follow. At the risk of being invidious, I feel I must also pay special tribute to Stourbridge WEA, with whom I shared three years of the liveliest discussion.

My teaching in and around Birmingham included many visits to the Pre-Raphaelite collection in Birmingham City Art Gallery, and I would like to thank Stephen Wildman and Tessa Sidey for making their prints and drawings available to me, and for welcoming my students. Without my six years in Birmingham, I would never have had the opportunity of sharing the public response to Pre-Raphaelite art which has been so integral to the writing of this book.

It was not experience, alone, however, that made me able to formulate the readings which follow, and I wish to give special recognition to all the feminist critics who have done so much to revolutionise the reception of Pre-Raphaelite art in recent years; in particular, Jan Marsh (who gave me personal encouragement in the early stages of this project), Griselda Pollock, Deborah Cherry, Marcia Pointon and Lynda Nead.

My wider theoretical debts will, I hope, emerge in the course of the readings but, on a personal note, I am indebted to the guidance provided by Sara Mills (who also commented extensively on an early draft of this text) and Pat Waugh. I was also grateful for the particular directions offered by Tony Pinkney, Margaret Beetham, and my other 'anonymous' readers.

This is also the place to pay tribute to all the time and energy my editor, Jackie Jones, has invested in this project: her advice and guidance throughout the writing and production of this rather complex publishing venture has been much appreciated. Thanks also to my copy-editor, Jenny Potts, for all her hard work in seeing the manuscript through its last stages.

Since this book's origins belong to my years in the academic wilderness (between Ph.D and lectureship), I wish also to acknowledge the substantial practical support and encouragement offered by my parents, colleagues and friends: in particular, Deirdre Burton (who first suggested I submit a proposal), Stephen Regan (who suggested *me* to Jackie Jones), Tom Davis, Mark Storey, Pat and John McEvoy and Karen Harvey. I also extend belated greetings to my new friends and colleagues at Lancaster University: in particular Alison Easton and Jackie Stacey (it's fascinating getting to know one's key bibliographic reference!).

I was also most grateful to receive financial support from the British Academy in the form of a Small Research Grant, which assisted in my travels around the country to view the various paintings.

As for many of my generation, my academic career involved a long and gruelling apprenticeship 'on the margins', the experience of which is undoubtedly reflected in the political engagement of the readings which follow. For her unrelenting belief in me through these long years of struggle, I therefore dedicate this book to Sarah Oatey; many of the observations included in the readings which follow we arrived at together, and the fact that any of them achieved publication owes mostly to her.

The author and publisher gratefully acknowledge the following for permission to reproduce in colour the works of art in this book:

Laing Art Gallery, Newcastle upon Tyne (Tyne and Wear Museums) for *Laus Veneris* by Edward Coley Burne-Jones (plate and cover illustration); Manchester City Art Gallery for *The Lady of Shalott* by William Holman Hunt; The Makins Collection for *Mariana* by Sir John Everett Millais and The Board of Trustees of the National Museums & Galleries on Merseyside (Walker Art Gallery) for *Lorenzo and Isabella* by Sir John Everett Millais; The Tate Gallery, London for *Beata Beatrix* and *The Girlhood of Mary Virgin* by Dante Gabriel Rossetti, *The Eve of St. Agnes* by Arthur Hughes, and *Queen Guenevere (La Belle Iseult)* by William Morris.

Introduction

This book is an inter-disciplinary study of the art and literature associated with the British Pre-Raphaelite movement: an exploration through associated visual and verbal texts of the production and consumption of certain images of women, both in their historical context and in the present day. In this sense it is not simply a book *about* the representation of women in Victorian art and literature; it is also an attempt to address the problem of what the twentieth-century feminist is to do with such images. The 'women' of the book's title are thus both the women then, and the women now: women as subjects of discourses, and women as consumers.

It is, indeed, in its emphasis on the feminist *consumption* of such texts that this book will be seen to differ most substantially from the other recent studies of Pre-Raphaelite women.[1] As such, it is my hope that it will supply an additional, yet complementary, perspective to the excellent work of Jan Marsh, Griselda Pollock, Deborah Cherry, Marcia Pointon and Lynda Nead, at the same time as initiating a broader theoretical debate in which the Pre-Raphaelite subject matter is a means rather than an end in itself.

It will be seen that the book is structured as a series of short chapters on particular poem–painting combinations. In most cases, the chapters deal with one or two literary texts, and a similar number of visual representations. This selectivity was deliberate, since it would have been easy (and often extremely tempting) to multiply the number of visual texts in each case. Readers may already be aware, for example, that in the United States in 1982 a whole exhibition was devoted to representations of 'The Lady of Shalott', while illustrations to many of the Keats and Tennyson poems featured here are prolific.[2] Something of the fascinating range of Pre-Raphaelite 'literary' subjects has already been demonstrated in Jan Marsh's work, however, and the theoretical interest of this project required specificity. The result, I trust, has been to provide the reader with precise, working examples of what feminist

inter-disciplinary critical practice actually involves: particularised demonstrations of both its possibilities and its limitations.

Towards a Theory of Gendered Reading

The theoretical interest of the project is, perhaps, best explained by the questions I wish to raise in these opening pages: namely, what can the twentieth-century feminist reader/viewer actually *do* with male-produced nineteeth-century images of women? Is it ethically legitimate to deconstruct/reconstruct a text in which the dominant ideology is blatantly sexist/misogynistic and make it 'work for feminism'?[3] And, if so, is it possible to appropriate *all* texts in this way, or are there aesthetic/ideological factors intrinsic to each which enable or frustrate such activity?

Implicit in these questions is the unresolved theoretical debate concerning the relative importance of text and reader in the production of meaning. Although in literary criticism some sophisticated compromises have now been achieved, I was initially impressed by the fact that feminists working in the visual arts have been less apparently willing to break with the conditions of the text's production and consumption in order to assert their 'rights' as readers and viewers. This is to say, they have tended to maintain a stronger sense of 'context' *vis-à-vis* the text's institutional/commercial origins. Thus although recent feminist criticism in the visual arts, including film and cultural studies, has employed similar post-structuralist reading strategies to 'split open' texts and appropriate them for its own ends, it has been with a political circumspection sometimes lacking in the virtuoso rereadings of the literary critics. A generalisation of this kind will inevitably be open to any number of exceptions, but I found that I concluded this project with my initial impression still intact: that the material conditions in which the visual arts are produced/marketed/consumed limit and frustrate the viewer's textual appropriation of them. Although it is impossible to prove that the exclusively male production and dissemination of nineteenth-century art works excluded the female viewer in any absolute sense (many women did, indeed, attend the exhibitions and directly or indirectly supported their husbands' patronage), the institutions in which those texts were manufactured and viewed (e.g., the Royal Academy) were so intrinsically patriarchal that it would have been extremely difficult for women to participate significantly in the processes. It is therefore

really only in the twentieth century, with the mass reproduction of nineteenth-century art, that the female viewer has been able to 'consume' these images and insert herself in their discourses.

In the following sections of the Introduction I wish to examine some of the ways in which feminists working in the different disciplines (literature, 'art history' and film studies) have developed reading/viewing strategies which break with these rules of consumption. In so doing, I will be tracing a development from early 'feminist critique' in the respective disciplines, through the more sophisticated post-structuralist reading strategies based on the work of theorists like Althusser, Macherey, Derrida and Lacan, and ending with the debates concerning women's 'pleasure' in texts whose ideological project/status is less than 'sound' (e.g., Hollywood cinema, television soap opera, popular romance, nineteeth-century High Art). This overview will, I hope, identify the two main strands of recent feminist critical activity in dealing with 'images of women': that is (1) the interrogation/'deconstruction' of the texts themselves by a set of reading strategies designed to expose their ideological complexities and contradicitions, and (2) a renewed focus on the role of the feminist reader/viewer and her relation to such texts in terms of pleasure and positioning.

I will end this overview with a brief discussion of the political implications of such activity and, in the section headed 'Breaking the rules: Text vs Context' (pp. 22–5), propose a coda that while it may be technically possible for the feminist reader/viewer to read all such texts 'against the grain', it may be both difficult and politically undesirable for her to do so in every case. I shall be proposing, indeed, that it is only in texts of sufficient 'complexity' that effective 'symptomatic' reading can take place; that in texts in which the 'dominant ideology' (see below) assumes monolithic control it would be perverse to insist upon a 'positive' feminist reading.

Reading Strategies 1: Feminist Critique

In both literature and the visual arts, the first feminist interventions into male-produced images of women took the form of what has subsequently been labelled 'feminist critique': a radical rereading of canonical and popular texts which exposed their sexism, misogyny and pornography, and frequently laid explicit blame on their authors/ producers. In literary criticism the two ground-breaking works were

Kate Millett's *Sexual Politics* (1969) and Germaine Greer's *The Female Eunuch* (1971). These books were immediate best-sellers, and Millett and Greer were undoubtedly instrumental in relaunching the modern women's movement after its post-war demise.[4] While both texts set out to debunk patriarchy as an institution, Millett's polemic was laced with named culprits from the world of literature: Norman Mailer, Henry Miller and D. H. Lawrence were all identified with the violent misogyny of their own male characters. Millett's technique, which I have described elsewhere as 'the art of incriminating quotation', was to plunder her victims' texts for evidence of negative representations of women.[5] This use of selective quotation, and her problematic conflation of author and character, were quickly criticised by members of the literary establishment (and, indeed, by other feminist critics). However, Millett's exposé of the deep-seated fear and hatred of women present in popular and canonical texts like Lawrence's *Women in Love* fuelled the fires of 'feminist critique' which have been raging, in albeit more sophisticated forms, ever since.

Parallel activity in the visual arts included John Berger's *Ways of Seeing* (1972) and Linda Nochlin's and Thomas B. Hess's *Woman as Sex Object* (1972).[6] Berger's book, which was published alongside a television series, sought to dehabituate the reader's response to the visual, both in High Art and in popular culture (advertisements,etc.). On the subject of the representation of women, Berger attempted to draw a distinction between positive and negative images of women, proposing that Rembrandt's nude portraits of his wife escaped prurience by virtue of their intimacy and affection. Nochlin's thesis, however, was perhaps more representative of first-wave feminist critique in its conclusion: namely, that the only means of countering the unfavourable representation of women in art is for them to become its producers. In the introduction to this collection of essays, Nochlin perceives it to be a simple matter of fact that in the history of western art 'The imagery of sexual delight or provocation has always been created *about* women for men's enjoyment, by men' (p. 15). Nochlin does not appear to regard this as either a calculated plot or a problem, but reasons optimistically that 'The growing power of women in the politics of both sex and art is bound to revolutionize the realm of erotic representation' (p. 15). Nearly twenty years on, feminists will surely agree that no-one has been *bound* to do anything; that the wave of consciousness-raising produced by the late 1960s radicals did not automatically transmit itself into an alternative ideology. Moreover, the whole question of how, and in what way, women can produce/

consume erotic pleasure remains one of the most tortured areas of feminist debate.[7] Nochlin's naive assumption that simply by moving women into the role of producers all will be well remains (in the 1990s) largely hypothetical, and, now as then, offers little suggestion as to what women are supposed to do with images of women produced by/for men.

Before passing on to illustrate how feminists from both disciplines have developed more sophisticated strategies for 'reading' 'images of women', it should, I feel, be said that the type of critique practised by Millett and her immediate successors still has a significant, and politically valid, role to play. Although we might now be aware of the critical naivety of 'blaming' individual authors or a monolithic patriarchy for negative representations of women, in the classroom, or on the gallery floor, or in our readings of the popular press, gut reactions of disgust and outrage continue to be a pervasive and, I feel, legitimate part of feminist experience. The difference is that it is now only 'off the record' that women continue to articulate their suspicions of a 'patriarchal conspiracy'.

Reading Strategies 2: Symptomatic Reading

This and the following sections of the Introduction will offer a brief overview of the theoretical premises that inform the readings performed in this book. I begin by looking at the range of 'deconstructive' approaches available to the post-structuralist reader/viewer and then proceed to the more contentious issue of textual 'reconstruction' and women's pleasure: to what extent is it possible to usurp the laws of a text's production/consumption and 'reclaim' it for feminism? As Marxist-feminists is it politically legitimate to discover pleasure in a text whose manufacture was intended for an exclusively male audience, and whose dominant ideological message might be inimical/degrading to women?

These two reading practices are, of course, closely related and might be said to represent two stages of feminist reading strategy. Clearly, it was not until women readers had developed the techniques/practices necessary to uncover the ideological 'gaps' in texts belonging to high or mass culture that they were able to search those same aporia for pleasure: still less to acknowledge that their positioning *by* such texts is not necessarily a negative experience.

The two theorists who did most to enable 'against the grain'

criticism were undoubtedly Louis Althusser and Pierre Macherey.[8] Their work is, of course, intimately related to that of Derrida, Lacan and Barthes, but since it would be impossible to present much more than a parody of their theories and practices in such a short space, I have decided to limit my comment to the specific aspects of Althusser and Macherey's work that have most bearing on this project.

In his 1971 essay, 'Ideology and ideological state apparatuses', Louis Althusser offered a radical restatement of Marx's theory of the relationship between ideology and the economic base. As Chris Weedon explains:

> Louis Althusser argues . . . that the reproduction of the relations of production, which is central to the maintenance of capitalist social relations, is secured by *ideological state apparatuses* such as schools, the church, the family, the law, the political system, trade unionism, the media and culture, backed by the repressive apparatuses of the police and the armed forces. Each ideological state apparatus contributes to the reproduction of capitalist relations of exploitation in the 'way proper to it' and the means by which it determines dominant meanings is *language*.[9]

The revolutionariness of Althusser's reformulation is that it gives the 'superstructure' a role *equal* to that of the 'base' in the perpetration of capitalism. Thus the oppression/repression of individuals within capitalism is related not only to economics (i.e., who *owns* the 'means of production'), but also to the cultural institutions (the legal system, the church, the education system, the family) which are intrinsic in maintaining those relations. For those working in literature and the visual arts Althusser's essay initiated a new generation of political criticism; not only were literary and other texts presented as 'reflections' of bourgeois society (in the manner of earlier Marxist critics like Georg Lukács and Christopher Caudwell) but as active agents in the production/reproduction of ideological discourses.[10]

Apart from registering this new relation between base and superstructure, Althusser's 1971 essay also introduced the concept of 'interpellation' to explain how individuals in capitalist society were 'recruited' by its ideologies. In a much-quoted passage he presents the term thus:

> I shall then suggest that ideology 'acts or 'functions' in such a way that it 'recruits' subjects among the individuals (it recruits them all), or 'transforms' the individuals into subjects (it transforms them all) by the very precise operation I have called *interpellation* or hailing, and which may be imagined along the lines of the most common everyday police (or other) hailing: 'Hey, you there'.[11]

'Interpellation' is thus the means by which every subject is bound by the ideological state apparatuses operative in his/her own society.

Implicit in Althusser's description of this process is the notion that it is also inescapable (i.e., that we cannot reject our interpellation, or, by an act of consciousness, transcend it):

> In this preliminary remark, and these concrete illustrations, I only wish to point out that you and I are *always already* subjects, and as such constantly practice the rituals of ideological recognition, which guarantee for us that we are indeed concrete, individual, distinguishable and (naturally) irreplaceable subjects. The writing I am currently executing and the reading you are currently performing are also in this respect rituals of ideological recognition, including the 'obviousness' with which the 'truth' or 'error' of my reflections may impose itself on you. . . . I might add: what thus seems to take place outside ideology (to be precise, in the street), in reality takes place in ideology. What really takes place in ideology seems therefore to take place outside it. (pp. 161, 163)

While a cogent account of how subjects, material and textual, continue to be restrained by ideological institutions (e.g., the 'need' to be heterosexual, married, a parent, etc.) despite a (necessarily) 'unconscious' desire to be otherwise, Althusser's formulation quickly attracted the criticism of a large number of critics who denounced his 'scientific Marxism' as perniciously deterministic. One of the most outspoken of these critics was E. P. Thompson who, in *The Poverty of Theory*, saw Althusser's supposed 'critique' as no less than a prescription *for* totalitarianism: 'Althusserianism is Stalinism reduced to the paradigm of theory.' In his retrospective on this debate, Steven B. Smith in *Reading Althusser* comments on Thompson's hostility thus:

> The linchpin of Thompson's charge is really against Althusser's denial of the role of human agency in history and consequently against the type of philosophical determinism he has embraced. This far more serious charge gets to the heart of Althusser's conception of history as a 'process without a subject'.[12]

As Smith observes, what Thompson was resisting above all was the implicit exclusion of 'conscious human-choice, value, and action in history'.[13] If the subject is 'always already' interpellated then s/he may never achieve the 'agency' necessary for social change/amelioration. Another critic, Ted Benton, shows how this deterministic aspect of Althusser's formulation is also dangerously reductive:

> Secondly, the concept of 'interpellation' is no advance over the conception of socialization offered by functionalist sociology, in that in the context of Althusser's identification of 'ideology' with 'ruling ideology' there is no basis for 'interpellation' of oppositional forms of subjects. Individual human subjects can be no more than willing 'dupes' of the social system.[14]

While not necessarily humanist–Marxists in the Thompsonian sense, it is significant that the literary critics (including feminists) who have subsequently worked with Althusserian ideas have done so only by

rejecting what Benton describes as the 'identification of "ideology" with "ruling ideology"'.[15] They have preferred to treat the ideological construction of the subject as complex and contradictory, and in so doing have utilised both Macherey's model of the contradictory text (see below) and Raymond Williams's hypothesis that in addition to the dominant ideology, any society in any given historical moment will produce/reproduce additional ideologies. These Williams named as: 'alternative', 'oppositional', 'emergent' and 'residual'.

Williams explores the relationship between these ideologies in the second part of *Marxism and Literature* (1977) where he observes that: '*no mode of production and therefore no dominant social order and therefore no dominant culture ever in reality includes or exhausts all human practice, human energy, and human intention.*'[16] This is to say, no dominant ideology holds monolithic sway over a culture although it may remain dominant precisely by its ability to marginalise/silence the discourses of competing ideologies. Janet Wolff, meanwhile, in *The Social Production of Art* offers a neat gloss of Williams's four ideological 'types':

> Alternative ideologies may be either *residual* (formed in the past, but still active in the cultural process), or *emergent* (the expression of new groups outside the dominant group); they may also be either *oppositional* (challenging the dominant ideology), or *alternative* (co-existing with it).[17]

Williams's 'refinements in terminology' have, as Wolff observes, contributed greatly to cultural analysis by allowing the critic to register covert opposition and dissent in a subtext of a work while acknowledging the dominant ideology out of which it has been produced. This model of competing ideologies has been central to the work of British Marxists like Terry Eagleton, and has been necessarily implicit in the work of all feminists who have attempted to go beyond a 'critique' of male-produced texts. In literary criticism this sense of plural and contradictory meaning has developed alongside the recognition of a work's *textuality* and the rejection of the notion of authorial intention. Thus Eagleton has been able to read Richardson's scandalously misogynistic *Clarissa* 'on behalf of feminism' by identifying in it a tumult of ideological/textual contradictions, and Kate Belsey, in her book on Milton, prefaces her readings with the disclaimer: 'The interpretation I want to offer does not seek out an apparition; instead it attends to an appearance, the signifying surface of the text, not an essence concealed by the words, but the textuality of the words themselves.'[18] What Belsey does, in practice, is plunder these 'surfaces' for the ideological inconsistencies that reveal them to have a

meaning supplementary to that which either (a) Milton 'intended' himself, or (b) which is held by the dominant ideological discourse of the text. By such means the 'oppositional' and 'alternative' ideologies present in a text like *Paradise Lost* may be released, and a patriarchal work be made to speak on behalf of feminism.

In the work of readers like Belsey, then, a highly self-conscious emphasis is placed on the *text-as-text*. While Althusser's base–superstructure model was essentially sociological, Pierre Macherey's *Theory of Literary Production* (1966) directed itself specifically to the ideological workings of literary texts. It is a theory passionately opposed to what Macherey himself labels 'immanent' or 'essentialist' criticism. 'When we explain the work, instead of ascending to a hidden centre which is the source of life (the interpretative fallacy is organicist and vitalist), we perceive its actual decentred-ness.'[19] By rejecting the notion of a 'hidden centre', Macherey consequently allows the literary text a new complexity and contradictoriness – a 'decentredness' which is inimical to monolithic intepretation. Indeed, Macherey's most stunning theoretical move was to propose that instead of our finding a text's 'meaning' in its overt ideological statements, we look, instead, at the gaps in those statements; that is to say, we attend not to what the text says but to what it does not say:

> Between the ideology and the book which expresses it, something has happened; the distance between them is not the product of some abstract decorum. Even though ideology itself always sounds solid, copious, it begins to speak of its *own absences* because of its presence in the novel, its visible and determinate form. (p. 132)

The practice of reading texts according to their 'gaps' and 'absences' has been labelled 'symptomatic reading' and has, for obvious reasons, become a feature of much feminist criticism. Both in feminist critiques of male-produced texts, and in a gynocritical analysis of texts written by women, many of our 'political' conclusions are necessarily *inferred*. Issues of sexuality, for example, are frequently written out of a work's main text, but, as readers, we are able to pick them up in the work's silent 'margins':

> Thus the work is certainly determined by its relation to ideology, but this relation is not one of analogy (as would be a reproduction): it is always more or less contradictory. A *work is established against an ideology as it is from an ideology.* Implicitly, the work contributes to an exposure of ideology, or at least to a definition of it. (p. 133)

One particular image Macherey uses to describe the relationship between ideology and text is that of the cracked mirror. It is an

evocative image and, since it relates conceptually to my own reading strategies in the following chapters, I will dwell for a moment on its implications. At the same time that he insists the literary text is without a hidden centre, an essential 'core of meaning', so does he disclaim any naive relation between ideology as it figures in the text and as it figures in 'the outside world'. Metaphorically substituting mirror for text he writes:

> In effect, the relationship between the mirror and what it reflects is *partial*: the mirror selects, it does not reflect everything. The selection itself is not fortuitous, it is symptomatic; it can tell us about the nature of the mirror. . . . The secret of the mirror is to be sought in the form of its reflections; how does it show historical reality, by what paradox does it make visible its own blindness without actually seeing itself. (pp. 120–2)

To convey adequately the partiality of the image reflected in the mirror, that is to say, the ideology inscribed in the text, Macherey then introduces the further term of *fragmentation*. Like that of Tennyson's 'Lady of Shalott', the surface of Macherey's mirror is cracked: 'In actual fact, it is not enough to say that the mirror catches a fragmented reality; the very image of the mirror is itself fragmented. The mirror renders real discontinuities by means of its own complexities' (pp. 121–2). The text, then, according to Macherey's metaphorical model is a cracked surface, discontinuous both with the 'outside world' and with itself; a site of 'contradictory expressions', of eloquent gaps and silences:

> The mirror is expressive of what it does not reflect as much as what it does reflect. The absences of certain reflections, expressions – these are the true object of criticism. The mirror, in certain areas, is a blind mirror: but it is still a mirror for all its blindness. (p. 128)

Subsequent critics have, not surprisingly, found problems with Macherey's mirror model. Eagleton, for example, has observed that 'such a drastically modified mirror might hardly be said to be a mirror at all'.[20] He also points out that in his later work Macherey rejected questions of text/reality by reflecting on the material reality of art itself. For those of us still working with issues of representation within a materialist context, however, Macherey's 'cracked mirror' remains an infinitely suggestive trope.

What Machereyan criticism means, in practice, should, I hope, become clear in the subsequent readings. Allied to Althusserian notions of subject interpellation, and Williams's postulations of 'alternative ideologies', it offers the feminist reader the means of 'breaking apart' resistant texts; of shattering the ideological coherence

of their surfaces to reveal *not* a 'hidden centre', but a fluid and contradictory repository of discourses.

Reading Strategies 3: Symptomatic Reading in Practice

In this section I wish to offer a few examples of symptomatic reading in practice.

The second part of Macherey's *Theory of Literary Production* consists of a collection of brilliant individual essays on Tolstoy, Jules Verne, Borges and Balzac. The mirror metaphor, indeed, is introduced in the course of the Tolstoy reading, and Macherey uses it to demonstrate that the relationship between an author and his/her text is by no means fixed; that authors can never 'control' the ideological meaning of their works:

> Tolstoy's version of his age is incomplete because of his personal and ideological relation to it. In particular, we know that he could not grasp its revolutionary characteristics; thus it is not because he reflected the revolution that he earned the title of mirror of the revolution. . . . What is seen in the mirror of the work is not quite what Tolstoy saw, both in himself and as an ideological spokesman. . . . The fact that we can recognise Tolstoy's era in his work does not mean that he truly knew that era. (p. 121)

Such observations are equally true of the writers and artists whose work is represented in this book; the reason that we can read Tennyson or Rossetti 'against the grain' depends precisely on the fact that they did not control the ideological content of their work from some transcendent, omniscient, authorial position, nor that they 'reflected' the ideologies of their historical epoch in some naive way; it depends rather on the fact that their works are inscribed by, and are reproductive of, the discourses of their era: discourses whose web-like complexity militate against any monolithic notion of Victorian ideology.

Examples of recent critical works which have approached Victorian culture according to such a model include Rod Edmond's *Affairs of the Hearth* and Lynda Nead's *Myths of Sexuality*.[21] Both these authors base their reading strategies on the discourse theory of Michel Foucault, supplementing the Machereyan notion that the ideological significance of a work may lie in its gaps and margins, with the radical notion that the key ideological discourses of an era (e.g., 'sexuality', 'madness') are not evidence of hegemonic state repression but are, on the contrary, productive and reproductive of a complex power relationship. Both Edmond and Nead have exploited the ambivalence

implicit in the Foucaultian notion of discourse to highlight the paradoxes of Victorian culture on issues such as sexuality. Thus Edmond writes:

> He [Foucault] argued that power in the west in recent centuries has been concerned to generate forces, to make them grow so they can be ordered, rather than to impede them and make them submit. In *The History of Sexuality* he argued that the relation of power to sexuality has not been one of suppression but of incitement and proliferation. (p. 11)

What this thesis means in practice is illustrated by Edmond's wonderfully complex readings of Victorian narrative poetry. Rejecting the old, clichéd ideas of a 'Victorian frame of mind' on matters relating to sexuality and family life, he combines Raymond Williams's model of 'competing ideologies' with Foucault's model of the 'generative discourse' to show there 'can be no representative voice, nor can there be a single frame of mind':[22]

> One must insist on voices, on debate and argument, on the questioning of normative values, even as a lack of consensus as to what was normative. The explanatory model used by many literary and art-history commentators assumes that writers and painters simply express or reflect the dominant values of their period. Such a model is incapable of explaining the complex process of cultural production. (p. 9)

Thus when reading a text like Tennyson's *The Princess*, Edmond is able to avoid fundamentalist judgement on its ideological content and offer the following 'open verdict':

> *The Princess* is concerned with deeply significant issues, but structures its treatment of these in such a way that an ideology of 'helpmeets', a picture of changing bourgeois marriage practices within the regulatory context of the family, emerges as inevitable and inviolable. To say this, however, should neither be to sneer at a fascinating poem riven with tensions and contradictions, nor to endorse it as an apologia for our own family and marriage practices. (pp. 126–7)

While such graciousness towards the text's 'complexity' may be regarded by some Marxist/feminist critics as indulgent (Edmond opposes Eagleton's 'strenuous Lacanian reading' in his own discussion), it undeniably has the virtue of illustrating the fact that uncomfortable ideological contradictions do co-exist in such texts.[23] My own feeling, which I will address again at the end of the Introduction, is that a recognition of such complexity need not be disengaged from a final, political judgement on the part of the reader; this is to say, we might acknowledge the existence of 'oppositional' or 'emergent' ideologies in a work (to use Williams's terms), but concede (as is the case with *The Princess*) the triumph of

'the dominant'. This, I believe, indicates the text's variable contribution to the production of meaning: gendered and political readings are possible for *any text*, but it is only the more ideologically complex ones that we can finally recruit 'on behalf of' socialism/feminism. In the chapter on 'Guenevere', for example, the reductiveness of Tennyson's text is in significant contrast to the productivity of William Morris's.

Lynda Nead's *Myths of Sexuality* utilises a theoretical paradigm similar to Edmond's. Like Edmond, her principal referent is Foucault and she, too, is interested in the *multiplicity* of discourses by which women and sexuality were inscribed in the nineteenth century:

> No discourse, therefore, can be looked at in isolation. This book sets out to establish the inter-relations between official discourses on sexuality; to locate visual culture within this distribution and to examine the specific role and effectiveness of visual forms. (pp. 3–4)

In practice, Nead's readings of, say, the 'representation' of the prostitute in nineteenth-century art involves not only references to contemporary literature, but also to the proliferation of non-literary texts on the subject; the work of sexologists and birth-controllists, the campaigners for the control of contagious diseases, scientists, journalists, and etiquette manuals, are all plundered to separate out the competing ideologies surrounding the representation of women in Victorian society. Most importantly, however, she also addresses the ideology and politics of visual representation itself; showing how the painted image is in no way a simple reflection of even conflictual ideology. She writes:

> Reflection theory is based on a straight-forward pattern of cause and effect according to which a painting, for example, is described as a more or less accurate reflection of an already existing social reality. While it is acknowledged that Victorian art was frequently sentimental or that it glossed over the higher and more disturbing elements of nineteenth-century society this is simply seen as a distortion in the mirror of art in which ideological interests prevent a true reflection of the world. (p. 4)

When considering the representation of the prostitute, for example, Nead draws a significant comparison between Rossetti's watercolour, *The Gate of Memory*, and William Bell Scott's poem 'Maryanne'. While the latter offers some 'explanation' for the subject's present condition, her 'utter abandonment', the painting reduces the prostitute to little more than an object of representation: 'The prostitute has become the subject of "art" and art does not provide a space for women as physically deviant or unpleasurable' (p. 132).

Although she does not name Macherey, and although she would presumably consider the 'mirror image' to be too overlaid with connotations of 'reflection' to be useful, Nead's readings are nevertheless another example of the 'symptomatic' approach to texts which has developed through the British Marxist school of criticism. Like Macherey, Nead and Edmond scrutinise the surfaces of texts for the cracks and fractures which will disclose the paradoxes operative in contemporary discourses.

Where Nead has used the Foucaultian theories of discourse as a means of splitting open the ideologies of visual texts, Griselda Pollock has turned to psychoanalysis. Her essay, 'Woman as sign: Psychoanalytic readings', must certainly be recognised as one of the most perceptive and sophisticated analyses of images of women yet performed; in particular for the way in which she has made full use of a psychoanalytic infrastructure within a materialist objective.[24] Indeed, she is careful to make clear the terms of her engagement at the beginning of the essay when she writes:

> To invoke psychoanalysis might seem to fall prey to a similar criticism of over-privileging the individual artist and looking for explanations within his psyche. Psychoanalysis has, however, been deployed within feminist theory, film and literary criticism as well as art history in order to expose structural formations not personal idiosyncrasies. Psychoanalysis is a tool used to alert us to the historical and social structures which function at the level of the unconscious. Not only has feminist political theory stressed the necessity of subjecting the so-called personal to socio-economic and ideological analysis but developing theories of ideology within Marxism have involved recognition of the unconscious level of its operations in producing us as subjects for specific regimes of meaning. (p.127)

In the essay she therefore proceeds to analyse the iconography of Rossetti's paintings not in terms of his own personal 'unconscious', but rather according to an historical unconscious represented by works labelled 'Rossetti'. In this reading, she finds that the paintings betray a fear and anxiety about women peculiar to the art of the late nineteeth century: a castration complex that, in its effort to control the 'threat', sought to make women increasingly non-specific, two-dimensional, rhetorical: 'These were not faces, not portraits, but fantasy' (p. 122). It is significant that in this analysis Pollock has effectively broken through the rules of production and consumption that she is elsewhere so careful to preserve. Albeit cautiously, she has used a twentieth-century reading position to undermine the tyranny of the patriarchal context in which the work was created and, as a twentieth-century feminist, made it say something different from what Rossetti or the contemporary viewers would have understood. Yet because her psychoanalysis is practised

with an historical consciousness, what she reveals is concerned precisely with the rules of production and consumption that she has transgressed. She has crept under the wire fence surrounding the painting, without forgetting that it is still there.

Pollock's essay is also effective in demonstrating the way in which such reading strategies may become *pleasurable*. This is not the same sort of pleasure as that which will be discussed in the next section of this Introduction, but the pleasure the feminist reader/viewer may derive by exposing the ways in which a text undermines and subverts its own ruling discourse. Thus, writing about Rossetti's *Astarte Syriaca*, Pollock proposes that all the fear and dislike of women manifest in other 'Rossettis' suddenly becomes visible: '[*Astarte Syriaca*] raises to a visible level the pressures that motivated and shaped the project of "Rossetti" – the negotiation of masculine sexuality in an order in which woman is the sign, not of woman, but of that Other in whose mirror masculinity must define itself' (p. 153). Yet this large and imposing image (180 × 105 cm), categorised by earlier art historians as a typical *femme fatale*, 'a cruel and frightening image of love', may speak directly to the feminist viewer eager to celebrate such strength and power. Pollock, following an interesting formulation of literary texts by John Goode, writes that: 'In the case of *Astarte Syriaca*, the dominant ideological structures within which the fetishistic regime of representation is founded are exposed and the viewer is *positioned against the patriarchy*' (my italics).[25] This is to say that in a painting like *Astarte Syriaca*, the conflicting ideologies by which it is informed have become visible to such an extent that they explode the authority of context and genre that might seek to contain them. The very power that the other 'Rossettis' are trying to negate images like *Astarte Syriaca* and *Pandora* confirm, and in them the twentieth-century feminist is invited to short-circuit the system of masculine production and consumption from which she has been officially excluded. The image speaks directly to her 'against the patriarchy' in which it is inscribed.

In this section, then, I have aimed to show how the symptomatic approach to reading visual and verbal texts initiated by Althusser and Macherey has been appropriated by recent critics for the purpose of 'gendered reading'. Despite its problematic associations with the idea of 'reflection', Macherey's fragmented mirror remains a compelling image for what the text has become is post-structuralist reading practice: a shattered surface whose cracks and fissures represent the ideological gaps into which the feminist may, if she chooses, insert herself.

Reading Strategies 4: The Pleasure Factor

In the previous section I offered examples of critics working with literature and the visual arts who have made patriarchally produced texts work on behalf of feminism. I also indicated, in my discussion of Griselda Pollock's criticism, how this type of activity may be thought pleasurable; by 'breaking the rules of consumption', by exposing the gaps in the ideological construction of a text, the feminist is sometimes able to reconstruct it 'in her own image'. Thus Rossetti's *Astarte Syriaca* emerges, through Pollock's analysis, as a powerful feminist heroine: a symbol not of Rossetti's degrading desires, but of his *fears*. The text is turned on its producer and made to break the bounds of his intention.

A similar reflex has been explored by feminists seeking to understand why women find pleasure in images (visual and verbal) of other women. Most of the work in this area has been by critics working in film studies, popular culture and media advertising, but their findings have had profound implications for all feminists working with representations of women.

Of particular interest to my project here is the fact that the work done on Hollywood cinema and popular romance has had to confront the issue of how the twentieth-century woman reader/viewer can apparently take pleasure in images that are ostensibly negative ('ideologically unsound') and frequently manufactured for a male audience. While we can rationally explain the complex 'deconstructive' procedure which enabled Pollock to reconstitute Rossetti's *Astarte Syriaca* as a feminist heroine, it is less easy to account for the 'uncritical pleasure' thousands of women take in film-stars, the heroines of popular romance or the images of mass-media advertising. At last realising that it is not sufficient to dismiss these female pleasures as patriarchally inscribed weaknesses, feminist critics have set about acknowledging the pleasure women (of different states of feminist consciousness) find in such images. As Tania Modleski has written in her book, *Loving with a Vengeance: Mass-produced fantasies for women* (1982):

> Thus women's criticism of popular feminine narratives has generally adopted one of three attitudes: dismissiveness, hostility – tending unfortunately to be aimed at the consumers of the narratives; or, most frequently, a flippant kind of mockery.
> . . . In assuming this attitude, we demonstrate not so much our freedom from romantic fantasy as our acceptance of the critical double standard and of the masculine contempt for sentimental (feminine) 'drivel'.[26]

Rejecting this academic snobbery, Modleski explores the reasons for the continuing appeal of the romance genre, hypothesising as follows:

'Their enormous and continuing popularity, I assume, suggests that they speak to very real problems and tensions in women's lives' (p. 14).

Such a line of enquiry registers a shift of emphasis from the reader/ viewer as the active producer of meaning, to her role as *consumer*. This is not to say that these theories of textual interpellation (i.e., the text is 'recruiting' the reader in the Althusserian sense) constitute the reader as entirely passive, but they are more concerned with how she is 'positioned' by a text than how she may be able to subvert that positioning.

Until recently, explanations of how women relate (take pleasure in) images of themselves, have been divided into two main categories: the first comes under the heading 'Transvestitism'; the second, 'Narcissism'. As was indicated above, most of the theorising in this area has been done by feminists working with film. Laura Mulvey's early investigations into the positioning of the spectator in the dominant (i.e., popular) cinema seemed to prove conclusively that such cinema was addressed specifically to male spectators, and that the only pleasure women could therefore be expected to derive from such viewing was by becoming 'nominal transvestites': 'The female social audience can be caught up by the rhetoric of dominant cinema because on some level they identify with "masculine" modes of address.'[27] In recent years, film theorists like Teresa de Lauretis have posited the more sophisticated explanation of *double identification*, whereby the female spectator may be understood to identify with the 'figure of narrative movement' (usually the active, male protagonist) *and* 'the figure of narrative closure' (usually the female object of the action/gaze).[28] Mary Ann Doane, who quotes de Lauretis in her book, *The Desire to Desire* (1987), regards the complication caused by this theoretical contradiction (that the female spectator can occupy both masculine and feminine subject positions at the same time) as itself revealing: 'Perhaps the female spectator – or, more accurately, the projected image of the female spectator – *is* that of being stranded between incommensurable entities.'[29] Yet whichever way it is presented, the fact that female viewers can, and often do, assume a masculine gaze when looking at images of women is something that would seem to be upheld experientially. The best instance I can cite of seeing it in action is that of a female visitor to the 1984 Pre-Raphaelite Exhibition who, pausing in front of Rossetti's *Fazio's Mistress* commented admiringly: 'Lucky Fazio!'

Griselda Pollock is understandably resistant to the idea of such

vicarious gratification, in accordance with her general political mistrust of male-produced images of women. In this, her reasoning is entirely logical, since her materialist analysis of women's exclusion from High Art, in this and every respect, does not permit such pleasure. Thus in her essay, 'Modernity and the spaces of femininity' (*Vision and Difference*) she writes:

> Without that possibility ['that texts made by women can produce different positions within this sexual politics of looking'], women are both denied a representation of their desire and pleasure and are constantly erased so that to look at and enjoy the sites of patriarchal culture we women must become nominal transvestites. We must assume a masculine position or masochistically enjoy the sight of woman's humiliation. (p. 85)

Yet although my previous discussion will have revealed that I find Pollock's analysis theoretically sound and politically *preferable*, my experience, both as a teacher and in writing this book, has forced me into the uncomfortable position of admitting that in the practice of looking at images of women, the most ideologically discomforting concepts are borne out. Where women viewers ought to feel alienated and indignant, they are constantly seduced.

Apart from the female spectator being seduced into viewing images of women through men's eyes, film theory has also dealt substantially with narcissism. Narcissism, since Freud, is, of course, a good deal more complex than the dictionary definition of a 'tendency to self-worship'. According to Simone de Beauvoir's reading of Freud in *The Second Sex*, narcissism, like lesbianism, is a psychic phase that all girls must pass through on the road to womanhood.[30] Although she gives the narcissistic tendency in women a social explanation ('Woman, not being able to fulfil herself through projects and objectives, is forced to find her reality in the immanence of her person', p. 641), de Beauvoir closely follows Freud's own prescription that narcissism, like the other complexes of childhood and adolescence, becomes dangerous and psychotic if it persists into adulthood. She implies that while it is perhaps inevitable that women should fall into the trap of narcissism, it is not inevitable that they should stay there. If they do, she warns, they will become the victims of creeping paranoia:

> The older she grows, the more eagerly she seeks praise and success and the more suspicious she is of conspiracies around her; distracted, obsessed, she hides in the darkness of insincerity and often ends by forming around her a shell of delirious paranoia. (p. 652)

Aside from this sensational warning, de Beauvoir writes interestingly on the practice of narcissism. Again following Freud, she notes that 'it

is impossible to be *for one's self* actually an *other*' (p. 642), and goes on to examine the different means women have employed to obtain a satisfactory re-presentation of themselves. Apart from the mirror itself, the narcissist is most likely to favour other women (or representations of other women) to yield her up a desirable image of herself. In the Freudian analysis, this tendency fits in perfectly with the explanation of adolescent lesbianism in which the young girl 'covets in the other the softness of her own skin, the modelling of her own curves; and, *vice versa*, in her self-adoration is implied the worship of femininity in general' (p. 366) (at the time when she is first discovering the general social and sexual inferiority of women). According to the Freudian scheme, however, this narcissistic/lesbian infatuation merely anticipates entry into full heterosexual maturity, where the insecurities of the female ego are abandoned, and the woman transmutes all her 'penis envy' into her desire for a child. Women who persist in regressive lesbian/narcissistic behaviour are, as the previous de Beauvoir quotation warned, in serious trouble. And yet as we all know – and as de Beauvoir herself knew – female narcissism does commonly persist beyond adolescence; more, it is sanctioned and promoted by many agencies of our social lives. It is a calculated commercial ingredient in visual images of every kind: what women desire most are themselves.

In recognition of this commercially tested hypothesis, recent feminists have searched for a more positive and enabling interpretation of narcissism. This, in turn, has had significant repercussions for 'images of women criticism' in general, bringing feminists closer to an acceptable explanation of women's visual (and specifically erotic) pleasure. In her essay, 'How do women look?: The female nude in the work of Suzanne Valadon', Rosemary Betterton cites Luce Irigaray to suggest ways in which the narcissistic reflex may be celebrated as a *positive* sign of female difference; a different way of looking:

> Luce Irigaray in 'This Sex Which Is Not One' claims that the kind of look which separates the subject from the object of the gaze and projects desire on to that object is essentially masculine. Female eroticism is bound up with touch much more than with sight, women's pleasure being autoerotic. This, she argues, means that women have a problematic relationship with the whole process of looking in western culture. Women are bound within visual discourse to become objects and never subjects of their own desire.[31]

In such circumstances, to obviate the distance and take pleasure in oneself (outside the experience of other images) is an essentially radical gesture. The problem with Irigaray's definition of narcissism, as Betterton observes, is that 'it posits an essential feminine erotic

experience outside cultural and social definitions' (p. 221), and disregards the most prevalent kind of narcissistic pleasure which depends precisely upon those masculine/mass-produced images that Irigaray's 'autoeroticism' rejects.

Mary Ann Doane, in contrast, places the commercial aspect of narcissism at the very heart of her analysis of its role in female scopophilia (the pleasure of looking). She argues that female narcissism is part and parcel of the changes taking place in capitalist society in general, whereby commodity fetishism is 'more accurately situated as a form of narcissism' (p. 32). Instead of desiring *things*, the twentieth-century consumer has become increasingly obsessed with *images*. Desire for fridges and furniture has been replaced by desire for clothes and cars (i.e., commodities that relate to our self-image). And women, of course, have been at the centre of this sea-change: 'The female spectator is invited to witness her own commodification, and furthermore, to buy an image of herself' (p. 25). In terms of explaining the resurgence of popularity in the Pre-Raphaelites in the 1970s and 1980s this annexing of narcissism to commodity fetishism is persuasive. In this context, the 1984 Exhibition could be seen to have presented its female spectators with a choice of narcissistic images not so very different to those they were avidly consuming in their magazines. As Doane writes about the similar relationship between women and the cinema: 'The cinematic image for the woman is both shop window and mirror, the one simply a means of access to the other' (p. 32).

Yet Doane's analysis of narcissism, like Pollock's of transvestitism, is perhaps too rigidly correct to be enabling when it comes to reading images of women. The pleasure we have in looking persists *in spite of* all the rules that tell us we should not. Is there any way, then, that such pleasures may be understood and legitimated, instead of understood and condemned?

In the case of the narcissistic reflex, there most certainly is a way in which such pleasure might be appropriated for feminism, and that is by exploiting its lesbian connotations. In her chapter on Margarethe Von Trotta in *Women and Film*, Ann Kaplan shows how the doubling of female characters in Von Trotta's films reveals much about the complex relationship between narcissism and lesbianism:

> *Marianne and Juliane*, like the other films, deals with close relationships between women, all of whom are, in one way or another, doubles. This doubling is not a mere externalisation of an inner split (as was the case in the German Romantic *doppelgänger*); nor is it intended simply to show the different possibilities for women struggling to find themselves in an alien, male-dominated realm. It

functions rather on an altogether more complex level, revealing first, the strong attraction women feel for qualities in other women that they themselves do not possess; second, the difficulty women have in establishing boundaries between self and Other; and finally, the jealousy and competition among women that socialisation in patriarchy makes inevitable. [32]

Crucial here is Kaplan's realisation that narcissistic–lesbian desire can be understood as being *compensatory* in the profoundest of senses. When she writes about 'the strong attraction women feel for qualities in other women that they themselves do not possess' she is pointing to a process of identification far more far-reaching than either Irigaray's 'autoeroticism' or Doane's commodity fetishism. Women need and desire other women to compensate for what they lack themselves. Women need and desire *images of other women* for the same reasons. While it is true that sometimes this need is purely superficial – a compensation for, or a confirmation of, their own physical beauty – often it is much more. Women are role models for one another; are each other's heroines. And in so much as none of us can be expected to live without aspirations, such desires cannot be dismissed as the simple wish-fulfilment of frustrated lives. Von Trotta's films, indeed, bring us to a new psychoanalytic explanation for narcissism that could be, but has not been, used alongside the more consciously materialist explanations. That patriarchy and capitalism might be responsible for creating the particular circumstances that drive women to desire and to purchase idealised images of themselves does not mean that such desire is somehow trivial and demeaning. I remember someone telling me once that they liked the images of Pre-Raphaelite women 'because they appeared *so strong'*. You and I might not agree, but if this particular woman felt attracted to/identified with the paintings for this reason, who are we to deny her that pleasure? My point here is very simple: narcissism is never merely a question of vanity, and placed in certain circumstances, and viewed in a certain way, it can be regarded as a serious expression of women's need for one another. Lacking 'the qualities of another woman' is surely one up on lacking a penis.

During the later stages of writing this book I was interested to discover that other feminists had been moving towards a similar hypothesis. In the excellent collection of essays entitled *The Female Gaze* (1988), Jackie Stacey offers a bold explanation of women's pleasure in popular narrative cinema by positing the notion of *fascination* between women. [33] This 'fascination', she insists, is something far more complex than either simple sexual desire *for*, or narcissistic identification *with*, a female other. Focusing on two

Hollywood movies which are partly about women looking at one another, she writes:

> Both *Desperately Seeking Susan* and *All About Eve* tempt the woman spectator with the fictional fulfilment of becoming an ideal feminine other, while denying complete transformation by insisting upon differences between women. The rigid distinction between *either* desire or *identification*, so characteristic of psychoanalytic film theory, fails to address the construction of desires which involve a specific interplay of both processes. (p. 129)

Such a realisation, Stacey suggests, is a means of broadening feminist intervention in contemporary films; a subtle negotiation that allows for a pleasure *additional* to that experienced by viewing lesbian narrative films, or by making specifically lesbian readings of mainstream films not concerned with lesbianism. 'Fascination', moreover, is a concept that can be used to explain the pleasure of all women in looking at other women, regardless of whether they identify themselves as lesbian or not:

> This fascination is neither purely identification with the other woman, nor desire for her in the strictly erotic sense of the word. It is a desire to see, to know and to become like an idealised feminine other, in a context where the difference between the two women is repeatedly re-established. (p. 115)

In this section I have attempted to show that the pleasure feminist readers/viewers take in patriarchally inscribed images of women are not exclusively 'deconstructive' ones; this is to say, it is not only by reading such representations 'against the grain' that we may be able to make them work for feminism, but also in acceding to the power they have *in interpellating us*; in making visible our own needs and desires. What both sets of reading strategy have in common, however, and to which I now turn my attention, is the liberty they take with the historical/cultural specificity in which the text was produced.

Breaking the Rules: Text vs Context

While I have presented both the above types of reading strategy as an expression of radical feminist activity, it must nevertheless be acknowledged that they are circumscribed by a large political question mark. This concerns the fact that both in 'reading against the grain', or in yielding to a text's implicit pleasures, the feminist reader/ viewer is side-stepping the fact that the texts themselves were frequently produced in a different context with a different audience

in mind. In the case of Victorian art (and, to a lesser extent, literature), we have to acknowledge the fact that we are dealing with commodities that have been produced exclusively by and for men. Recalling this, it is salutary that we should suffer a moment's doubt and (theoretical sophistications aside), wonder if it can ever be legitimate to respond to the 'products' of patriarchy other than critically. Certainly there are many of us for whom the past and present institutionalisation of Pre-Raphaelite art seems, at times, irrevocably alienating. In their review of the 1984 Tate Gallery Exhibition, for example, Deborah Cherry and Griselda Pollock commented ironically on the role of the exhibition's sponsor 'whose interests involved not only the mineral, banking and property concerns, but publishing houses, zoos and wax-works, as well as newspapers and magazines':

> High Culture plays a specifiable part in the reproduction of women's oppression, in the circulation of relative values and meanings for the ideological constructs of masculinity and femininity. Representing creativity as masculine and Woman as the beautiful image for the desiring masculine gaze, High Culture systematically denies knowledge of women as producers of culture and meanings. Indeed, High Culture is decisively positioned against feminism. Not only does it exclude the knowledge of women artists produced within feminism, but it works in a phallocentric signifying system in which woman is a sign within discourses on masculinity. The knowledges and significations produced by such events as *The Pre-Raphaelites* [reference to the 1984 Exhibition] are intimately connected with the workings of patriarchal power in our society.[34]

As Pollock later observed in *Vision and Difference*: 'What were they [i.e., the sponsors] supporting – an exhibition which presented to the public men looking at beautiful women as the natural order of making beautiful things?' (p. 16).

As we have seen, however, Pollock herself has subsequently produced readings of Pre-Raphaelite art that resist this notion of hegemonic conspiracy and prove that the texts concerned can have a more complex meaning for the feminist viewer. Likewise, the contributors to Marcia Pointon's *Pre-Raphaelites Re-viewed* have strongly resisted the idea that the Pre-Raphaelite group should either be lauded or condemned according to any monolithic concept of male creativity.[35] Pointon and her contributors advocate a new specificity in the study of Pre-Raphaelite art, but one which is historically contextual rather than specifically biographical:

> It is our aim to map a terrain of artistic production at particular moments, taking account of ideology and, in particular, grounding our work in theories of vision, spectatorship and intertextuality. Our model is that of a concatenation of texts strung out, often untidily, across time, class, and nation. The rationale for

> choice of text is determined not by biography but by the presence of competing
> discourses inscribed in sites that are historically and socially specific: vision and
> stereoscopy, the orient, gender, for example. (p. 9)

What the Pointon collection represents is, indeed, a new type of *contextual reading* which, like Nead's *Myths of Sexuality*, owes much to Foucaultian discourse theory. As with Nead's project, these readings locate a text's meaning in the discourses and events surrounding its historical production. Thus, Kate Flint, in her chapter on Holman Hunt's *The Awakening Conscience*, examines a range of texts contemporary with the painting (newspaper and journal reviews, personal letters, contemporary fiction, the paintings alongside which it was exhibited at the Royal Academy, church sermons and medical treatises) in order to read it 'rightly':

> To read *The Awakening Conscience*, to read the whole exhibition, not just as
> contemporary critics reported it, but as contemporary visitors might have under-
> stood it, means, in fact, placing it back in what we can recover of the context of
> 'reading' paintings at the time of the 1854 Academy exhibition. To do this
> involves using art history not as a means of celebrating an individual work, but of
> understanding the cultural complexity of a specific moment. (pp. 64–5)

Such an approach will appear, at first sight, to be coming from a very different position from the 'symptomatic' readings described earlier. Text has been replaced by context as the ideological site where meaning is produced, and the reader is not looking for 'gaps' in the text so much as clues 'on the side-walk'. It is not the contradictions within a text that reveal its ideological complexity, but rather the historical discourses by which that text is inscribed.

Yet such a distinction is, I would like to suggest, an artificial and ultimately unnecessary one. All Althusserian/Machereyan readings depend on a dialogue between text and context; indeed, many of the problems with the symptomatic model have derived from its imperfect negotiation of the complex way in which 'ideology in the real world' relates to 'ideology in the text'. As we saw earlier, Macherey rejected the idea of simple 'reflection' early on, but failed ever to explain satisfactorily the relation of the two. Discourse theory has subsequently provided materialist critics with a means of breaking down this binary opposition between text and world: a means of retaining a sense of the political and historical specificity informing a work without falling back on the naive concept of reflection. The textuality of poem and painting are preserved without denying its *relation* to history.

In my own readings, therefore, I have striven to work with both text and context; to relate the contemporary discourses on sexuality,

gender, romantic love, *et cetera* to the cracks and gaps in the texts themselves in a way that does not assume a simple reflective relation between art and life. At the same time, I acknowledge that the gendered readings I engage in frequently flaunt the rules of 'context': my 'reading against the grain' has often led me to disregard not only authorial intention but also the specifics of a text's production and consumption, so that as a twentieth-century reader/viewer I have ignored what factors informed its meaning in the nineteenth century. Thus I have moved between reciprocal notions of readership wherein I am once free and circumscribed. As a twentieth-century feminist I feel that I have the capacity to make of a text what I will, while at the same time acknowledging that such readings may wilfully ignore and excuse the patriarchal discourses out of which it was created. Indeed, the central hypothesis linking the subsequent chapters may best be understood as an expression of this very anxiety: to what extent can the twentieth-century feminist reader *legitimately* press a resistant text? Are all texts liable to feminist appropriation, or will this itself depend on their ideological complexity? Some answers to these questions are, I hope provided in the chapters which follow, and will be directly addressed again in the conclusion. My purpose here has been to demonstrate something of the recent theoretical history that has informed this 'reading adventure'; to record the range of reading strategies the twentieth-century feminist now has at her disposal.

The Historical Moment: 1848/1984

A final coda must be written into this Introduction which acknowledges not only the role of historical discourses in the production of meaning, but also the historical context *per se*: the *moment* when these texts were first produced, and the moment when we, as readers and viewers, 're-produced' them. Recognition of such local specificity is especially important in a collection of readings, such as this one, which is largely achronological in its treatment of texts. Although there is some gesture towards chronology in the fact that I begin with Rossetti's earliest oil-painting (1848–9) and end with one of Burne-Jones's later ones (1873–8), and although the majority of the paintings – *Mariana, Beata Beatrix, Isabella, Guenevere* – belong to what is recognised as the Pre-Raphaelite movement's first phase, there are a few wild cards.[36] In the chapter on 'The Lady of Shalott' I deal with Waterhouse's painting of 1888 as well as Holman Hunt's of

1886–1905, and the chapter on 'Madeline' features a work by another Pre-Raphaelite associate, Arthur Hughes, as well as one by Millais. The dominant grouping of paintings from the early period means, moreover, that Burne-Jones's *Laus Veneris* and the 'Lady of Shalott' paintings may be read historically as post-scripts to the ideological conflicts fought out on the earlier canvases. The textual focus of my readings inevitably loses sight of such factors at points (see discussion above), and I feel the reader should be alert to such blind spots. It is to be hoped, however, that my notes will go some way to 'filling in' the literary and art-historical background to texts which I felt too cumbersome to include in the readings themselves.

The year 1848 is, of course, inscribed in our cultural and political history as 'the year of revolutions'. The fact that it was also the year in which the original Pre-Raphaelite Brotherhood was formed cannot, therefore, go unheeded, and commentators eager to advance the 'revolutionariness' of Pre-Raphaelite art will find the contingency suggestive. Reading the texts in the context of this historical moment one may argue (as Raymond Williams has done *vis-à-vis* the novels of the period) that the formal experimentation of the Pre-Raphaelite group was representative of 'the contradictions in social experience and in ideology' being generated at that time. While it may equally well be argued that these 'contradictions' persist throughout the Victorian era (indeed, throughout *all* historical periods), the focus on 'crisis' moments undoubtedly has the benefit of adding a sense of historical agency to the ideological struggles taking place.

It must be said, however, that any political connection between the Pre-Raphaelite group and the revolutionary period in which they worked is implicit rather than explicit. Their manifesto (drawn up by William Michael Rossetti as secretary to the Brotherhood in 1848) appears, at first sight, to attack nothing more than the sterility and 'mannerism' of contemporary Academy art:

> To have genuine ideas to express; to study Nature attentively, so as to know how to express them; to sympathise with what is direct and serious and heartfelt in previous art, to the exclusion of what is conventional and self-parading and learned by rote; and most indispensable of all, to produce thoroughly good pictures and statues. [37]

The emphasis on 'truth' and 'sincerity' (note the adjectives 'genuine' and 'heartfelt') may, of course, be read as an expression of the moral idealism of a 'revolutionary age' but the fact remains that (with the significant exception of William Morris), the Pre-Raphaelite group was largely 'agnostic' in its politics as well as in its religion, and most

of the members' early cultural aspirations were as reactionary as they were revolutionary; an ambivalence that is most notoriously visible in their passion for the art and culture of the Middle Ages.

For this reason it seems to me important to acknowledge a political ambiguity in the Pre-Raphaelite group *per se* which is complementary to that found in their works. As Raymond Williams identified in his essay on 'The Bloomsbury fraction', the Pre-Raphaelite Brotherhood (as an avant-garde group) occupied a position both inside and outside of contemporary bourgeois culture:

> In their earliest phase they were irreverent, impatient, contemptuous of shams; they were trying to find new and less formal ways of living among themselves. For a moment, which did not last, they were part of the democratic turbulence of 1848. . . . But in their effective moment, for all their difficulties, they were not only a break from their class – the irreverent and rebellious young – but a means towards the necessary next stage of development of the class itself. Indeed this happens again and again with bourgeois fractions: that a group detaches itself, as in this case of 'truth to nature', in terms which really belong to a phase of that class itself, but a phase now overlaid by the blockages of later development. It is then a revolt against the class but for the class, and it is no surprise that its emphases of style, suitably mediated, become the popular bourgeois art of the next historical period. [38]

The paradoxical nature of this class relation helps to explain why, in some of the readings which follow, my discussion will equate a Pre-Raphaelite text with the Victorian ideological mainstream, while in others it will present the texts as being *in opposition to* that ideology. Although all Victorian art and literature is necessarily inscribed by differing and conflicting discourses, the work of the Pre-Raphaelite group, operating both for and against its own class, is especially volatile.

I would like to end this Introduction, however, by reminding us again of our own historical context: the 'moment' at which these readings have been made. As will be evident from the biographical sketch contained in the Preface, my own 'consumption' of Pre-Raphaelite art was made from within the period of Thatcherite ascendancy; a period, that is, in which our own culture was vigorously redefined by the forces of capitalism, and for which the 1984 Tate Gallery Pre-Raphaelite Exhibition stood as an ironic emblem of the way in which 'Victorian values' – patriarchy, patronage, conspicuous consumption – were popularly re-inscribed. Yet if, as a British subject whose first vote coincided with Mrs Thatcher's election as prime minister, I wrote from a position within Thatcherism, as a feminist I also wrote against it. I wrote against the discourses of a 'residual' liberal humanism and an 'emergent' post-

feminism; I wrote against a reactionary tide of heterosexual romantic love and 'the importance of family life'; I wrote against the new homophobia inscribed in Clause 28/29. Thus, despite institutional gestures towards recognition, reading and writing as a feminist is still an act of opposition. No matter how sophisticated our strategies become, whether we derive our pleasures from traditional 'critique' or from a more subtle relationship to 'the text', we should never forget the wider politics of our actions: to read as a woman is always to read 'against the grain'.

Notes

1. Recent studies of women in the Pre-Raphaelite Movement include: Jan Marsh's *The Pre-Raphaelite Sisterhood* (Quartet, London, 1985); Jan Marsh's *Jane and May Morris* (Pandora, London, 1986); Jan Marsh's *Pre-Raphaelite Women* (Weidenfeld and Nicolson, London, 1987); Griselda Pollock's 'Woman as sign in Pre-Raphaelite literature' (written in collaboration with Deborah Cherry) in her *Vision and Difference: Femininity, feminism and the history of art* (Routledge, London, 1988); Lynda Nead's *Myths of Sexuality* (Basil Blackwell, Oxford, 1988); Jan Marsh's *The Legend of Elizabeth Siddal* (Quartet, London, 1989); Marcia Pointon's *Pre-Raphaelites Re-viewed* (Manchester University Press, Manchester, 1989).
2. The catalogue produced for this exhibition, entitled *Ladies of Shalott: A Victorian masterpiece and its contexts*, was published by Brown University Press in 1985. In addition to the catalogue itself, it contains a number of essays including Elizabeth Nelson's 'Tennyson and the Ladies of Shalott'.
3. In *The Rape of Clarissa: Writing, sexuality and class struggle in Samuel Richardson* (Basil Blackwell, Oxford, 1986) Terry Eagleton argues that texts can be made to work 'on behalf of feminism' in the same way that they can be made to 'work on behalf of socialism'.
4. See Kate Millett, *Sexual Politics* (Virago, London, 1977) and Germaine Greer, *The Female Eunuch* (Paladin, London, 1971).
5. See my own chapter on 'Sexual politics' in *Feminist Readings/Feminists Reading* (Harvester Wheatsheaf, Hemel Hempstead, 1989).
6. John Berger, *Ways of Seeing* (Penguin, Harmondsworth, 1972); Linda Nochlin and Thomas B. Hess, *Woman as Sex Object: Studies in erotic art 1730–1970* (Art News Annual, New York, 1972).
7. Some of the best recent essays on 'feminist erotica' are gathered together in Rosemary Betterton's *Looking On: Images of femininity in the visual arts and media* (Pandora, London, 1987).
8. 'Against the grain', which is the title of Terry Eagleton's collected essays, is a phrase coined by Walter Benjamin in 'Theses on the philosophy of history'. Here Benjamin uses it in the following context: 'A historical materialist therefore dissociates himself from it as far as possible. He regards it as his task to brush history against the grain' (quoted as the epigraph to Eagleton's essays, *Against the Grain: Essays 1975–1985* (Verso, London, 1986)).
9. Chris Weedon, *Feminist Practice and Post-Structuralist Theory* (Basil Blackwell, Oxford, 1987), p. 29.

10. See Christopher Caudwell, *Illusion and Reality*, 2nd edition (Lawrence and Wishart, London 1946) and Georg Lukács *Studies in European Romanticism* (Grosset and Dunlap, New York, 1964).
11. Louis Althusser, 'Ideology and ideological state apparatuses' (often referred to as the 'ISAs' article) in *Lenin and Philosophy and Other Essays*, translated by Ben Brewster (New Left Books, London, 1971), p. 48. Further page references are given after quotations in the text.
12. Steven B. Smith, *Reading Althusser: An essay on structural Marxism* (Cornell University Press, Ithaca, N.Y., and London, 1984), p. 22. See also: E. P. Thompson, *The Poverty of Theory and other essays* (Merlin Press, London, 1978).
13. *ibid.*, p. 22.
14. Ted Benton, *The Rise and Fall of Structural Marxism: Althusser and his influence* (Macmillan, London, 1974), p. 107.
15. *ibid.*, p. 107. See the critics cited in the next section of the Introduction as illustrations of this point.
16. See Raymond Williams, *Marxism and Literature* (Oxford University Press, Oxford, 1977), p. 125.
17. Janet Wolff, *The Social Production of Art* (Macmillan, London, 1981), p. 53.
18. See Eagleton, *The Rape of Clarissa*, and Catherine Belsey, *John Milton: Language, gender, power* (Basil Blackwell, Oxford, 1988), p. 6.
19. Pierre Macherey, *A Theory of Literary Production*, translated by Geoffrey Wall (Routledge, London, 1978), p. 79 (first published Librairie François Maspero, 1966). Further page references are given after quotations in the text.
20. See Eagleton, 'Macherey and Marxist literary theory', in his *Against the Grain: Essays 1975–1985* (Verso, London, 1986), p. 23.
21. See Rod Edmond, *Affairs of the Hearth: Victorian poetry and domestic narrative* (Routledge, London, 1988). Page references to both this and Nead, *Myths*, are given after quotations in the text.
22. 'The Victorian frame of mind' is the title of a book by Walter E. Houghton (Yale University Press, New Haven, Conn., and London, 1957).
23. The article by Terry Eagleton that Edmond refers to is 'Tennyson: politics and sexuality in "The Princess" and "In Memoriam"', published in Francis Barker (ed.) *1848: The sociology of literature* (University of Essex Papers, Colchester, 1978).
24. Griselda Pollock, 'Woman as sign: Psychoanalytic readings', in her *Vision and Difference: Femininity, feminism and the history of art* (Routledge, London, 1988). Page references are given after quotations in the text.
25. John Goode, 'Woman and the literary text', in Judith Mitchell and Ann Oakley (eds), *The Rights and Wrongs of Woman* (Penguin, Harmondsworth, 1976). Quoted in Pollock, *Vision and Difference*, p. 152.
26. Tania Modleski, *Loving with a Vengeance: Mass-produced fantasies for women* (Routledge, London, 1982), p. 14. Further page references are given after quotations in the text.
27. Laura Mulvey quoted from Annette Kuhn, *Women's Pictures: Feminism and cinema* (Routledge and Kegan Paul, London, 1982), pp. 62–3. Details of Mulvey's publications are given in the Bibliography.
28. Teresa de Lauretis (*Alice Doesn't: Feminism, semiotics, cinema* (Macmillan, London, 1984), cited in Mary Ann Doane, *The Desire to Desire: The woman's film in the 1940s* (Indiana University Press, Bloomington, 1987), p. 7.
29. Doane, *The Desire to Desire*, p. 7.
30. Simone de Beauvoir, *The Second Sex*, translated H. M. Parshley, 2nd English

edition (Penguin, Harmondsworth, 1972). Page references are given after quotations in the text.

31. Betterton, *Looking On*, pp. 220–1.
32. E. Ann Kaplan, *Woman and Film: Both sides of the camera* (Methuen, New York and London, 1983), p. 10.
33. Jackie Stacey, 'Desperately seeking difference', in Lorraine Gamman and Margaret Marshment (eds) *The Female Gaze: Women as viewers of popular culture* (Women's Press, London, 1988), p. 129. Further page references to this chapter are given after references in the text.
34. Deborah Cherry and Griselda Pollock, 'Patriarchal power and the Pre-Raphaelites', *Art History*, 1984, 7 (4), 494.
35. Pointon (ed.), *Pre-Raphaelites Reviewed*. Page references given after quotations in the text.
36. The original Pre-Raphaelite Brotherhood (formed 1848) only survived as a practising group for some four years. After this, individual members started to go their separate ways, although many shared principles survived until *c.* 1860. In 1858 Rossetti met with William Morris and Edward Coley Burne-Jones while he was working on the Oxford Union murals, and this new grouping is often seen to represent a new generation in Pre-Raphaelite art.
37. Quoted in the 1984 Tate Gallery Catalogue, *The Pre-Raphaelites* (hereafter TGC), from William Michael Rossetti's *Dante Gabriel Rossetti: His family letters, with a memoir* (1895).
38. Raymond Williams, *Problems in Materialism and Culture* (Verso, London, 1980), pp. 158–9.

Chapter 1

The Virgin: Solid Frames

Whenever the visitor finds her way to the Pre-Raphaelite collection in the Tate Gallery, she may expect to find Dante Gabriel Rossetti's two earliest oil paintings glowing ever richly on the walls. These two, small, gold-framed and gold-embossed pictures are both representations of the Virgin Mary: *The Girlhood of Mary Virgin* (1848–9) (see Plate 1) and *Ecce Ancilla Domine* (1849–50).[1] In any study of Rossetti's art, as in any visit to this collection, these two paintings of the Virgin are the place to start, claiming a special priority over all that follows. Not only are these Rossetti's earliest paintings, they are also his most prototypical: this is 'Rossetti' at his most Pre-Raphaelite, his most medieval, his most idealist, his most spiritual.[2] They are also 'Rossetti' at his most Victorian, his most conventional, his most misogynist. For here we are at the Beginning: the Virgin, proclaimed Rossetti in an oft-quoted letter, 'was a symbol of female excellence . . . [to be taken] as its highest type'.[3] In terms of production, technique, and ideology, these two early paintings therefore function as the prototypical baseline against which all Rossetti's later images and mythologies have come to be read. They are the starting point from which his psychosexual passage from 'Virgin' to 'Whore' has traditionally been traced.[4] But they also provide an apt introduction to Rossetti the poet-painter; the double sonnet inscribed in the frame of *The Girlhood of Mary Virgin* immediately confronting the viewer with what Catherine Golden has described as the 'double-sided nature' of Pre-Raphaelite art in general.[5] In an article which focuses on two, late, poem–painting combinations, *Astarte Syriaca* and *Proserpine*, Golden argues that the presence of the written text on the frame/canvas 'ensures that the reader/viewer readily apprehends both the literal and symbolic sides of a subject': that the physical and erotic beauty which dominate when the text is read atextually, is tempered by its mythic associations.

In this chapter, which will function as my own theoretical baseline,

I wish to begin by exploring the nature of inter-disciplinary art; not in the terms of the many philosophers and aestheticians who have agonised for centuries over the similarities and differences between the visual and the verbal, but through the eyes of a representative twentieth-century female viewer/reader who has to decide what effects such inter-textual production has upon her role as consumer.[6] The crucial questions she will be forced to ask (as I know from my students) are: how do these words (inscribed on frame or canvas) affect my perception of this image? How do paintings which are illustrations to written texts differ from those to which the written text has been appended (as in the case of *The Girlhood*)? How does a visual text (which exists in space) differ from a written text (which exists in time), and how is the translation between the two media effected? And finally, how is the literariness of Pre-Raphaelite art related to the production/reproduction/consumption of Pre-Raphaelite women? Was it collaboration, collusion or the sheer proliferation of texts that created the myths, stereotypes and discourses that we can recognise so easily today?

Let us prepare a way for answering these questions by returning to the paintings in hand. 'Why', asked my friend as we stood in front of *The Girlhood* for the nth time, 'is the dove sitting on a gold plate?' 'Because it's a halo', I replied, wondering how I could ever claw my way back through the years of 'teaching' these pictures to engage with the politics of their representation. Learning to distinguish plates from halos is, of course, where we all begin. Thus, my hypothetical 'naive viewer', confronting this picture for the first time must start by subduing all the delights of its shapes and colours to its representational content; by suspending the formal connection between dull-scarlet cloth, tri-point (which Mary is embroidering), and lily vase, for a rough approximation at what *they are*. After a few seconds she will have identified a girl sewing, an older woman seated next to her, a dwarf angel standing next to a large pile of books with a lily balanced on top, and a man (placed the other side of a dividing wall) attaching a vine to a trellis. She will then, possibly, take in additional features such as the landscape behind the window, the lamp on the wall, the dove. Whether she sees the halo or the bunch of thorns lying upon the floor will depend upon whether she knows what these things are. For as E. H. Gombrich brought to wide public consciousness, perception is determined by cognition: we only see things when we have a name for them.[7] In *Art and Illusion* he argues that 'even to describe a visible world in images we need a developed system of schemata'. To see

something *as a tree*, we first require the *concept* of a tree; an artist who sets out to draw a tree does so through a process of what Gombrich calls 'schema and correction'; testing the image s/he is producing against the original concept. 'Without some starting point', Gombrich writes, 'we could never get hold of the flux of experience' (p. 76). Identifying gold plates as halos is thus described in pedagogical terms as a 'familiarity with conventions'; and symbols are, in this respect, simply a sophisticated subset of our broader 'conventional' vocabulary. As almost every book on Victorian art is obliged to point out, the Victorian public were *au fait* with a complex religious symbolism to a degree that we, in the twentieth century, are not.

This much determined, we have reached the point where our female viewer will either step closer to the canvas and commence a quick, mechanical translation of its acrostic signs, or give up, walk away and turn her attention to another picture. It is important to realise, however, that the technical illiteracy of the latter viewer might already have granted her a claim over the image that her more knowledgeable sister will have unwittingly forfeited; that is, the possibility of making for the picture a narrative of her own choosing. Forget the halos and doves and you are left with the image of a serene and beautiful young woman for whom you might, if you wish, invent your own story. The woman next to her might be an elder sister; the man outside the window, an elder brother. Or else he might be her lover. The landscape might be Italy. The time is almost certainly 'a long time ago'. Into such non-specified places it is certain that many a visitor to the Tate will have have wandered and speculated. She might have been, to use Jackie Stacey's term, 'fascinated' (see Introduction, pp. 21–2). And she will have unwittingly defied the laws of the text's production and consumption; she may not even have read Rossetti's name on the frame, let alone cared what and for whom he was painting.

For the viewer burdened with the knowledge of prefigurative symbolism, such narrative choices, will, by this stage, be rapidly diminishing. The possibility of the seated girl being simply 'any girl' will have evaporated the moment her halo was spotted. Speculations concerning her person and personality will have, at once, been suspended, and ousted by symbolic associations. 'Mary', for the biblically literate, represents not a person but a specific set of actions and qualities. It is true that these might vary from viewer to viewer, but in all cases they are constrained. Mary, in the Protestant mind, is simply the mother of Christ; and it is this archetype our viewer will

now see cameoed against the drab-green curtains, not a character of her own choosing.

If her biblical knowledge is sufficiently advanced, the viewer will then proceed to read on. Familiarity with other visual texts and with the Bible will help her to identify first St Anne, and then to posit the figure the other side of the wall as either St Joachim or Joseph.[8] Almost immediately a temporal dimension will have crept into her reading at the point she names this man as Mary's 'future husband'. Contextualised within a story with which she is familiar, this image is now *a moment in time*; a 'frame' in an on-going narrative. And as she casts her eye around the room, she will glimpse other signs of the future: the thorns, the red cloths, the lilies will all remind her of the Passion; the angel and the lily, of the annunciation. By these means Christ himself has entered the picture as the son that she will both give birth to and watch die. The space of thirty years are scanned without so much as a twitch of the eye. Because, for our more experienced viewer (if she has got this far), such visual–temporal adjustments will have become second nature. It will be an aesthetic convention with which she is more than familiar. And it will probably have taken her no more than five minutes to follow its instructions.

But instructions necessitate rules, and until such a time as she can position herself to break free of them, the viewer who has swallowed Rossetti's painting thus whole, will necessarily be their victim. Such slavish analysis of consensual symbolism is, as I have witnessed in countless students, the surest way to limit their enquiry. Symbols are 'read' as explanations. Identifying Mary, remembering the Bible story, our unfortunate viewer may end up by seeing less than her 'illiterate' sister. By such subtle means is the web of cultural ideology extended; by learning discourses we learn to obey them. We become willing participants in a game we think we are dictating. We read *The Girlhood* as 'a biblical text' and forget that it is about Mary, about women. We interpret it, perhaps, in the way Rossetti would have hoped; we interpret it *only* in this way.

Such, then, are two of the possible routes available to the twentieth-century female viewer in the first few minutes of her encounter with *The Girlhood of Mary Virgin*. A similar challenge will present itself each and every time she confronts a representational image, as it will confront readers of this book. *Making sense* is what we involuntarily do to paintings of a certain kind (i.e., those which appear to 'mirror' reality; those with an incipient narrative content). But in making sense, we are ourselves made sense of. To understand the rules, we have to have been

already 'interpellated' by them.[9] Rossetti's *The Virgin* is interpreted as a religious painting by a cultural consensus that extends from the nineteenth century to the present day; it is a painting *about women* only through ignorance (as in the case of my first hypothetical viewer), or at the point we start breaking the rules.

Many theories have been put forward to explain the significance of Rossetti's passion for combining the visual and the verbal in a single text, but in view of the above conclusions I want to open the debate by suggesting that our canny Brother had a prophetic vision of our own 'illiterate' age. Certainly, the title alone is no longer enough to ensure the sort of informed biblical reading that I have just posited, and as we edge towards the twenty-first century, the range of our references is likely to be limited even more. Inscribing some sort of schematic explanation on the canvas itself was the surest way of delimiting the text's interpretation, and it was a strategy to which Rossetti adhered (more than any other of the Pre-Raphaelite group) throughout his career. The double sonnet which is inscribed in the frame of *The Girlhood* is one of many collected together in his *Complete Poems* as 'Poems for Pictures'[10]:

I
This is that blessed Mary, pre-elect
God's Virgin. Gone is a great while, and she
Was young in Nazareth of Galilee.
Her kin she cherished with devout respect:
Her gifts were simpleness of intellect
And supreme patience. From her mother's knee
Faithful and hopeful: wise in charity
Strong in grave peace: in duty circumspect.
So held she through her girlhood: as it were
An angel-watered lily, that near God
Grows, and is quiet. Till one dawn, at home.
She woke in her white bed, and had no fear
At all, – yet wept till sunshine, and felt awed;
Because the fulness of the time was come.

II
These are the symbols. On that cloth of red
I' the centre, is the Tripoint, – perfect each
Except the second of its points, to teach
That Christ is not yet born. The books (whose head
Is golden Charity, as Paul hath said)
Those virtues are wherein the soul is rich:
Therefore on them the lily standeth, which
Is Innocence, being interpreted.
The seven-thorned briar and the palm seven-leaved
Are her great sorrows and her great reward.
Until the time be full, the Holy One

> Abides without. She soon shall have achieved
> Her perfect purity: yea, God the Lord
> Shall soon vouchsafe His Son to be her Son.

The complex significance of such annotations are best understood if we now return to our hypothetical viewer.

Foremost among the verbal texts appended to any visual image is, of course, the title. Although I ignored its implications when considering the immediate impact of a visual text upon its viewer, it is, for casual viewer and connoisseur alike, the source to which we first turn for explanation. With respect to the historical and mythological subjects that represented the élite of Victorian art, such tags constituted not only their classification, but also their status. 'A landscape with Hagar and an angel' was *worth* far more than something simply entitled 'A landscape'; similarly, domestic scenes featuring biblical characters were thought of more highly than those just featuring peasants (i.e., 'Genre' painting). Titles provided the viewer not only with an identifiable subject, but also with an appropriate register of response. They did, and do, control the interpretation of visual images more than any other single factor.

If our viewer to the Tate had thus stooped down to read the title on the frame of *The Girlhood*, her interpretation of it would have been predetermined from the start. Without biblical/textual knowledge, she would have been told enough to prevent her from seeing this as 'a girl sewing'; with such knowledge, it would have lent a different emphasis to her symbolic analysis: instead of ranging so quickly over the whole Bible story, she would probably have dwelt on the concept of 'girlhood'. She would have focused on the painting as a representation of Mary's life during a certain phase of her development, not simply as a point in time. She would also be forced to think about the painting's depiction of virginity in more than simply an abstract way; virginity would suddenly become the 'meaning' of the painting. 'The girlhood of Mary Virgin' easily translates into 'The virginity of the girl Mary'. It would become, indeed, a painting in which the whole of the Virgin's life *up to that point*, was balanced against her life to come, her life after. The iconography of the room would suddenly extend to include non-religious symbols, such as the wall separating Joseph from the Virgin. It would be a different painting from the one she had previously seen.

Rossetti painted his two pictures of the Virgin in a religious climate which was hostile to Mariolatry. Contemporary reviews of *Ecce Ancilla Domini*, in particular, were critical and scornful of the painting's

Catholic/High Church overtones.[11] Historically, it was a time when such symbolism had been more or less successfully purged from the religious paintings of the day, and it was thus to be expected that the mid-Victorian audience would have some difficulty in interpreting the iconography of Rossetti's dissensions. One might, for example, compare Rossetti's paintings here (and those of the other Pre-Raphaelites) with the religious work of the Academicians such as Charles Eastlake which emphasised the sentimental ideality of biblical figures through a careful (and often comforting) choice of subject (e.g., *Christ Blessing Little Children*, 1839), and not by recourse to symbolism.[12] The backgrounds of Eastlake's paintings contain few contextualising features, and are often bare and shadowy. Such public ignorance was clearly the occasion for the second of the sonnets accompanying *The Girlhood*, printed first in the catalogue of the Free Exhibition, and later inscribed on the present frame (see text printed on pp. 35–6).

For our present-day viewer, as for the lapsed Victorian, this item-by-item account of the iconography, would have rendered the image instantaneously didactic. Read *before* the painting itself has been surveyed, it would dictate both the spirit in which it was to be read, and the way in which it was to be read: it would, moreover, control the *order* in which it was to be read. Instead of an idiosyncratic survey of the contents, the viewer would (from her position close to the canvas) be compelled to look from text to picture and back again, in the sequence dictated by the sonnet's list. All pictorial elements (formal and contextual), would by this means be subordinated to the textual. The painting would become an illustration; the illustration would become an explanation.

The constraints effected by such a juxtaposition of visual and verbal texts is of immense significance in any attempts to theorise the comparative influence of written text and visual image on the reader/viewer. Although it might be supposed that a verbal text *appended* to a visual text would be of secondary significance, its evident purpose, when inscribed on the frame, is to dominate; to determine the way in which/order in which the visual image is to be read. Such attempts at semiotic 'fixing' are of special significance in Pre-Raphaelite painting (especially from the early period), in which the representation of figures/objects is already sharply focused and clear-cut. The 'will' to monolithic meaning is dictated by separateness of colour, by sharpness of line; while the function of the symbolism is also to negate ambiguity, rather than to inspire it. The extreme stillness and rigidity of *The Girlhood* is usually explained simply in terms of the early Pre-

Raphaelite penchant for medieval two-dimensionality, but the son-
nets betray a deeper fundamentalism in which the concept of 'purity' is
especially resonant.

It is important to realise, however, that what any attempts to
control textual meaning ultimately reveal is the impossibility of ever
doing so. Although I have postulated an 'intention' behind Rossetti's
presentation of visual and verbal text, I am not (as a post-structuralist
reader/viewer) suggesting that such strategies were ever completely
successful: didacticism in art is an ever-losing battle against the
'slipperiness' of the sign, and the nineteenth-century dependence on
elaborate narrative titles for paintings is essentially a testimony to
this.

Apart from its itemisation of symbolic contents, Rossetti's sonnets
thus *attempt* to control the viewer's moral and religious reception of
the painting. They are also the means by which the twentieth-century
viewer can witness most clearly the ideological circumstances of their
production; identify this as a painting about women *per se*, as well as
about one woman, Mary. For this, to quote again from Rossetti's
letter, is a picture depicting 'female excellence'; excellence that can
only be achieved by a 'perfect purity'; a purity as stark and as clear-cut
as the lines and colours of the painting; as timelessly (ahistorically)
frozen as the Virgin's cameoed head. Whereas the second of the
sonnets lists the symbols of the Virgin's excellence, the first translates
them into conduct: to *become* a lily, to achieve such innocence, such
excellence, she did this:

> Her kin she cherished with devout respect:
> Her gifts were simpleness of intellect
> And supreme patience. From her mother's knees
> Faithful and hopeful; wise in charity;
> Strong in grave peace; in duty circumspect.

By this means Mary becomes the domestic 'angel' whose conduct is
repeatedly inscribed in nineteenth-century bourgeois literature; the
archetype of female 'excellence', celebrated and promoted by the
Victorian middle classes. John Ruskin's lecture 'Of Queen's Gardens'
(*Sesame and Lilies*, 1865) and Coventry Patmore's poetic sequence *The
Angel in the House* (1854–63), are two of the texts most frequently
quoted to describe the role of the Victorian middle-class woman.
'Simpleness of intellect' in such texts went hand-in-hand with
superior moral value, in a discourse which expected women to be the
'moral educators' of households by paradoxical virtue of their igno-
rance. Thus Ruskin writes:

Woman's power is for rule, not for battle – and her sweet intellect is not for invention or creation, but for sweet ordering, arrangement and decision. . . . This is the true nature of home . . . it is a place of peace: the shelter not only from all injury, but from all terror, doubt, and division.[13]

Glance again at the picture with such discourses in mind, and the sharpness of the lines will have acquired a new keenness; the austerity and control of the design, a new command. Our viewer, having got this far, will recognise for the first time that the Virgin's dress is grey, her shoulders slightly stooped, her aspect servile. Her sewing is no longer part of the text's Christian symbolism, but a sign of Woman's 'Duty'. The seven-thorned briar on the floor prefigures her own suffering as well as Christ's; a fate from which, 'pre-elect', she cannot escape. For the first time we see, indeed, that far from being content or archetypally expressionless, Mary is fearful. We are fearful. We are women reading a text which carries within it an ominous warning, and before which we either lower our own eyes, or, as feminists, summon our political contempt and turn quickly away. So much for Rossetti's sonnets being a mere appendage to his painting: placed strategically, they are an obvious attempt to fix the Virgin in her place and we in ours.

Yet while hypothesising the politics of authorial intention, it must also be remembered that this was a painting we were never meant to see; leastwise, it was not a painting we were invited to look at. Rossetti's observations of female purity, and duty, and behaviour, were produced, we must remember, for a male audience who would regard such a text as a philosophical and moral articulation of a shared consensus. They would not consider what it was to be dutiful, or respectful, or awed and frightened; they would merely approve it. And so they, unlike the female viewers, would glance at the words on the frame for a few moments before returning to other things. They would enjoy (what we can only with effort enjoy) the painting's fresco-like primary colours, its meticulous brushwork, its gilded archaisms. They might (if they were twentieth-century male viewers) include it in a book on 'Pre-Raphaelite medievalism', because they do not, for a moment, consider it a text about women. Such are the differences between viewing as a man, and viewing as a woman: then and now, with knowledge and without.

The inscription of a verbal text on a visual image is a special, and relatively rare, species of inter-disciplinary art. It may have the effect, as we have postulated here, of undermining the priority of both word and image. Which text dominates will depend upon the

arbitrary chances of viewing: whether the viewer sees the written text
when she first sees the painting; whether she begins by reading that
text (having seen it), or whether she ignores it and/or returns to it
after her visual appraisal. Most significantly, the question of which
came first – poem or painting – is totally lost. Anyone seeing
Rossetti's sonnets in his *Collected Works* would be assured of their
secondary status, but *in situ*, on the frame itself, they can easily, as we
have witnessed, assume the authority of the primary text. Outside the
poem–painting composites, however, the matter of whether the
visual or the verbal text came first, determines the sort of art we are
dealing with. Victorian art, as all commentators note, was intensely
literary, by which they mean it was primarily illustrative. Indeed, the
majority of visual texts we will be dealing with in this collection of
essays, are illustrations to anterior verbal texts: a poem by Keats,
Tennyson, or one of the Pre-Raphaelites themselves; a play by
Shakespeare, or Dante's *Vita Nuova*. Sometimes these visual texts
will illustrate specific lines; sometimes a theme, a story or an idea.
But they will all be translations and interpretations of a literary text,
or texts, that preceded them in composition (with the notable
exception of Burne-Jones's *Laus Veneris*, which preceded Swinburne's
poem); attempts to convert the narrative and the temporal into the
epiphanistic and spatial. The opposite activity – of translating visual
images into verbal ones – has always been rarer, and with the
exception of Rossetti's own 'Poems for paintings', was so amongst the
Pre-Raphaelites. Yet all this is to simplify hugely; no text, visual or
verbal, emerges in isolation or with single reference. The paintings
we shall be examining here are products of their engagement with
multiple visual texts, even as they are of multiple verbal ones. As the
following chapters will repeatedly illustrate, the referents of any
literary painting are slippery and unreliable. There is no such thing as
an unproblematic transition from word to image, and often, as in the
criticism of 'popular' cinema, the reader/viewer is permitted to
consider the engagement of the two media only in the most
circumspect of ways. To this extent, we live in an age of criticism in
which *ut pictura poesis* is both implausible and undesirable, both as a
practice and as a critical concept. We have become accustomed to
assessing a film-based-on-a-novel not in terms of its faithfulness of
rendition, but as something in its own right: as an autonomous
performance. Likewise, writing of Elizabeth Siddal's *The Lady of
Shalott* for the 1984 Tate Gallery Exhibition Catalogue, Deborah
Cherry took great care to insist that:

The drawing does not put the poem into pictorial form. It does not illustrate a content which exists outside of itself or in the poem. Its narrative comes into being in the telling, creating another story to that which is told in the poem or in those drawings by Hunt, Millais, and Rossetti which claim the poem as their subject.[14]

The extent of such autonomy, as we will see in the following readings, is a variable factor. On a common-sense level it is possible to see that some paintings are more direct illustrations of their literary source than others. But in every case, and as Macherey's reading method has shown us (see Introduction, p. 9), it is in the gaps – in the sutures between text and text – that the greatest pleasures are to be had. Not only do the differences between versions reveal much about the ideological interests of their producers and presence/absence of a guiding cultural consensus, but they also admit contradictions and inconsistencies by which those ideologies can be deconstructed and reclaimed. By bringing two or more texts into collision with one another, their mechanics are unwittingly (and sometimes shamefully) revealed. A simple act of comparison between Tennyson's 'The Lady of Shalott' and Holman Hunt's painting of the same subject gives students a better idea of why the unfortunate maiden *had* to die than months spent pouring over the poem on its own; similarly, a cross-reading of Morris's *Defence of Guenevere*, Tennyson's *Guinevere*, and the 'original' by Malory will allow an unprecedented insight into the discourses of power and danger that circulated about the adulterous woman in the nineteenth century. For the feminist reader, then, the enjambement of visual and verbal texts is explosive and liberating, placing her in a position of unequivocal power. Into the melée of discourses she is able to enter her own; in the discord between texts, to reconstruct a female subject as abused, as resplendent, as outrageously anarchic, as the complexities of the text will allow. It is her chance to usurp the male reader, the gallery-going audience. It is *her* space.

But such pleasures are for subsequent chapters. Here we must end by returning to the painting we left in dismay some pages ago to reconsider why, given all the deconstructive fuel at our disposal, we could find no way through or beyond Rossetti's image of 'female excellence'; no way of claiming for our own the delicately glowing, gold-burnished exquisiteness of a painting that is the earliest, purest, cleanest that Rossetti ever produced. The answer, as we have already seen, lies partly in the text hammered to the frame. In the article cited earlier, Catherine Golden has argued that the function of the verbal text affixed to Rossetti's frames/canvases was to temper their 'erotic beauty' with mythic associations (e.g., in his painting *Proserpine*).[15]

This is, I feel, a polite way of explaining a much broader didacticism which was intended not to correct one viewing possibility so much as impose the right one, the *only* one. In the case of *The Girlhood*, certainly, the text tells us not only that she was Mary, Mother of Jesus (and therefore decidedly not Christina Rossetti, spinster, who model-led for the picture), but that she was a woman representing specific qualities that (if we are women) we should aspire to, or (if we are men) we should require in female dependents. Because, moreover, this written text was made for the picture and physically attached to it, the female viewer, her nose close to the canvas, finds little space for Macherey's 'gaps and silences'. This tendency to the monolithic is, I would like finally to suggest, in significant contrast to *Ecce Ancilla Domini*, which has always produced the most anarchic and lively interpretation amongst students ('It looks like a delivery room in a hospital!').[16] This second painting of the Virgin (first exhibited in 1850), features two figures: the cowering, red-haired Virgin, who crouches on a narrow, white bed, and the Angel Gabriel, who floats a little above the ground with an aurora of yellow flames around his feet and holds a long-stemmed lily in his right hand. The Virgin does not appear to see the angel, but her eyes, which would appear to stare fixedly into space, are directed towards the stem of the lily. Although all the elements in the painting are presently static, they are tense with frozen movement. One imagines that the Virgin might at any moment leap up from her bed and scream, or alternatively burst into tears. This sense of repressed energy is very much in contrast with the *passive* stillness of *Mary Virgin*.

Such a comparison of course raises the whole matter of *to what extent* the text controls the reader's intervention. As I anticipated in the Introduction, this is the question which will recur, in some form, in all the readings performed here, and its 'difficulty' should be immediately manifest. The 'experience', as reader, which I would like to postulate here is that although the viewer *could* attempt to over-ride wilfully the didacticism of Rossetti's poem–painting, it is difficult. This painting, as I suggested at the beginning of the reading, is 'fundamentalist' in every way. It is painted in Primary Colours. It is about Duty. It depicts a 'Symbol of Female Excellence'. Thus although a feminist critique of the text is possible, there are few of the *aporia* necessary for a more productive feminist reading.

Yet Rossetti, no more than the other Pre-Raphaelites, could make his women sustain their pose indefinitely, and the Virgin, archetype though she was, could not be retained as a two-dimensional cameo

frozen in her act of duty. The gap between what she *ought* to be (the Virgin of the double sonnet) and what she *might* be could not be covered over. Despite desperate efforts at control, the contradictions existed which would enable her eventual release. Thus we witness that the Virgin of Rossetti's *Annunciation* has already contested her circumscription, moved into the third dimension. Unlike her predecessor, this Virgin moves and breathes; behind her downcast eyes she might also think. And what she thinks, neither she nor we are told. For here there are no verses telling us. This woman may think what we wish her to think. As a textual subject she is not fixed by the solid frame that surrounds her, and the visitor to the Tate Gallery may write for her a different story.

Notes

1. Dante Gabriel Rossetti (1828–82) began his painting career in the early 1840s, when he entered the Sass Drawing Academy in London. He became a full student of the RA Schools in 1845, where he concentrated on literary illustration. In 1848 he joined forces with William Holman Hunt and John Everett Millais, and this group, together with F. G. Stephens, Thomas Woolner, James Collinson and William Michael Rossetti (secretary) formed the Pre-Raphaelite Brotherhood (hereafter PRB). *The Girlhood of Mary Virgin*, Rossetti's first major oil painting, was shown at the Free Exhibition in March 1849. W. M. Rossetti records that Dante Gabriel began work on *Ecce Ancilla Domini* in November of the same year, observing that he planned the latter to be one of two companion pictures, the other featuring the death of the Virgin (see William E. Fredeman (ed.), *The Pre-Raphaelite Brotherhood Journal: William Michael Rossetti's diary of the Pre-Raphaelite Brotherhood 1849–1853* (Oxford University Press, Oxford, 1975)). This painting was first exhibited at the National Institution which opened on 13 April 1850, and then again in the winter of the same year at the North London School of Design. It is significant that after these two early experiments in oil, Rossetti worked almost exclusively in watercolour for the next decade.
2. Like Griselda Pollock, I have used quotation marks to indicate that by 'Rossetti' I am not referring to Rossetti the biographical subject but to the collective *works* of a common producer (see Pollock, *Vision and Difference: Femininity, feminism and the history of art* (Routledge, London, 1988), p. 124). This distinction between the biographical and the generic also appertains to my discussion of the other artists and writers discussed in these essays.
3. Letter by Rossetti in Bodleian Library. Quoted TGC, p. 65.
4. See John Dixon-Hunt, *The Pre-Raphaelite Imagination* (Routledge and Kegan Paul, London, 1968). Dixon-Hunt, in common with many commentators, distinguishes a sea-change in Rossetti's work in the early 1860s, when he turned away from watercolour and Elizabeth Siddal, to oil paint and Fanny Cornforth.
5. See Catherine Golden, 'Dante Gabriel Rossetti's two-sided art', *Victorian Poetry* 26 (1988), 395–402.
6. Some classic texts to deal with the relationship between literature and the visual

arts include: Lawrence Binyon, 'English poetry and its relation to painting and the other arts', *Proceedings of the British Academy* XXXVIII (1942); John Dryden, 'A parallel of poetry and painting' (1695); Rhoda L. Flaxman, *Victorian Word-Painting and Narrative: Towards the blending of genres* (UMI Research Press, Ann Arbor, Mich., 1987); Jean Hagstrum, *The Sister Arts: The tradition of literary pictorialism: and English poetry* (University of Chicago Press, Chicago, Ill., 1958); John Dixon-Hunt, *Encounters: Essays on literature and the visual arts* (Studio Vista, London, 1971); Lothar Hönnighausen, *The Symbolist Tradition in English Literature: A study in Pre-Raphaelitism and fin-de-siècle* (Cambridge University Press, Cambridge, 1988); Gotthold Lessing, *Laocoön, or The Frontiers Between Painting and Poetry* (1766; see Bibliography for new edition); Jeffrey Meyers, *Painting and the Novel* (Manchester University Press, Manchester, 1975).

7. See E. H. Gombrich, *Art and Illusion* (Phaidon, Oxford, 1960). Page references are given in the text.

8. Laura L. Doan, in 'Narrative and transformative iconography in Dante Rossetti's earliest paintings' (*Soundings*, 17, 4 (1988), 471–83), assumes that the male figure outside the window is St Joachim. Doan also finds ideological significance in this painting's static two-dimensionality. She writes:

> The most surprising aspect of *The Girlhood of Mary Virgin* is that, despite the symbolic clutter, the image is static rather than dynamic. In a painting where every detail is a source of meaning, where most participants work actively at embroidery or gardening, the overall impression is, paradoxically, flat and stilted. . . . This painting seems, ultimately, a collection of exhausted signifiers; it makes sense – but only within the confines of a conventional iconographical context. (p. 477)

9. See Introduction (p. 6) for explication of Althusser's explication of 'interpellation'.

10. Text as inscribed at the bottom of the existing frame of *The Girlhood of Mary Virgin* (see Plate 1) and reproduced in TGC, p. 65. Alaistair Grieve in the *TGC* notes that the original frame was inscribed only with the second of the sonnets (i.e., that explaining the painting's symbolism), although the first was printed in the catalogue to the Free Exhibition of 1849. There were also several significant changes made to the first sonnet between the different versions. I print here the earlier version which I advise readers to compare closely to that reproduced on pages 35–6. It will be seen that the changes made reinforce Mary's domestic *obedience*. In the first version, for example, she shows 'devout respect' to God; in the second, 'to her kin'. Most significant, however, is the exchange of 'duty' for 'pity' in the eighth line:

> This is that blessed Mary, pre-elect
> God's Virgin. Gone is a great while, and she
> Dwelt young in Nazareth of Galilee.
> Unto God's will she brought devout respect,
> Profound simplicity of intellect,
> And supreme patience. From her mother's knee
> Faithful and hopeful; wise in charity;
> Strong in grave peace; in pity circumspect.
> So held she through her girlhood; as it were
> An angel-watered lily, that near God
> Grows and is quiet. Till, one dawn at home
> She woke in her white bed, and had no fear

at all, – yet wept till sunshine, and felt awed:
Because the fulness of the time was come.

The Works of Dante Gabriel Rossetti (Ellis, London, 1911), p. 173.

11. The reviewer in the *Atheneum* (20 April 1850) wrote of *Ecce Ancilla Domini* that it was 'a work evidently thrust by the artist into the eye of the spectator more with the presumption of a teacher than in the modesty of a hopeful and true aspiration after excellence'. Quoted in the TGC, p. 73.

12. This painting by Eastlake is reproduced in the Open University A102 Illustration Booklet. It is housed at Manchester City Art Gallery.

13. John Ruskin's lecture 'Of Queen's Gardens' is printed in the collection, *Sesame and Lilies* (1865); see *The Works of John Ruskin*, ed. Edward T. Cook and Alexander Wedderburn (George Allen, London, 1903–12). Extracts also printed in J. M. Golby (ed.), *Culture and Society 1850–90* (Oxford University Press, Oxford, 1986), pp. 118–22.

14. Deborah Cherry, TGC, p. 266.

15. Catherine Golden, 'Rossetti's two-sided art'.

16. D. G. Rossetti, *Ecce Ancilla Domini*. 1849–50. Oil on canvas mounted on panel, 28⅞ × 16½ in. (72.6 × 41.9 cm). London, Tate Gallery. See TGC, no. 22, p. 73. This painting is widely reproduced in books on Pre-Raphaelite art.

Chapter 2

Beatrice: Hazy Outlines

In most accounts of Rossetti's career, Beatrice emerges as a secular variant of 'Mary Virgin'. She is the 'perfect purity' of the Virgin incarnated in mortal form, and then snatched away again before her golden hair has time to tarnish. She is also synonymous, in the popular mind, with Elizabeth Siddal; the woman whom Rossetti 'worshipped' and painted for ten years before he eventually married and then immortalised after her death in the painting, *Beata Beatrix* (see Plate 2).

The mythological construction of Elizabeth Siddal has come under some rigorous scrutiny in recent years, not least in the work of Jan Marsh. In *The Pre-Raphaelite Sisterhood* (1984) and more recently, in her book *The Legend of Elizabeth Siddal* (1989), Marsh has compared and contrasted the stories surrounding the name of 'Siddal' with what we know of her 'real life' as a woman and artist.[1] In *The Pre-Raphaelite Sisterhood* she illustrates the difference between Rossetti's idealised studies of Siddal, those by fellow Pre-Raphaelite artists (Hunt and Millais), and that by Siddal herself. Her description of Siddal's own self-portrait is a useful point of comparison for the following discussion of *Beata Beatrix*:

> The portrait is interesting and competent for an artist without formal training or previous experience in oils. It belongs to the honest rather than 'improved' school of self-portraiture and is far-removed from the chocolate-box feminine image of the time which women were accustomed to seeing. It is straightforward, uncompromising and surprisingly strong, emphasizing the large-lidded eyes, distinctive mouth and long neck. The head and shoulders are unadorned except for a small white collar; the hair is ginger against a green background and the face looks out from the circular canvas with a frank and slightly vulnerable expression but no self-indulgence. There is a stiffness in the handling and the work is not naturalistic, but the effect is successful and may be favourably compared with the similar portrait that Gabriel painted a few months later, also on a green ground in an oval frame, which presents a much more glamorized view of Lizzie. (pp. 44–5)

The painting by Rossetti which Siddal refers to here is no. 668 in the

Surtees Catalogue, where it is given the title of A *Parable of Love* and dated *c*. 1850 (Marsh suggests 1853–4 is more likely), but Siddal's austere and 'Quakerish' presentation of herself exists as a significant touchstone against which all Rossetti's studies may be read, not least *Beata Beatrix* itself.

Griselda Pollock and Deborah Cherry have similarly explored the 'textuality' of Siddal's construction in their essay 'Woman as sign in Pre-Raphaelite literature', concluding that what we have come to identify as 'Siddal' is a collection of tropes dominated by 'passivity', but including a whole host of other associations such as 'fragility', 'incapacity', 'inactivity' and 'suffering.'[2] And Beatrice is, inevitably the literary heroine in which all these traits are brought (all too literally) to rest: ' "Siddal" becomes Beatrice, the beautiful, adored, and yet unattainable image for the masculine artist inspired by her beauty, a beauty which he [Rossetti] fabricates in the "beautiful" drawings he makes'.[3] In this chapter I wish to explore the legacy of this mythology as it affects the modern reader/viewer; to examine the extent to which the Rossetti dream has become ours, or whether there are other ways of explaining the enduring popularity of *Beata Beatrix* among female viewers.

Rossetti, as is widely known, was more than a little obsessed with his literary namesake. His translation of the *Vita nuova* at the age of twenty stood at the threshold of his career as a Pre-Raphaelite painter, poet and Dante scholar. It has been deemed a very competant translation, and its story reverberated through his work for over a decade.[4] In *Dante and English Poetry*, Steve Ellis locates Rossetti's translation within a mid-nineteenth-century cult which focused on Dante specifically *in relation to Beatrice*. During this period all of Dante's works came to be read 'through' the *Vita nuova*. Of Rossetti in particular Ellis writes:

> For Rossetti, all roads lead back to the *Vita Nuova* and 'Dante the philosopher', Dante the politician is unrecognisable from Rossetti's poem [i.e., 'Dante at Verona']: the man who wrote the *Commedia*, *Monarchia* and *Convivio* remains for Rossetti the man who shut himself up in his rooms and wept for a year over Beatrice's death.[5]

But to understand the enduring popularity of the Beatrice myth we need first to establish the discourses that surrounded Rossetti's literary heroine. In the early poem, 'Dante at Verona', as in the *Vita nuova* itself, she is felt and seen primarily as a reflex of Dante's longing; an expression of his loss.

Rossetti wrote 'Dante at Verona' between 1848 and 1850 (that is,

during the same period he was preparing the translation), and Steve Ellis has observed that apart from the *Vita nuova* itself, Rossetti's characterisation of Dante in this poem was most certainly influenced by Carlyle's lecture, 'The hero as poet', which focused on Dante's wretchedness: 'This picture of Dante can be regarded as a sort of diluted Byronism, with the fierceness gone but the sorrow remaining' (p. 112). Without a narrative with which to hold its eighty-five stanzas together, 'Dante at Verona' is a very difficult poem to summarise. Its ramblings are not, however, without interest, since, rather like Wordsworth's *The Thorn*, they draw particular attention to the text's 'loquacious narrator' who retraces his heroes' footsteps with all the greedy vicariousness of the twentieth-century 'literary' tourist:

> As that lord's kingly quest awhile
> *His life we follow*, through the days
> Which walked in exile's barren ways, –
> The nights which still beneath one smile
> Heard through the spheres one word increase, –
> 'Even I, even I am Beatrice'.[6]

The inclusive first-person pronoun, 'we', is used throughout the poem as the reader is invited to imagine Dante wandering around the courts and fountains of Verona. 'Watch we his steps', whispers the speaker before shifting his address to the ghost himself in the passage quoted here. In other passages, the speaker sketches in the life of Can Garde's court (the women and the wine), only to dismiss them again as things Dante himself 'recked not'. His distaste for the jester – an anecdote deriving from Petrarch – is used merely to reinforce the single-mindedness of his devotion to Beatrice, while his protest against the Republican Movement in Florence (metaphorically represented as the Prostitute Respublica) is depoliticised by its explanation *in* Beatrice:

> Such *this* Republic! – not the Maid
> He yearned for, she who yet should stand
> With heaven's accepted hand in hand,
> Invulnerable and unbetray'd;
> To whom, even as to God, should be
> Obeisance one with Liberty. (p. 14)

In this poem, then, which reviews the years spent at Verona following Beatrice's death ('Years filled out their twelve moons, and ceased / One in another') Beatrice exists as a ghostly manifestation of the poet's own suffering and desire:

> For then the voice said in his heart,
> 'Even I, even I am Beatrice';
> And his whole life would yearn to cease:

Till having reached his room, apart
Beyond vast lengths of palace-floor,
He drew the arras round his door.

At such times, Dante, thou hast set
Thy forehead to the painted pane
Full oft, I know; and if the rain
Smote it outside, her fingers met
Thy brow; and if the sun fell there,
Her breath was on thy face and hair.

Then, weeping, I think certainly
Thou hast beheld, past sight of eyne, –
Within another room of thine
Where now thy body may not be
But where in thought thou still remain'st, –
A window often wept against: (pp. 9–10)

Beatrice's 'otherness' in the stanzas quoted here is not the otherness of another person, nor of a woman, but of a self that exists on the 'other-side' and may not be reached. Although palpable (Dante feels hands upon his brow), the cipher of desire that is Beatrice has no physical body, no voice, no material identity. As such, the speaker's repetition of the lines from Dante's *Divine Comedy*, 'Even I, even I am Beatrice', assume special ambiguity, referring both to the voice that haunts and taunts Dante with its treacherous promise of a thing that is not there, and also to the brutal fact that Beatrice is, indeed, 'no-other' than himself. Such a reading is in line with Jerome McGann's presentation of Rossetti as one of the many nineteenth-century writers who anticipated the solipsisms of the twentieth-century deconstructionists.[7] He concludes:

> This point of view established the basic contradiction within which Rossetti's work was to develop. The practical dimension of the contradiction can be expressed as follows: how does one paint or write poetry when the world of getting and spending constantly impinges, transforming the fair illusion of a pure pursuit of Beauty into other, darker forms – at worst unworthy, at best distracting, but in any case equally illusionistic? . . . In the end Rossetti's poetry will repeat Dante's journey in the opposite direction, descending from various illusory heavens through a purgatory of unveilings to the nightmares and hells of his greatest work, the unwilled revelations arrived at in *The House of Life*. (pp. 342–3)

Writing about 'Dante at Verona', McGann draws attention to the historical displacement of the speaker which 'paradoxically . . . intensifies the aura of poetic self-consciousness':

> He [Rossetti] turns away from his own age and self, but in doing so the contemporaneous relevance of his acts of historical displacement is only heightened. 'Dante at Verona' is in this respect a clear allegory which

deconstructs itself. Dante's alienation has its contemporary (Rossettian) analogy in the speaker of the poem who celebrates Dante's critique of luxurious society. But whereas the Dante of Rossetti's poem speaks out openly and plainly against the world of Can Garde, there is no plain speaking at the contemporary level, merely gestures and vague allusions. (p. 350).

Only once, in the poem's account of the vision that occasioned sometimes to fall as a 'shadow' upon Dante's face, are we provided with glimpses of Beatrice's external existence:

> Ah! haply now the heavenly guide
> Was not the last form seen by him:
> But there that Beatrice stood slim
> And bowed in passing at his side,
> For whom in youth his heart made moan
> Then when the city sat alone.
>
> Clearly herself: the same whom he
> Met, not past girlhood, in the street,
> Low-bosomed and with hidden feet;
> And then as woman perfectly,
> In years that followed, many and once, –
> And now at last among the suns
>
> In that high vision. But indeed
> It may be memory might recall
> Last to him then first of all, –
> The child his boyhood bore in heed
> Nine years. At length the voice brought peace, –
> 'Even I, even I am Beatrice'. (p. 15)

Instead of fixing her to a mortal existence, however, these tableaux of Beatrice at different ages have the effect of destabalising her presence still further: the refrain, 'Even I, even I am Beatrice' seems now to be repeated in wonder that this woman/adolescent/child should add up to one self that was Beatrice. Not single enough to be an Ideal, an Abstraction, she is thus the archetypal floating signifier; the textual identity that Elizabeth Siddal was supposedly mythologised into was no more substantial than the mythologies themselves.[8]

The view that Rossetti's women were no more than projections of himself is not a new one. In 1968 John Dixon-Hunt set out to prove that the idealised images Rossetti portrayed in word and image were no more, no less, than manifestations of his own 'soul's beauty'.[9] In *The Pre-Raphaelite Imagination* he refers to the early story 'Hand and soul' to explain the connection between the beautiful woman of Rossetti's paintings and the artist's soul: 'She becomes an ideal beauty because, as the story illustrates, her message re-affirms the ultimate sanctity of an artist's vision and the corresponding inadequacies of trying to accommodate his insights to contemporary realities'

(p. 178). While of *Beata Beatrix* he writes: 'It is impossible to say that *Beata Beatrix* illustrates Dante or is just a commemorative portrait of his wife, our response to its considerable power must acknowledge that it offers a tangible equivalent of an intricate spiritual reality' (p. 179).

The challenge for us, as feminist readers and viewers, however, is to decide what to do with the representations that are left. For, even allowing that such images may be read as narcissistic projections of a tortured male genius (comparable to the recent readings of Tennyson's early 'women poems', for example), we are still left with images that are *images of women*, and require to be responded to as such.[10]

In this chapter I wish to propose that the popular success of *Beata Beatrix* would seem to derive from the very fact that the figure in the painting is an 'outline' that has *not* been filled in. Based on a literary legend that the twentieth-century audience is unlikely to be conversant with, Rossetti's hazy vision of a semi-conscious woman succeeds because of its vicariousness. Even those familiar with the textual source will, as we have seen, find little to restrict their *impression* of this representation of womanhood. In anarchic contrast to the sharp and didactic lines of *The Girlhood*, Rossetti's Beatrice floats in a space that is defined neither spatially, temporally nor morally. It is true that Beatrice is culturally associated with purity and perfection, but, unlike the Virgin, these are attributes ascribed to her not on account of her dutiful behaviour, but as a result of her untimely death. Her heroism is thus achieved gratuitously, and here, even for the female viewer conversant with the story, we have a clue to Beatrice's enduring fascination: Beatrice gives back to her audience a desirable illusion of purity and perfection without suggesting how such things are achieved.

In every aspect, indeed, Rossetti's *Beata Beatrix* is an image of negation, nothingness and death. Although earlier feminist critics (and most certainly my students) have registered the uncomfortable implication that Siddal's own death was the unwitting consummation of her Beatrice role, the invidious appeal of such an image for the female viewing public has not been calculated. For the 'fuzziness' of the Beatrice image, both in visual and verbal texts, is not achieved as gratuitously as it might at first appear. The pleasure purloined from *Beata Beatrix* is not simply derived from the viewer making of the image what she will. It is rather, and more sinisterly, a reflex of sympathetic default. When she looks at *Beata Beatrix* the twentieth-century female viewer may be positioned to see an image of death disguised as romantic denial. It is an image she is familiar with because

she sees it every day in the media; it is an image of a woman who has been denied, and is, more importantly *denying herself*; it is an image of a woman starving herself; a woman becoming increasingly 'pale and interesting'. Rossetti called it 'being rapt visibly towards heaven' (see below); we see its ghost every day as a sanitised *anorexia nervosa*. And this, not simply in the sense of becoming thin, but of becoming *less*; becoming less, psychologically as well as physically, so that we end up as simply a flattened outline, a romantic shape in which to pour the requisite dreams. Because it is the hazy, two-dimensional outline of Rossetti's Beatrice that post-1960s consumerism has aspired to; it is the cleanness of line, the flatness of flesh, that women are encouraged to desire for, and of, themselves. To this extent Beatrice is no more and no less than a fashion plate in *Vogue*; it is simply that she comes in poster form that she is suitable to hang on walls. Griselda Pollock draws this parallel between twentieth-century fashion photography and Pre-Raphaelite 'portraiture' in her chapter on 'Woman as sign: psychoanalytic readings'.[11] Here she writes:

> Often there was only a blank, air-brushed expanse of colour in which eyes freely floated above undulations of shocking and moistly red shiny lips. These were not faces, nor portraits but fantasy. I recognised a striking parallel with nineteeth-century drawings of female faces by D. G. Rossetti which were also *not* portraits. (p. 122)

At this point it becomes necessary to read this hypothetical explanation of the twentieth-century popularity of the painting against the circumstances of its contemporary production and consumption. *Beata Beatrix*, it must be remembered, was not originally destined for a female audience. Details of its provenance reveal that after Rossetti had begun work on it some time in 1864–6, it was commissioned by the Hon. William Cowper-Temple, and that after its completion in 1870, Rossetti began work on a crayon copy for William Graham and was later persuaded to produce the oil replica now in Birmingham City Art Gallery.[12] It was not a painting exhibited in Rossetti's lifetime, but well known among his (male) friends, as is evidenced in the care he took to describe it in his frequently quoted letter to T. Horner of 11 March 1873.[13] In this letter he writes:

> The Picture must of course be viewed not as a representation of the incident of the death of Beatrice, but as an ideal of the subject, symbolized by a trance or a sudden spiritual transfiguration. Beatrice is rapt visibly into Heaven, seeing as it were through her shut lids (as Dante says at the close of the Vita Nuova): 'Him who is Blessed throughout all ages'; and in sign of supreme change, the radiant bird, a messenger of death, drops the white poppy between her open hands. In

the background is the city which, as Dante says 'sat solitary in mourning for her death' and through whose street Dante himself is seen to pass going towards the figure of Love opposite, in whose hand the waning life of his lady flickers as a flame. On the sundial at her side the shadow falls on the hour of nine, which number Dante connects mystically in many ways with her and with her death.

Both this letter, and the biographical knowledge that it was a portrait of Rossetti's 'dead wife' have done much to romanticise and mysticise the subject, as well as providing it with a narrative which is lacking in the painting itself. Indeed, it is interesting to observe that the identification of this painting as 'Beatrice' depends entirely upon the items/symbols that occur outside the main figure herself, in what is graphically another space, another time; sundial, shadowy city and the twin figures of 'Love' and Dante float in an indeterminate space beyond Beatrice's head, while it takes a 'radiant bird' carrying an opium poppy to indicate that the woman with closed eyes is, in fact, dying. These objects, together with the quotations from the *Vita nuova* and the *Divine Comedy* which Rossetti had inscribed on a frame of his own design, were necessary to secure the 'meaning' of his work, even for a learned audience.[14] In addition to patrons and the general public there was, however, a small specialised audience for the painting among other members of the Pre-Raphaelite circle. Fellow artists like Madox Brown and Holman Hunt had followed Rossetti's obsession with the Beatrice theme throughout the 1850s, and would also have been peculiarly sensible to the Siddal connection. Indeed, it was Madox Brown who once reported having seen 'Guggums [Siddal] looking more ragged and more beautiful than ever'; a statement which indicates that there was some consensus of taste among the group for sickly, delicate women. Seen in this context, the limp, bloodless form of Beatrice becomes, for the male aesthete, a symbol as seductive as it clearly is for the female audience. Here we have a canvas wherein male and female fantasies of the feminine may both be reciprocated. The narcissistic/masochistic pleasure of self-denial meets the sadistic pleasure of voyeurism. On this point it is interesting to see that in the Tate Gallery Catalogue, Alaistair Grieve notes that 'strangely, nobody has remarked on the phallic pointer of the sun-dial projecting towards the frozen ecstasy of her face', implying that for the (male?) audience such an interpretation is a matter of implicit consensus.[15] One concludes that *Beata Beatrix* has been as successful as any Hollywood movie in positioning its spectators of both genders.[16]

Yet having established the obvious routes by which the Beatrice myth has been assimilated and possessed by nineteenth-century male and twentieth-century female audiences alike, it is necessary to

question whether the visual and verbal obsessions of Rossetti's youth may not be plundered for some more positive purpose; to see if the hazy outline of the Pre-Raphaelite Beatrice might not be resurrected as the site of more contradictions than Rossetti and his contemporaries ever dreamed. In order to begin these subtle exhumations it is necessary, first, to return to the literary texts: to Dante's own *Vita nuova* and to Rossetti's treatment of the subject in 'Dante at Verona'.

Dante's Beatrice had little more material identity than Rossetti's heroine.[17] Her personal attributes are, indeed, conceptual abstractions. She exists, principally, as a chain of abstract superlatives; because she is the object of love, she is necessarily the 'fairest', 'purest', the 'most gracious' of all the women in Florence. She never speaks or is given a voice, her utterances being limited to her reported greetings to Dante. Her rank, status and family name are never revealed: she is simply 'Beatrice'. As an abstract concept in the speaker's mind, it is also important to remember that she shares her role with the figure of 'Love'. Love appears to the speaker as a male personification, identified as male, significantly, because he laughs.[18] This laughing spirit guides and inspires the speaker, leads him to where his beloved is, and, at times, chastises him. Love is thus the true addressee of the poet's thoughts; Beatrice the mere *object*.

That Rossetti was aware of, and slightly embarrassed by, the intransitive nature of his hero's desire is evident from the Introduction with which he prefaced his own translation of the *Vita nuova*. He writes:

> But it is true that the *Vita Nuova* is a book which only youth could have produced, and which must chiefly remain sacred to the young; to each of whom, the figure of Beatrice, less ladylike than lovelike, will seem the friend of his own heart.[19]

In the sonnet, 'On the Vita Nuova of Dante', moreover, Rossetti's speaker seems to indicate that the dominant attraction of the text is its portrayal of a 'Paradisial Love' which emerged in spite of 'man's shameful swarm'.[20] The love of Beatrice, like the adoration of the Virgin, is a love which negates sexual lust. Indeed, she is never allowed to become an object of sexual desire. Protected first by her pre-adolescence (she is a child when Dante first falls in love with her), her brief adulthood is spent behind a screen of protective women who follow her wherever she goes.[21] Then, before there are any social demands upon her womanhood (i.e., marriage), she dies. Her death enshrines her virginity, her asexuality. Purity is held intact, but only at the expense of death.

The impossibility of the clause that demanded women to be chaste yet procreative has been comprehensively explored in Marina Warner's *She Alone of all her Sex*.[22] In her text, Warner argues passionately from the side of the women who have, throughout the centuries, been oppressed and punished for their inability to resolve physically the blighting paradox. Yet while it is true that within patriarchy it is women who have been the material victims of this moral absurdity, it is also appealing, from our twentieth-century viewpoint, to turn the tables and see how the men have suffered from the very discourses they have produced, courted and sustained. Witness, for example, how Dante and his nineteenth-century name-sake seem to have suffered. Not that I am proposing compassion; merely an ironic recognition that the only way in which the male seems to have been able to mitigate the burden of the 'shameful swarm' was in devoting himself to a love that was no love: that could only ever be love-in-death. Read in this light, the twentieth-century feminist audience may begin to look upon *Beata Beatrix* with new indulgence. For notwithstanding the voyeuristic conditions that have enabled Rossetti, Rossetti's friends and Alaistair Grieve to take a particular interest in the pointed sundial and Beatrice's open-mouthed vulnerability, we know that she has, and ever will, elude them. As other critics have observed with increasing clarity, the Victorian obsession with female sexuality was essentially an obsession of fear. In 'Woman as sign' Griselda Pollock sweeps boldly over a selection of Rossetti's bust-length portraits, and exposes their fetishisation as an expression of extreme psychosexual trauma, at the same time indicating the pleasure the female viewer may take in representations which thus unwittingly position the audience 'against patriarchy'.[23] The same reflex, I would suggest, is available to the viewer of *Beata Beatrix*.

In the first place, a knowledge of the literary texts upon which this heroine has been constructed reveals not a victim *per se* (such as this 'dying woman' must otherwise appear), but a ghostly signifier that no man will ever hold, ever possess. The extreme vacuousness of Dante's dream, his desire for the 'fairest', the 'purest', the 'most gracious' *of nothingness* warrants a modicum of ironic satisfaction. While it is true that a 'real woman's' death might have been the occasion for Rossetti's painting, the irony of the representation ultimately falls back upon the male producer himself. Rather than a sinister abuse of Siddal's 'proper identity', it is perhaps possible to read Rossetti's idealisation of her as Beatrice as an expression of his own impotence: of his inability to realise Woman, or Love, in terms other than Death.

With a little tortured meditation, then, we have arrived at a point where the twentieth-century feminist reader/viewer can, if she wishes, claim Beatrice as her own. There is not much to claim, it is true: merely an emptiness, the blurred and diminishing outline of a woman that no man will ever possess because it is by default that she exists. Whereas Rossetti's Virgin was rendered safe by having her virtues nailed to the frame of the painting, Beatrice is suspended in her own ghostly vacuum. Instead of representing a set of values, she evades the dangerous ideological contradictions that lurk inside other Pre-Raphaelite heroines. But in her non-referentiality she plays what is perhaps the most cynical trick of all: 'Even I, even I am [not] Beatrice.'

Notes

1. See Jan Marsh, *The Pre-Raphaelite Sisterhood* (Quartet, London, 1985) and *The Legend of Elizabeth Siddal* (Quartet, London, 1989). Page references are given after quotations in the text.
2. See Pollock, *Vision and Difference: Femininity, feminism and the history of art* (Routledge, London, 1988), pp. 91–114.
3. *ibid.*, p. 106.
4. The full text of this translation is reproduced in *The Works of Dante Gabriel Rossetti*, ed. William Michael Rossetti (Ellis, London, 1911), including Rossetti's 'Introduction' of 1861. For a detailed historical contextualisation of this translation see the excellent chapter 'Rossetti and the cult of the *Vita nuova*' in Steve Ellis's *Dante and English Poetry: Shelley to T. S. Eliot* (Cambridge University Press, Cambridge, 1983).
5. Steve Ellis, *Dante and English Poetry*, p. 110. Further page references are given after quotations in the text.
6. *Works*, p. 7. Further page references are given after quotations in the text.
7. Jerome McGann, 'Dante Gabriel Rossetti and the betrayal of truth', *Victorian Poetry*, 26, 4 (1988) 339–62.
8. Although Steve Ellis, in *Dante and English Poetry*, concludes his chapter on Rossetti's Beatrice by acknowledging her as a 'repository of ultimate values' (p. 134), it is significant that he describes her not as a 'presence' but as a 'region'. Conflated into a 'universal' which will compensate Rossetti's 'sheer religious uncertainty', Beatrice assumes the shadowy boundlessness of God himself.
9. See John Dixon-Hunt, *The Pre-Raphaelite Imagination* (Routledge and Kegan Paul, London, 1968). Page references are given after quotations in the text.
10. See Lionel Stevenson, 'The "high-born maiden" symbol in Tennyson', in John Killham (ed.), *Critical Essays on the Poetry of Tennyson*, (Routledge and Kegan Paul, London, 1979). Stevenson reads poems like 'Mariana' and 'The Lady of Shalott' as metaphorical expressions of the poet's need to turn from the interior world of 'art' to the world of 'reality':

> As soon as this abstract opinion began to take specific form in the poet's mind it embodied itself in the familiar figure of the imprisoned maiden. This

time no process of interference is necessary to convince us that the poet is symbolizing an inner experience of his own. Stevenson, like Dixon-Hunt, does not, however, address why the male artist should express his soul's angst in a female form, save to observe that, in Jungian psychoanalysis the unconscious 'is always of the opposite sex'.

11. In *Vision and Difference*. Page references are given after quotations in the text.
12. According to the records held by Birmingham City Art Gallery, a crayon copy of *Beata Beatrix* was made by Rossetti for William Graham in 1869, and an oil replica begun in 1872. The version now at Birmingham was painted *c*. 1877.
13. Printed in TGC, p. 209.
14. The two typographic inscriptions on the frame of the Tate Gallery version are as follows: (bottom) 'Quomodo sedet sola Civitas!' ('where solitary sat the city') and (top) 'Jun: Die 9: Anno 1290' (the date of Beatrice's death). In the roundels are represented the sun, stars, moon and earth referred to in the last lines of the *Divine Comedy*: 'Love which moves the sun and other stars.'
15. TGC, p. 209.
16. See Laura Mulvey, 'Visual pleasure and narrative cinema', *Screen*, 16, 3 (1975), 6–18, and Mary Ann Doane *The Desire to Desire: The woman's film in the 1940s* (Indiana University Press, Bloomington, 1987) and discussion in the Introduction, pp. 17–22.
17. Steve Ellis, *Dante and English Poetry*, quotes Nicolette Gray to show that Rossetti's Beatrice, although archetypal, was so in a different way from Dante's icon of universalised Christian 'Love':

> This has the effect, as Mrs. Gray suggests, of completely 'de-universalizing' Beatrice's significance and drawing her within the cycle of privacy and secrecy celebrated in Rossetti's own love poems. . . . The beloved's 'universality' that Rossetti celebrates . . . sees the woman not as the vehicle of a divine force but as the replacement for it, with love for her representing a complete abnegation of everything else. (pp. 121–2)

18. In Chapter XXV Dante explains his male personification of Love thus:

> That I speak of love as if it were a bodily thing, and even if it were a man, appears from these three instances: I say that I saw him coming; now since 'to come' implies locomotion and, according to the philosopher, only a body in its own power is capable of motion from place to place, it follows that I classify love as a body. I also say that he laughed and spoke, which are things appropriate to a man, especially the capacity to laugh; and so it follows that I make love out to be a man. (*La vita nuova*, trans. Barbara Reynolds (Penguin, Harmondsworth, 1969))

The *active* role of Love, as opposed to the *passive* status of Beatrice, is also set out at the beginning of the text. Here the speaker pronounces:

> From then on indeed Love ruled over my soul, which was thus wedded to him early in life, and he began to acquire such assurance and mastery over me, owing to the power which my imagination gave him, that I was obliged to fulfil his wishes perfectly. He often commanded me to go where I might see this angelic child and so, while I was still a boy, I often went in search of her. (*Vita nuova*, trans. Reynolds, p. 30)

19. *Works*, p. 297.

20. 'On the Vita Nuova of Dante', *Works*, p. 195.:

> So I, long bound within the three-fold charm
> Of Dante's love sublimed to heavenly mood
> Had marvelled, touching his Beatitude,
> How grew such presence from man's shameful swarm.

21. Beatrice's entourage is depicted in Rossetti's watercolour of 1852, *Beatrice, Meeting Dante at a Marriage Feast, Denies Him Her Salutation*. It depicts the following episode from the *Vita nuova*:

> Then, pretending nothing was wrong, I leaned for support against a fresco painted in a frieze around the walls of the house. Afraid that other people might notice how I was trembling, I raised my eyes and as they rested on the women gathered there I saw among them the most gracious Beatrice. . . . A number of women present, observing my transformation, began to be astonished and, talking about it, they mocked me in company with the most gracious one herself. (trans. Reynolds, pp. 47–8)

This episode is also portrayed in a painting by Henry Holiday in the Walker Art Gallery, Liverpool.

22. See Marina Warner, *She Alone of all her Sex: The myth and the cult of the Virgin Mary* (Random, New York, 1983).

23. See Pollock, *Vision and Difference*, pp. 151–2:

> Some art historians have found *Astarte Syriaca* a cruel and frightening image of love, obviously reading it as a kind of *femme fatale*. I would like to propose an entirely opposite reading, seeing in its scale, active posture and empowered glance, an image which transcends the stalemated, fetishistic quality of so many of the images previously discussed. (p. 152)

Chapter 3

Mariana: Gorgeous Surfaces

Tennyson's 'Mariana' and John Everett Millais's painting of the same name are an inter-disciplinary combination which have received considerable critical attention in recent years.[1] Part of the attraction undoubtedly derives from the fact that Millais's painting (see Plate 3) is a very literal illustration of Tennyson's text. Exhibited with the refrain

> She only said, 'My life is dreary,
> He cometh not,' she said;
> She said, 'I am aweary, aweary,
> I would that I were dead!'

which recurs in the first, fourth and sixth stanzas, it is explicitly connected with Mariana's psychological crisis: her claustrophobic hopelessness caused by the 'wasting' of another day. I quote the last two stanzas:

> All day within the dreamy house,
> The doors upon their hinges creak'd;
> The blue fly sung in the pane; the mouse
> Behind the mouldering wainscot shriek'd,
> Or from the crevice peer'd about.
> Old faces glimmer'd thro' the doors,
> Old footsteps trod the upper floors,
> Old voices called her from without.
> She only said, 'My life is dreary,
> He cometh not,' she said;
> She said, 'I am a aweary, aweary,
> I would that I were dead!'
>
> The sparrow's chirrup on the roof,
> The slow clock ticking, and the sound
> Which to the wooing wind aloof
> The poplar made, did all confound
> Her sense; but most she loathed the hour
> When the thick-moted sunbeam lay
> Athwart the chambers, and the day
> Was sloping toward his western bower.

59

Then, she said, 'I am very dreary,
He will not come,' she said;
She wept, 'I am aweary, aweary,
Oh God, that I were dead!'[2]

Details from these stanzas, the 'thick-moted sunbeam' and the mouse
behind 'the mouldering wainscot', appear in Millais's painting and
thus identify it very precisely with Mariana's late-afternoon crisis.
Apart from this explicit inter-disciplinary connection, both poem and
painting have proved compelling texts for critics to work on in their
own right. 'Mariana' remains the only one of Tennyson's 'high-born
maiden' poems to be regarded with any seriousness, while Millais's
painting (dated 1851) claims the distinction of being recognised as the
artist's first 'masterpiece' in 'the Pre-Raphaelite manner'.[3] Significant,
too, is the fact that both poem and painting have enjoyed a popular
audience: in any group of older students, I found at least two or three
who had learned the Tennyson poem in their youth. Like 'The Lady of
Shalott', its chief allure has undeniably been aural: a verbal sensuous-
ness which compares well with the painterly surfaces so admired in
Millais's painting.

The surfaces of both poem and painting are, it must be said,
seductive. Teaching both 'Mariana' and 'The Lady of Shalott', I have
often had to force my way beyond my students' reluctance to tamper
with their 'superficial' pleasures. Many admit candidly that they have
never before thought what the texts (and here I include 'The Lady of
Shalott') were 'about'. The web Tennyson has his ladies weave is not
least a web of words. Rather than digging deeper, therefore, I am
proposing that we explore this poem–painting combination *in terms of
the texts' surfaces*, and posit that it is *through* lilting refrains and tactile
fabrics that both texts effectively smother the cries of their heart-
broken maiden.

'Mariana' is a poem from which it is hard to quote extracts. Start
reading it in class, and before you know where you are, you are at the
end. Its rhythm rocks, its refrain seduces. The listener is enchanted by
the subtle modulations in its tone, without ever considering its sense.
Hence the pervasive tendency to read the first line as 'flower-pots'
instead of 'flower-plots'. The ear hears less than the eye sees.
Especially significant in contributing to the overall hypnotic effect of
the stanzas is the way in which rhyme and line length conspire to
produce alternating sensations of comforting closure and lingering
openness. The penultimate line of each stanza (excluding the refrain),
for example, has a tendency to draw itself into a long, discomfiting

question which is then brought to rest in the final line. I quote here from the first and the third stanzas:

> Weeded and worn the ancient thatch
> Upon the lonely moated grange.
>
> Till cold winds woke the gray-eyed morn
> About the lonely moated grange. (pp. 206–8)

In both these instances, the penultimate line is given the added tremulousness of being syntactically 'hanging'; a device which culminates in the poem's final breathless stanza, wherein the instruments of Mariana's despair are piled upon one another:

> . . . but most she loathed the hour
> When the thick-moted sunbeam lay [_____]
> Athwart the chambers, and the day [_____]
> Was sloping towards his western bower. (p.209)
> (my annotation)

On an aural level, it is a device that tantalises expectation much in the same way that Mariana is tantalised by the deferred hope of Angelo's return.[4] The rhymes, also, deliver peculiar patterns of harmony and discord to the listener's ear, the most striking instance of the latter being the onomatopoeic 'shriek'd'/'creaked' of the penultimate stanza, which is in significant contrast to the flat and rounded sounds of 'house'/'mouse' and 'floors'/'doors'. A further pleasure gained from reading the poem aloud derives from the modulation of speed; not only are the lines variously long and short, they are also fast and slow; the most stunning example of the latter occurring after the caesura in line 5 of stanza 3 where the metre is slowed down almost to the point of stasis, before gathering itself again to deal with the exceptionally long final sentence:

> From the dark fen the oxen's low
> Came to her: without hope of change,
> In sleep she seem'd to walk forlorn,
> Till cold winds woke the gray-eyed morn
> About the lonely moated grange. (pp. 207–8)
> (my annotation)

All these syntactic subtleties are, of course, in addition to the elegant vowel sounds, alliteration and assonance habitually associated with the poem, and picked up by any student asked to examine 'how it works'. It works, it must be said, superbly; as evidenced by the number of students I have seen mesmerised before we got as far as the 'marish-mosses crept'. On this point, I would also draw the reader's attention to the high incidence of verbs of quietness and stealth that feature in

the text (see especially the fourth stanza). It is a poem that the reader is, in parts, inclined to whisper; its locus is the silent room in which every minute particular of sound is heard: doors creaking, leaves shaking, birds chirruping, clocks ticking. These sounds which 'confound' poor Mariana do the same, I would suggest, to many a reader. On an aural level, 'Mariana' is as intricately seductive as a piece of popular music; its variations in tempo and key being just enough to sustain interest and challenge expectation, without ever threatening serious disruption.

Yet it would be wrong to give the impression that 'Mariana's' surface attractions are without semantic reference. As readers listen, it is clear that they also catch at the visual images spun within the sounds and rhythms. Apart from the 'aural images' of sound and silence, the text is punctuated by direct or implicit references to colour; images picked up and held by the casual reader in her overall apprehension of the poem's surface. The first stanza, for example, glimmers with the festering combination of black mould and livid-green moss, co-ordinates returned to again in the 'blacken'd waters' and 'marish-mosses' of the fourth. In the second and third stanzas, in contrast, the night-time landscape is significantly bleached of colour: the 'morning' and 'even-tide' are likewise 'glooming' and 'gray-eyed', and these silvery 'neutral tones' are also associated with the shivering poplar. When the description moves indoors, a different set of colours are inferred through expectation and association. It is my experience, even with students who have not seen Millais's painting, that they suppose a certain richness of decoration in this 'dreamy house', although some, upon consideration, have described it as grey and dusty. The image that is invariably picked up on, of course, is the 'thick-moted sunbeam' which we suppose to irradiate the chambers with golden light. Such sounds and colours, are, in my experience, the abiding impression of this poem for the majority of readers. Mariana herself, who is never beheld in the third person, is simply a cipher through which the ghostly lament of the refrain is heard. Her function is manifestly vicarious: her sorrowful incantations merely 'set the mood' for Tennyson's delectable evocation of architectural decay. In the first instance, indeed, 'Mariana' reads not as a poem about a person, but about a *context*: a moated grange, a 'moted-sunbeam' and the muted colours of a-long-time-ago.[5]

At this point I would like to allude, in passing, to Gaston Bachelard's *The Poetics of Space* (1964), a text whose relevance I was alerted to regrettably late in the preparation of this book, but whose

metaphors provide a compelling point of reference for many of the readings. Bachelard's project, as he explains it in his Introduction, is concerned primarily with an examination of 'felicitous space'; with houses and other spaces (nests, shells, corners, chests, wardrobes) that are associated with what he calls 'psychological integration':

> With the house image we are in possession of a veritable principle of psychological integration . . . on whatever theoretical horizon we examine it, the house image would appear to have become the typography of our intimate being. . . . Not only our memories, but the things we have forgotten are 'housed'. Our soul is an abode. And by remembering 'houses' and 'rooms', we learn to abide within ourselves.[6]

An attention to interior space is, of course, a pervasive feature of Pre-Raphaelite art, together with the fact that its female subjects are housed in spaces which graphically relate to their social/psychological states. We have already seen, for example, how Rossetti's 'Mary Virgin' is fixed in a flat and static 'domestic' space; how Beatrice, by contrast, floats in an indeterminate space which is cut-off from the 'narrative space' of the city of Florence, represented in the background of the painting. With 'Mariana' and 'The Lady of Shalott' we arrive at texts in which the rooms in which the protagonists are placed are overt symbols of the narrative. Interior space in these two texts (visual and verbal) is directly associated with enforced imprisonment. In neither case is it a 'happy space', in Bachelard's sense of the term. And yet it is, I feel, our habitual association of interior space with 'comfort' that has encouraged readers and viewers of these paintings and poems (I refer specifically to *Mariana* and *The Lady of Shalott*, but the argument holds for numerous other Pre-Raphaelite texts) to apprehend them benignly. Even while the dark and cluttered surroundings in which these women are placed signal claustrophobia and oppression, they also (at the same time) signal comfort and security. Combined with the other formal seductions of Pre-Raphaelite art it is, I would like to suggest, the nostalgia for Bachelard's 'felicitous space' that has made these Pre-Raphaelite paintings especially resistant to a more materialist critique. Even when there is a story telling us that these women are oppressed, unhappy, rejected, their surroundings indicate 'protection'. The stories of the women and the *rooms* in which they stand, sit or sew, are thus different stories; different spaces.

This is not to deny, however, that Millais's Mariana physically dominates *her* space (see Plate 3). Although the surface appeal of the picture is very much associated with the decorative context in which

she stands, it is her voluptuous, velvet-sheathed form which occupies the centre stage and which elicits the initial sensuous delights of viewers. Following amused comments concerning the figure's evident 'back-ache', it is my experience that observers quickly turn their attention to her dress: to its exact colour (over which there is some confusion, especially in reproduction), to the texture of its material. Both these elements are given distinction by their contrast with adjacent items: the midnight-blue of the dress is seen in specific contrast to the fading orange velvet of the stool, and its plush warmth felt in contrast to the starched coolness of the linen-cloth covering the table. Yet although the figure of Mariana is undeniably at the centre of all this specular pleasure, it is unusual for viewers to remain with her, to start asking questions *of her*, before they have completed their survey of the room in which she stands. If asked to describe what they are seeing, they will pass on to other sources of colour: to the stained-glass windows whose design incorporates all the colours which dominate the room (the blue of Mariana's dress; the reds of the stool and the tapestry, the golden ochre of wall-covering and floor boards; the black of the dark shadows); to the embroidery itself; and to the autumn leaves that have fluttered into the room. In a canvas so dominated by this luxury of colour, items that fall outside the spectrum tend not to be noticed. Unless they are already familiar with the Tennyson poem, viewers will frequently overlook the narrative detail of the mouse; while the altar table, complete with silver candlesticks and censer, fails to be seen until it is pointed out. Presented out of context (i.e., out of literary or critical context), Millais's *Mariana* is the most seductively superficial of paintings. That is not to say that it is ostensibly without a subject (viewers are immediately conscious that it tells a story about something), but that the pleasures derived from its surfaces are such that they are reluctant to delve deeper. As with Tennyson's poem, who or what Mariana is matters less than the gorgeous context in which she is regarded.

But these surfaces are not empty signifiers. Mariana, unlike Beatrice, is not merely a hazy outline: this richly clad 'mature' woman had many a material representative in what Marion Shaw has described as 'the enclosed and shuttered lives of [Victorian] middle-class women':

> Yet the source of Mariana's power is essentially domestic and familiar; the 'broken sheds', the buzzing fly, the 'sparrow's chirrup', the poplar tree, these are the appurtenances of everyday life, particularly the enclosed and shuttered lives of middle-class women: 'I am like Mariana in the moated grange', wrote Elizabeth Barrett in 1845, voicing what many women must have felt, 'and sit listening too often to the mouse in the wainscot'.[7]

She is, more particularly, an *unmarried*, middle-class, middle-aged woman, and in the wider cultural context, her problem is no more, nor less, than 'unnatural' spinsterhood. The grossness of this aberration is, of course, partially mitigated in Tennyson's poem through the discourse of Romantic Love. We are not told that Mariana is an ageing spinster but simply that she has been abandoned by her erstwhile lover, Angelo. Without the specific contextualisation of Tennyson's Shakespearean source, moreover, we have no knowledge of why she has come to be a virtual prisoner of the moated grange. Only by cross-referencing to the material circumstances of unmarried women in Victorian society do we realise that (like The Lady of Shalott) she is imprisoned by her unmarried status itself.[8]

In this materialist contextualisation of Mariana's condition I have moved beneath the surfaces of the texts, but not, significantly, *beyond* them. It is important to realise that the means by which we socially locate Mariana are those very surfaces themselves: it is the voluptuousness of Mariana's figure that tells us that she is well past girlhood, the richness of her clothing that indicates her (comparative) wealth, and it is in her repeated refrain ('I am aweary, he cometh not') that critics have traditionally located her sexual frustration. Shaw, in what is certainly one of the most cogent feminist explications of Tennyson's text, quotes Foucault to specify the sexual subject of the poem: 'Mariana as women [*sic*] and "Mariana" as poem are both examples of what Foucault calls "an hystericization of women's bodies" whereby the female body was "analysed – qualified and disqualified as being thoroughly saturated with sexuality"' (p. 108). In line with Foucault's now widely held analysis of Victorian sexual discourses, Shaw thus includes 'Mariana' as one of a large number of texts which contributed to the prurient over-determination of sex and sexuality while ostensibly marking its repression.[9]

In this respect, it is possible to read the luxurious surfaces of both visual and verbal text as key elements in this production/reproduction. For once Mariana's person has been identified as a sexual subject, all the surfaces – all the sounds, colours and textures – begin to reverberate with libidinal connotations. This is not to suggest that they are metaphors or metonyms as such, but that their sensuousness deflects back upon Mariana herself, while ostensibly detracting from it. As Foucault commented: '[the Victorians] dedicated themselves to speaking of it [sex] *ad infinitum* while exploiting it as *the* secret.'[10] Regarded in this way, Tennyson's 'Mariana' is, indeed, the most polymorphously prurient of texts. While earlier critics tended to focus

on the poplar tree as the *single* explicit sexual allusion, the whole text may, in fact, be seen to drip and shake with Mariana's fettered desires. In the first instance, there is the simple fact of Mariana's 'abandonment', paralleled in the first stanza by the farmyard's degeneration: here the 'broken sheds' and 'unlifted' latch become provocative metaphors for her 'unused' (but clearly not virginal) state. The colours, similarly, may be seen to symbolise her own desirous (green) but decaying (black) position, while the various shapes and sounds which assail her (such as the swaying poplar) contrast with her own untouched silences. It is, of course, possible to go further. Once we have construed the fabric of the poem as a metaphor for Mariana's 'secret', we may observe that its line construction, its metre, its compositional structure replicate the unconsummated sexual act; the quickening and slowing of pace, the tantalising hanging lines, the repeated disappointment of the refrains, reveal a frustration that is very specifically sexual. Elaine Jordan, indeed, connects the metaphoric sexuality of the poem with its intricate stanza structure.[11] She writes:

> Stanzas with repeated rhyme schemes like those in this poem can be compared to elaborately jewelled caskets, in comparison to the linearity of ballads or the irregular movement of odes or free verse, which can seem to tract free expression of argument and emotion; treasured containers which suggested female genitals to Freud. Mariana's rhyme scheme is abab cdd ce fef.

Through such reasoning it may be seen that while, on one level, 'Mariana' would hardly seem to be 'about' its heroine at all, on another it is obsessed with her. Those readers and critics who have resisted the sexual inferences do so because they are reluctant to admit the full-scale eroticisation necessary for such a conceit to work. To propose the poplar tree as a phallic symbol is really neither here nor there. As Foucault and subsequent critics have shown, it is *only* by the over-determination of such discourses that their 'secret' was kept. Instead of hiding their obsession, they merely clothed it in velvet.

On this point it is interesting to consider how Millais's Mariana would appear were she naked. Her memorable pose, identified as a gesture of stiffness and weariness when clothed, becomes something quite other once her clothes have been removed. It becomes, indeed, frankly provocative: Mariana is presenting her body for inspection, while she gazes desirously into the eyes of the Archangel Gabriel represented in the stained glass. Several commentators have noted the implicitly erotic relationship between Mariana and the archangel. Malcolm Warner, writing in the Tate Gallery Catalogue, observes:

Mariana, working at some embroidery, stands and wearily stretches her back. The stained-glass windows in front of her show the Annunciation. The fulfilment the archangel brings the Virgin Mary emphasises by contrast Mariana's deep frustration. Millais copied them, changing their shapes, from windows in Merton College. (TGC, p. 89)

Andrew Leng, meanwhile, in his article 'Millais's *Mariana*', quotes George Macbeth on the overt sexuality of Mariana's pose *vis-à-vis* the angel:

The sensuous twist given to Mariana's body as she drowsily inclines her head – not, however, to look out for her absent lover, but to appraise the forward young angel making the two-finger sign of sexual invitation before her very eye in the Gothic window pane. . . . The boy in the window is, of course, the Archangel Gabriel, come to approach Mary with the news of her forthcoming impregnation. The meeting of his eyes, not with those of the virgin in the window, but with the hotter, more livingly lustful eyes of the girl in the room, pronounce the preliminary sexual arousal of a secular *Annunciation*.[12]

Yet in the painting as in the poem, this flagrant demonstration of sexuality is largely deflected by the text's surfaces. Not only the clinging surface of Mariana's dress, but in the surface textures and colours present in the room generally. Whereas in the poem, the sensuality was primarily visual and verbal, in Millais's painting it is most definitely the sense of touch that dominates. Every object in the room registers a comparative degree of heat or cold, with Mariana's velvet-clad body being the centre of heat, while the linen, stone casement and silver candlesticks are sources of cold. According to the same analogy, one can contrast the inanimate coldness of the glass angels in the windows with the scurrying mouse that is Mariana's only existential companion. The other tactile comparison is between the evident suppleness of Mariana's body and the crisp dryness of the autumn leaves. We may infer a warning here: this is a contrast rather similar to the green/black imagery of the poem wherein the youth of Mariana's body is threatened by decay. Darkness and light, too, effect a symbolic purpose similar to that found in the poem. Although the light streaming through the window would suggest that the narrative moment Millais has chosen to depict belongs to the last stanza, the area of darkness in which the altar is situated (with candle already glowing) prefigures all Mariana's long nights. Indeed, the way in which this shadow encroaches upon the centre of the painting may be considered a symbolic representation of day-in-night: the endless, indistinguishable round of 'morn' and 'eventide' that all her days have become. Against this sensual tapestry of cold and heat, light and darkness, velvet and linen, there stands Mariana's aching body; clad

in her velvet dress, she is an extension of these surfaces, even while she is cut in relief against them. Unlike the Mariana of Tennyson's poem, she is an inescapable material presence; a three-dimensional reality.

This brings us finally to the question of the text's sexual politics; the matter of where, as twentieth-century readers and viewers, we locate the responsibility for the image presented in poem and painting and decide whether any aspect of the image may be redeemed and/or celebrated. As was discussed in the Introduction, the sophistications of post-structuralist criticism mean that it is no longer possible to identify the narrator of a text with its author and force him/her to assume responsibility for the politics of its production. The speaker who describes Mariana need not be Tennyson, and even if it were, there is no way of knowing the relation in which s/he stood towards her/his subject (i.e., whether s/he was sympathetic or critical). The most legitimate target for the stereotyping of Mariana's thwarted sexuality would seem, in this case, to be the discourses of sexuality that, according to Foucault, multiplied sensationally during this mid-Victorian period. Mariana, viewed in this context, is the material embodiment of the paradox that denied the middle-class woman sexuality at the same time as it pruriently promoted its existence. Through the gorgeous surfaces of words and image, writers and painters like Tennyson and Millais were able to flaunt 'the secret' without ever naming it.

My retrospective conclusion as a feminist reader/viewer/teacher is that surfaces are slippery. As has been evidenced by the texts considered here, they leave us little to hold on to. Although it is true that Mariana, the middle-class, middle-aged, socially imprisoned woman, had her representatives in Victorian history, her textual self is hard to recover or reclaim for any radical purposes beyond a simple exemplification of her in terms of the prevailing 'myths of sexuality'. The problem is that although politically accountable (in a way Beatrice clearly was not), these politics remain elusive. Because she is a surface who looks but never speaks (except through her refrain) she denies the feminist reader/viewer access to those contradictions by which she has been bound. Unlike the Lady of Shalott, who blatantly exposes the perfidy of her imprisonment, Mariana has been effectively gagged. Ostensibly chained by only one ideological discourse (that of Romantic Love) the Mariana of both painting and poem fails to offer any suggestion that her circumstances are either absurd or unfair. Lapped in the seductive rhythms of her monolithic lament and

clothed in soft velvet, Mariana's gorgeous surfaces elude us. Although clearly a victim, there is little evidence on which to convict her persecutors.

Happily, the circumstantial evidence surrounding her cell-mate at Shalott serves us rather better.

Notes

1. Two of the most recent inter-textual articles to appear, both referred to in the course of this chapter, are Andrew Leng's 'Millais's *Mariana*: Literary painting, the Pre-Raphaelite gothic, and the iconology of the Marian artist', *Journal of Pre-Raphaelite and Aesthetic Studies*, 1:1 (Part 2) (1988), 63–72, and George Hersey's 'Hunt, Millais, and *Measure for Measure*', *Journal of Pre-Raphaelite and Aesthetic Studies*, 1:1 (Part 1) (1987), 83–90. Other earlier pieces include Michael C. Kotzin's 'Tennyson and Pre-Raphaelitism: Symbolism and point of view in "Mariana" and "The awakening conscience"', *Pre-Raphaelite Review*, 1, 2 (1977), 91–101.
2. Christopher Ricks (ed.), *The Poems of Tennyson*, vol. 1. (Longman, Harlow, 1987), p. 209. Further page references will be given after quotations in the text.
3. The story is that Millais embarked upon this painting after Tennyson (having seen *The Woodman's Daughter*, based on a poem by Coventry Patmore) had expressed the wish that 'he'd do something from me'. Quoted in TGC, p. 89.
4. The plot of Tennyson's Shakespearean source is neatly summarised by Malcolm Warner in the TGC as follows:

 > The idea for the poem comes from Shakespeare's *Measure for Measure*. Mariana is a character who has for five years been living a lonely life in a moated grange, after being rejected by her fiancé Angelo when her marriage dowry was lost in a shipwreck. She still loves Angelo, who becomes the severely legalistic Deputy to the Duke of Vienna, and longs to be re-united with him. In the play this eventually comes about, but neither Tennyson nor Millais gives any clue that such a happy ending might be in store (p. 89).

5. It is interesting to compare such 'mood-painting' with Millais's late landscapes, which have been described by Allen Staley as a 'complete betrayal of his original Pre-Raphaelite principles' (see Staley, *The Pre-Raphaelite Landscape* (Clarendon, Oxford, 1973)). In a note pasted on the back of the 6-foot canvas *Chill October* (1870), Millais nevertheless responded to his critics thus:

 > I chose the subject for the sentiment it always conveys to my mind, and am happy to think the transcript touched the public in a like manner, although many of my friends at the time were at a loss to understand what I saw to paint in such a scene. I made no sketch for it, but painted every touch from nature, on the canvas itself, under irritating trials of wind and rain.

6. Gaston Bachelard, *The Poetics of Space*, trans. Maria Jolas (Orion Press, New York, 1964), p. xxxii.
7. See Marion Shaw, *Alfred Lord Tennyson* (Harvester Wheatsheaf, Hemel Hempstead, 1988), p. 105. Further page references are given after quotations in the text.

8. See the reference to Elizabeth Barrett's onerous spinsterhood in Shaw's analysis cited in note 7.

9. See Michel Foucault, *The History of Sexuality*, vol. 1 (Penguin, Harmondsworth, 1984). Lynda Nead also employs Foucault's thesis in her *Myths of Sexuality* (Basil Blackwell, Oxford, 1987) (see discussion in Introduction, pp. 11–14).

10. Foucault, *History of Sexuality*, vol. 1, p. 35.

11. Elaine Jordan, *Alfred Tennyson* (Cambridge University Press, Cambridge, 1988), p. 60. It must be said, however, that other critics, e.g., Kenneth M. McKay (*Many Glancing Colours* (University of Toronto Press, Toronto, 1988)), read the inferences of sexual frustration as a mere metaphor for 'greater things': 'What one mistakes, at first, is the source and character of her overwhelming ennui and sorrow (felt as sexual frustration), not recognising that they issue from Mariana's own wilful separation from the natural landscape rather than from the landscape itself' (pp. 51–2). McKay's bizarre reading of the poem is based on the thesis that Mariana is being punished for her refusal to acknowledge a world 'rich in decay and death' (p. 54).

12. Andrew Leng, 'Millais's *Mariana*', (*ibid.*, p. 66), quotes from George Macbeth's 'Subliminal dreams', in *Narrative Art: Art News Annual 36*, ed. Thomas Hess and John Ashberry (Macmillan, New York, 1970), p. 36.

Chapter 4

The Lady of Shalott: Cracks in the Mirror

'The Lady of Shalott' was the most favoured of all Tennysonian subjects among Pre-Raphaelite and late-Victorian artists. In 1985 an exhibition was held at Brown University in the United States which brought together the international product of this obsession: canvases and drawings from both sides of the Atlantic which retold, resold and re-invented the story of the enchanted maiden; a story older, it must be said, than Tennyson or his sources, but which the laureate conveniently repackaged for his nineteenth-century audience complete with medieval trappings and mid-Victorian sentiments.[1] Yet the nature, if not perhaps the bewildering *extent*, of this contemporary popularity is easily accounted for before we even start looking at the text. It is interesting to speculate, indeed, on just how many of the later artists and illustrators had actually read Tennyson's poem, or, if they had, read it very closely. The paintings and illustrations of artists like John William Waterhouse ('*I am Half Sick of Shadows*', 1915) and Harold Sidney Meteyard ('*I am Half Sick of Shadows*', 1913) owe more to each other and the iconographic traditions of half a century than they do to their nominal source; the contextualisation and characterisation of the Lady are *inter-textual* rather than *textual*.[2] They are, in the last analysis, proverbial. 'The Lady of Shalott' had become, by the end of the nineteenth century, a concept rather than even a narrative archetype; she is a romantic idiom, a quotable catch-phrase. This mythologisation may also, of course, be attributed to the nature of the text itself; the fact, as Isobel Armstrong has shown in her essay on the subject, that it is pre-eminently a poem *about* the 'need for myth'.[3] Tennyson's own sources are, according to Armstrong, 'curiously unaccountable': 'Its strategy is to be opaque, proffering and evading interpretation simultaneously, so that the strategy itself becomes a form of signification' (p. 50).

71

In addition to its canonisation within the visual arts, 'The Lady of Shalott' has also enjoyed mass popularity as a verbal text well into the twentieth century. In my adult-education classes, there was always a sizeable proportion of students who knew the poem and could, in many cases, recite long passages of it by heart. My enquiries revealed that it was once a virtual core-curriculum text in the primary sector; a poem presented to pupils (when often quite young) for the express purpose of memorisation. It was consequently known to its students, like 'Mariana', almost solely through its surfaces: first, as a bewitching aural experience, and then as a visual one. When pressed on the latter point, however, discussion invariably revealed that what students meant when they described 'Shalott' as a 'visual text' were the pictures it seemed to generate in their own imaginations. If I sent them to the text to explore which images they found especially graphic/evocative, they were silent. Shalott, Camelot, and the river were all *conceptual* ideas belonging to the individual reader's fairy-book history, while the Lady of Shalott herself, never physically embodied in Tennyson's poem beyond her 'white robes' and 'lovely face', was each reader's stereotyped conceit of female beauty. For most readers she had fair hair, for some dark; for those who had already seen the paintings, she had red. Few, however, had gone beyond the most general outline or filled in a character; few had even contextualised her beauty within a moral framework ('good' or 'evil', 'holy virgin' or '*femme fatale*'). Yet, despite this vagueness, all my students long-familiar with the poem were adamant that their princess in the tower was the *real* one. And they were consequently shocked when I brought out the slides of Hunt, Rossetti, Egley and Meteyard, which violently displaced their own hazy outlines.

Beyond its mass popularity as a nineteenth-century conceit or a twentieth-century aural text, 'The Lady of Shalott' has recently been winning a new following among feminists. While the previous essay will have prepared readers for what I believe to be some of the more complex reasons for this interest, and *vis-à-vis* which the following reading will situate itself, it is fair to say that the text's primary feminist function has been metaphorical. The 'mysterious' circumstances of the Lady's imprisonment, her gender-specific occupation, the nature of her 'curse', the symbolic 'cracking' of the mirror, all provide excellent symbols for the ideological/psychological oppression of mid-Victorian women and, in particular, the crisis of subjectivity experienced by women forbidden to 'look beyond the mirror'. Nina Auerbach, writing in *Woman as Demon*, cites 'The Lady of Shalott' as

an example of the sort of myth-making that may be positively appropriated by feminists:

> We find it more difficult to define the imaginative status of Tennyson's vivid Lady of Shalott. We may allegorize her into the artist, the poet's anima, a fragile divinity, an heretical anti-divinity, and a great deal more, but she carries a suggestive resonance beyond these classifications, weaving a myth that belongs to herself alone, though its moral and spiritual status remain elusive. Perhaps because her myth is solely her own, not an exemplary tale into which she must fit herself, it is not King Arthur but this difficult creature who has become the haunting icon of her own day. The Pre-Raphaelites painted her with obsessive, virtually incantatory repetition. Like Anderson's Little Mermaid, she assumed compelling life as a mysterious amalgam of imprisonment and power. This woman who appropriated the bard's function to weave her own myth wove a spell over artists and readers that spread beyond her destiny in one particular poem or its source in Malory. It is this sort of heightened, resonant, and self-creating life, transcending conventional categories of value, that is the stuff of artistic and cultural mythologies.
>
> Until recently feminist criticism has depreciated this inter-action between myths of womanhood, literature and history, seeing in social history only a male mystification de-humanizing women. . . . More recently, as feminist criticism gains authority, its new sense of power involves not the denial of mythology, but the impulse towards it. . . . The mythologies of the past as well have become stronger endowments than oppressions. When properly understood, the angel in the house, along with her seemingly victimized Victorian sisters, is too strong and interesting a creature for us to kill.[4]

Pursuing the mythical significance of women and mirrors, several feminist critics have attempted psychoanalytic readings of the text. Andrew and Catherine Belsey, for example, posit *The Lady of Shalott* as a text about the 'arrogation of subjectivity' (for which the punishment is death).[5] In her 'look' towards Camelot and the outside world, the Lady has dared to seek the substantiation of her identity in a space which is reserved for the male. She has, in Lacanian terms, sought to enter the Symbolic realm when, as a woman, it is preferred that she remain in the Imaginary.[6] Similarly, Elaine Jordan, in the chapter of her book on Tennyson entitled 'Monologues and metononymy', plays rather tantalisingly with these psychoanalytic conceits, without ever theoretically identifying them.[7] She writes:

> No one has commented on what seems to me a curious fact, that in a poem about a Lady with a mirror, the traditional emblem of vanity, the Lady herself is never imaged in the mirror saying 'this is I'. It is always the real world, outside the room, outside the Lady's self, which is reflected. . . . Selfhood is silent in *The Lady of Shalott.*

The mirror, then, as such a significant and over-determined concept in feminist and psychoanalaytic criticism is likely to ensure *The Lady of Shalott's* eminent quotability for years to come.

Yet besides being an archetypal 'subject in crisis', the Lady is, as I first indicated, a bountiful symbol of material oppression; she is the imprisoned woman, the condemned woman, the murdered woman of many centuries. And she is also, more specifically, the middle-class, genteel and educated woman of too many Victorian novels and too many social statistics. Propertyless and hence powerless, she is the domestic angel condemned forever to a drawing room existence. She is Felice Charmond in Thomas Hardy's *The Woodlanders*; she is Charlotte Brontë's first Mrs Rochester; she is Wilkie Collins's Laura, Lady Percival Glyde.[8] She is all the women kept involuntarily under house arrest by their husbands until the law was at last changed in 1891. And it is to the construction of a social and historical context that I want first to turn as the beginning of my own retelling of the story. My objective here is to prove that the 'gorgeous surfaces' of this text (unlike that of 'Mariana) are ones that can, with a certain formula, be cracked, and that behind the poem's more obvious metaphorical delights lurk dark holes that allow the twentieth-century feminist reader radical intervention.[9]

Far from being a purely transcendental subject, Tennyson's 'fairy Lady of Shalott' *is* socially accountable; she has a clear statistical identity (spinster) and may, as Isobel Armstrong has pointed out, be placed 'inside the human order':

> Heard and not seen by the workers in the field, she may be the fairy they describe, in which case she is supernatural, and outside the human order and hierarchical order to which they belong. But equally she may be inside the human order. Her web-weaving may be a species of play if she belongs to the aristocratic human order. She may, on the contrary, share something with the peasants – they are both at compulsory work. (p. 61)

Once re-presented as a social and historical subject, her story can easily be explained in Marxist terms.

The Lady of Shalott is a character who suffers from what Althusser has called 'the imaginary distortion of the ideological representation of the real world' (see Introduction, pp. 5–9). This distortion, which has, of course, a precise narratorial manifestation in the 'mirrored images' she weaves in her tapestry, reflects her own interpellation by various Ideological State Apparatuses (principally Education, Religion, the Family and The Law), and their attendant agencies such as gender difference (the social construction of masculinity and femininity) and Romantic Love. Armstrong, indeed, reads the poem as a classic profiling of the Althusserian principle (discussed in the Introduction, p. 7) that, as human subjects, we can never move to a

position 'beyond ideology'. Interchanging 'ideology' with 'myth' (the subject of her own essay), she writes:

> Such a model of mythic creation . . . inevitably asks the question whether we are 'free' to weave that fabric or whether it is woven for us. How far are we active or passive inhabitants of the network of relationships constituting our world? In fact, the metaphor of mythic weaving in Tennyson's poem . . . constructs a rudimentary account of ideology and its problems. (p. 52)

According to this formulation, the Lady's story may be read as an interrogation of social determinism: 'How is it possible to be free to create change, and how can change occur in what are possibly deterministic circumstances?' (Armstrong, p. 54). The text's answer to this question, Armstrong concludes, is not only that the human subject is *not free*, but that she does not *desire* to be free: 'The Lady of Shalott' is a poem about the 'need for myth'; about the human subject's compulsive generation of myth (read 'ideology'). While I find this a fascinating conjecture on the poem's 'ultimate meaning', I wish, in my own reading, to concentrate on the *particular ideologies* by which the Lady has been interpellated, and how they can be textually revealed. In the following discussion I focus on some of the competing and conflicting discourses which may be discerned in the Lady's education, and whose contradictions may be seen to account for her tragedy.

Although we cannot construct for her any authorised system of education, we can infer from the text that Tennyson's Lady of Shalott (as a presumed gentlewoman) was equipped with basic academic skills (literacy, numeracy, religious and moral instruction), and training in the general female accomplishments (music, needlework and other crafts). In terms of the balance of these constituent parts, moreover, we would expect it to be an education dominated not by academic prowess but by 'accomplishment'; an education in which needlework and music were most certainly favoured above the classics and arithmetic, but in which a broad familiarity with literary texts was assumed. Although in the poem, the Lady's direct speech is limited to her two enigmatic statements: 'I am half sick of shadows' and 'the curse is come upon me', a literary knowledge is implicit in the nature of her yearning. In the description of the narrator (Section II of the poem) we hear traces of literary texts which span the centuries between Chaucer and Austen in their celebration of Romance and Romantic Love.

Superficial as this education might appear, it nevertheless contained within it the seeds of power implicit in all training. As Andrew and Catherine Belsey point out, the sewers and weavers associated with the Pre-Raphaelite movement were well on their way to

becoming fully fledged artists. Similarly, as she sits at her loom, the Lady of Shalott is not following a pattern, but designing her own tapestry from the images she sees reflected in her mirror. By analogy, her action of turning from mirror to 'life' crosses the boundary-line between craft and art. Such transgression is not without its price, however. As the Belseys explain: 'While her tapestry reflects life at one remove, she remains derivative and thus within the bounds of woman's art. But when she seeks a direct experience of the world she incurs death' (p. 45). The Lady's weaving, then, may be read as a symbolic figuration of the ideological contradictions by which she is riven. It is an occupation that is both appropriate and not appropriate; an act of duty and an act of deviance.

We have already noted that the education which gave the Lady of Shalott her drawing-room accomplishments also introduced her to the discourse of Romantic Love. The second section of Tennyson's poem is a veritable catalogue of the sentiments by which she has been infected; sentiments which make every figure that appears in the mirror actually or potentially one of a heterosexual pair:

> And moving through a mirror clear
> That hangs before her all the year,
> Shadows of the world appear.
> There she sees the highway near
> Winding down to Camelot:
> There the river eddy whirls,
> And there the surly village-churls,
> And the red cloaks of market girls,
> Pass onward from Shalott.
>
> Sometimes a troop of damsels glad,
> An abbot on an ambling pad,
> Sometimes a curly shepherd-lad,
> Or long-haired page in crimson clad,
> Goes by to towered Camelot;
> And sometimes through the mirror blue
> The knights come riding two and two:
> She hath no loyal knight and true,
> The Lady of Shalott
>
> But in her web she still delights
> To weave the mirror's magic sights,
> For often through the silent nights
> A funeral, with plumes and lights
> And music, went to Camelot:
> Or when the moon was overhead,
> Came two young lovers lately wed;
> 'I am half sick of shadows,' said
> The Lady of Shalott.[10]

Apart from the 'lovers newly wed', we can conjecture that 'page' and 'shepherd lad' exist in the Lady's mind as some other woman's lovers; that the 'surly village churls' are about to court the 'red-cloaked market girls'; that everything which exists, in short, is destined for its mate. This crude sexual destiny is then, in Part III of the poem, woven into the romanticised vision of Sir Launcelot. Launcelot, who has emblazoned on his shield the image of a 'red-cross knight' kneeling 'forever' before his Lady:

> A red-cross knight for ever kneel'd
> To a lady in his shield,
> That sparkled on the yellow field,
> Beside remote Shalott. (p. 392)

This is, of course, the authorised version of the relations between the sexes: the prescription that not only should every living thing find its partner but, once found, remain faithful to it. The desirability of such a union, institutionalised in the Christian world by marriage, brings the Lady of Shalott, like many an unmarriageable woman before and after her, to the point of despair. But this despair, unlike Mariana's, is not the product of a single ideological oppression. It arises, instead out of the juncture of two: not only has the Lady of Shalott's education overwhelmed her with discourses of Romantic Love, but also ones of Celibacy.

While, throughout the centuries, the Christian Church has officially sanctioned Romantic Love when conducted within the context of marriage, it has fiercely disapproved of it in its gratuitous (i.e., sexual/non-procreative) state. Alongside the discourse, therefore, that has been urging the Lady to find her sexual mate, exists another which insists upon her celibacy, and which is inscribed symbolically in the text by the 'curse' that has been laid upon her. It requires little deduction to see that the conflict between these two contending discourses represents the ideological centre of Tennyson's poem; that their explosive impact *is* the moment when the mirror cracks, and the loom floats wide:

> She left the web, she left the loom,
> She made three paces thro' the room,
> She saw the water-lily bloom,
> She saw the helmet and the plume,
> She look'd down to Camelot.
> Out flew the web and floated wide;
> The mirror crack'd from side to side;
> 'The curse is come upon me,' cried
> The Lady of Shalott. (p. 393)

The contest between these two discourses, moreover, is present in the characterisation of the Lady of Shalott herself; the heroine who is at once a bewitching 'fairy' (Parts I and II) and a pure Virgin, clothed in 'snowy white' (Part IV). The two polarised selves, so evident in the visual representations of the poem, are thus symbolic of a woman torn in two by her contradictory education; by the contending ideologies of Christian Celibacy and Romantic Love, and both underscored by the socio-economic forces that required a woman to marry or be rendered invisible. The moment, therefore, that the Lady of Shalott arises from her weaving and makes 'three paces thro' the room', does not merely signal her imminent 'dereliction of duty', but the moment of choice between the two principal discourses which have dominated her education.[11] The choice, however, as we know, is no choice. Romantic Love is a choice only for those with social and economic independence, and this Lady, having none, has only the choice of celibacy or death. Yet in cracking the mirror she has also cracked the system. By living out the impossibility of her situation, she exposes it for what it is; allows us, a century later, to see the ideologies by which she was torn apart for what they are.

Unhappily for William Holman Hunt who allegedly intended his 'Lady of Shalott' paintings and illustrations to be read as reproving texts on the 'dereliction of duty' (see note 11), we have been left with a visual text that gives the 'gaps and silences' disclosed in Tennyson's poem magnificent expression. For Hunt's *Lady of Shalott* (see Plate 4) refuses to be bound by the textual/sexual fate assigned her. Her massive height, muscular arms, and witch's hair signify an extraordinary *excess* of power. Depicted at the moment of crisis, Hunt's Lady meets her fate with *anger*. The wild, half-crazed expression that Hunt and his followers assumed would be read as an alarming caricature of women who neglect their proper function, is received by the twentieth-century viewer as a spirited defiance of the impossible Catch-22 in which she has been placed.

Hunt's painting of *The Lady of Shalott* exists in two versions: the giant American canvas (Wadsworth Collection, Connecticut) which measures 74 × 57 in., and the much smaller copy (reproduced in Plate 4) housed in Manchester City Art Gallery.[12] Both paintings date from the end of Hunt's career (1886–1905), but the composition is a reworking of designs made during the early years of the Pre-Raphaelite Brotherhood. Hunt's first known drawing of the subject dates from 1850 and is an obvious prototype for the later works; both loom (an ingenious variation on the standard type, and thought to have been

inspired by Hunt's travels to the Middle East) and mirror are already in place, together with the chosen 'narrative moment': the cracking of the mirror.[13] It can be argued, moreover, that the consistent elements in Hunt's design make manifestly clear his reading of Tennyson's poem; that he did, indeed, perceive it to be a reproving text on a woman's 'dereliction of duty'.

No other Ladies of Shalott are quite as uncompromisingly evil as Hunt's. Even in the 1850 sketch, whose simple outline gives little opportunity for psychological analysis, critics have read a 'bad character' (see Judith Bronkhurst, quoted in note 11 above). From this first drawing, indeed, the Lady's transgression is expressed explicitly in terms of her sexuality. In the subsequent design, made by Hunt for the Moxon edition of Tennyson of 1857, the figure has assumed a voluptuousness rare in Pre-Raphaelite art; the strong limbs, the heavy hips and breasts (which assume extra three-dimensionality in the paintings), are peculiarly at odds with the diminutive dimensions of the engraving.[14] From her first artistic conception, Hunt's Lady was very obviously neither fairy nor virgin.

What I want to focus on in this reading, however, is not simply a reconstruction of Hunt's intentions but the *disjunction* that exists between those intentions and our reception of the painting as twentieth-century feminist viewers. It is, without question, the most semiotically unstable of all the visual images reproduced in this volume. In the other instances where a 'positive' feminist reading is possible (e.g., Millais's *Isabella* or Morris's *Guenevere*) the appropriation is arrived at slowly: we painstakingly uncover the ideological complexity of the representation before us, and then begin retelling the story. The story of Hunt's Lady, by contrast, does not need to be retold. She is speaking her anger, frustration and outrage to us *at the same time* that she is, in Hunt's moral schema, enacting her punishment.

The room in which Hunt's narrative takes place conspires in this duplicity. The empty margins of Hunt's two drawings are, here, chaotically and claustrophobically filled. The walls are hung with dark tapestries upon which swirl the twisting bodies of angelic and allegorical figures, while the two roundels supporting the great mirror feature scenes of the Fall and the nativity (Wadsworth). The chaos of these representations intrudes upon the foreground space and, as in the case of Burne-Jones's *Laus Veneris* (see the discussion in Chapter 8), effectively breaks down the distinction between the historical continuum in which the central narrative is taking place and the

myths and legends in which the Lady's story is inscribed. It is significant, too, that Lancelot's reflection in the mirror occupies the same pictorial plane as the biblical figures: he, no more than they, is a part of the Lady's own time and space. The overall effect of these juxtapositions is, inevitably, to call into question the relation between inside and outside, myth and 'reality', but in such a way that the Lady's voluptuous, three-dimensional presence is even more disturbing. Unlike the case of Burne-Jones's Venus, the mythologising of the Lady's space does not undermine her pretensions to a full historical and sexual identity. Hunt's Lady of Shalott presents herself to the viewer as a 'real woman' in an artificial space. In the foreground of the composition, the flower petals, discarded sandals and flying birds tangle with the floating skeins of coloured wool to create further chaos (Wadsworth), while the positioning of the ornamental samovar/candelabra *inside* the frame of the loom intensifies the claustrophobic lack of space created by Hunt's 'close-up' framing of the action (the perimeter of the loom spills outside the frame of the canvas).

These exotic and chaotic trappings (tapestries, sandals, samovars), presumably included by Hunt to make clear that his Lady was 'already fallen', offer themselves to the feminist reader as a catalogue of the ideologies by which she has been oppressed and, now, torn apart. Like Tennyson's poem, this text is littered with graphic symbols of the contradictory discourses (Celibacy and Romantic Love) by which the Lady has been interpellated. Between the Garden of Eden and the Virgin Birth, the harem and the cloister, Hunt's Lady makes manifest the impossibility of her situation. A painting ostensibly representing an act of deviance is received by us as an act of noble defiance.

I wish to conclude this reading by turning briefly to one other Shalott painting which, by its extreme difference, makes explicit the reasons why Hunt's painting is so exciting for the feminist viewer. If Holman Hunt's wicked-witch-of-the-loom is the sinister embodiment of the Romantic Love syndrome, then John William Waterhouse's expiring princess may be seen as the virtuous *dis-embodiment* of Christian Celibacy.[15] From a canvas that vies with Hunt's Connecticut *Shalott* in magnitude and splendour, Waterhouse's 'snow-maiden' is an icon of ravished innocence. For Waterhouse's painting forbids questions, suspends narrative. Those who stand before it, even if they 'know the story', tend to forget what happens. The only portion of Tennyson's text that is evident is the ending, and then not the 'absolute ending'. This is not (to quote Rossetti on *Beata Beatrix*) 'a representation of the incident of death', but 'an ideal of the subject,

symbolized by a trance or a sudden transfiguration'.[16] Waterhouse's Lady, like Rossetti's Beatrice, is being drawn towards a conclusion that would seem more orgasmic than fatal. The only message her body gives to the viewer unfamiliar with the subject is one of expectation: 'she loosed the chain and down she lay'; *whither*, it hardly matters.

But this freezing of narrative, this suspension of interpretation, is, of course, essential to the preservation of her identity as the 'Virgin-Princess'. In significant contrast to Holman Hunt's desperate and much-criticised attempt to incorporate the whole of Tennyson's narrative into his design, Waterhouse is happy to leave us with as few signs of the Lady's peculiar past as possible. The only item from her previous life that she has been allowed to bring with her is her tapestry, and this is draped so incidentally over the sides of the boat, that its existence has frequently to be pointed out to students. Frozen, then, in the indeterminate act of 'loosing the chain', Waterhouse's Lady exists only for the moment the viewer beholds her. Despite (or, perhaps, because of) her characterisation in a context of purity, there is undeniably something centre-fold in the viewing conditions of this 7-foot canvas. In the particularisation of the moment, too, the sharply defined 'photographic' depiction of the Lady's face and figure stand out in voluptuous, three-dimensional relief against the hazy 'filtered' background. One of the painting's technical splendours is, indeed, the way in which the artist has so perfectly transposed Tennyson's 'Heavily the low-sky raining'. Both time of day and month of year can be guessed with some accuracy. This is four o'clock on a November afternoon when the light is just beginning to fail; still too light for the candles in the prow of the boat to be seen very easily, but once identified, seeming to glow with some intensity against the damp, darkening sky.

Suspended, then, not out of time but through its particularisation, Waterhouse's *Lady of Shalott* has nothing to do with repressed desires or broken mirrors. Although there is, as I indicated above, some ambiguity in the quality of the subject's expectation – sexual or fatal? – she is entirely passive *vis-à-vis* this destiny. Unlike Hunt's Lady, she is most decidedly without lust in its cruder manifestations; whatever desires she might have are within bounds, sexually intact (Waterhouse's Lady purports to be a virgin), and ready to be sublimated in her devotion to Christ (see the crucifix lying in the prow of the boat). The contrast between her person and that of Hunt's Lady need hardly be articulated. Although possessing hair as fetishistically magnificent as that of Hunt's Lady, the burning red tresses of Waterhouse's heroine

do not fly wildly about her, but instead blow lightly in the damp breeze. Where Hunt's Lady is strong and muscular, this archetypal fairy-princess is wan and slender, though in a way that provocatively exposes her breasts and gently swelling belly. And where Hunt's Lady gestures anger, Waterhouse's suggests only sorrow. For the one it is possible to construct a character, for the other it is not. We are back, indeed, with the 'hazy outline' of Rossetti's Beatrice.

Enough said, perhaps. Though is it really adequate to dismiss Waterhouse's Lady as the ideologically unsound opiate of the people when she clearly gives pleasure to so many? (the poster remains one of the Tate Gallery's best-selling reproductions) If we can reclaim a text like Hunt's against such spectacularly opposite authorial intentions, then surely we can find a space for Waterhouse's innocuous heroine? Perhaps. Perhaps not. As I confessed in the Preface, Waterhouse's *Lady of Shalott* was one of the images I carried away with me when I first visited the Tate at the age of eighteen. When my friend and I returned there during the writing of this book, however, whatever we had once found compelling in the image seemed to have evaporated with the November mists. As we sat cynically watching other female visitors to the gallery being visibly seduced, all we could seem to see was the embarrassing bulge of her stomach. An American colleague had once iconoclastically suggested the possibility of pregnancy, but when I looked now all I could see was the figure's pitiful vulnerability. It seemed that Waterhouse had established the fact of sexual difference in the most subtle of ways; with an eye that appraises at the same time that it enjoys, he had painted in the 'fleshly' tendency of the ageing female body; reassured his (male) audience that, however awesomely beautiful, women are impotent in the face of their own mortality. Such feminist fetishisation – seeing female bodies in terms of the bits in which they have evidently been sliced – undoubtedly kills romance. Although visually ravishing, Waterhouse's *Lady of Shalott* is not a sensible text for the feminist to fall in love with.

This essay will, I hope, have shown that *The Lady of Shalott* (both poem and paintings) offers high stakes for the twentieth-century feminist. Apart from its extensive quotability, the poem lays itself open to radical deconstruction; the ideological traps, gaps and inconsistencies showing both us, and her, the door. The visual responses to this latent instability lend further fuel to the fire. In their efforts to punish (Holman Hunt) or silence (Waterhouse) these disturbing voices, the artists have unwittingly highlighted the ideological embarrassments they were attempting to suppress. From

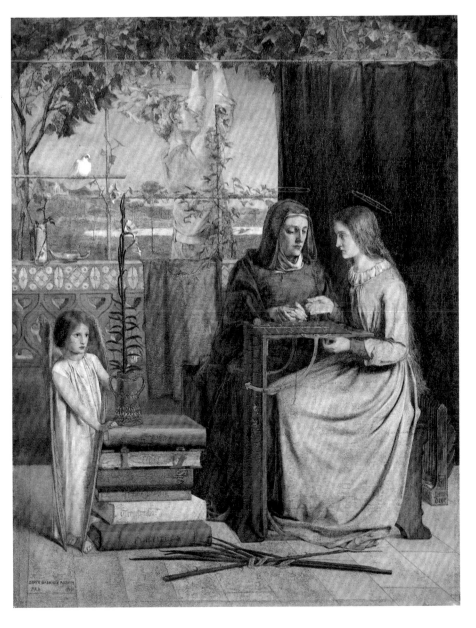

Plate 1 Dante Gabriel Rossetti (1828–88): *The Girlhood of Mary Virgin*, 1848–9. Oil on canvas, 32¾ × 25¾ in. (83.2 × 65.4 cm)

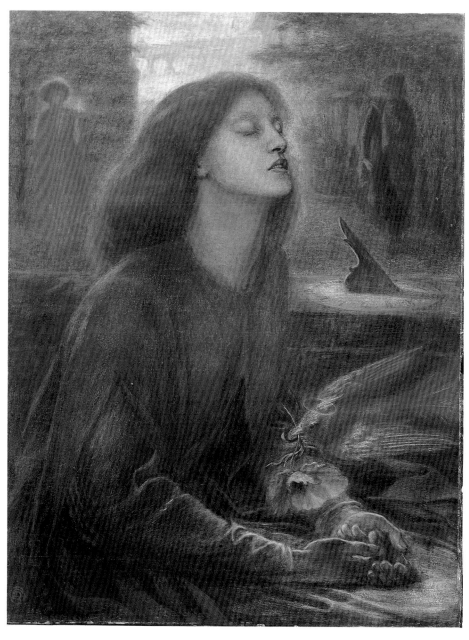

Plate 2 Dante Gabriel Rossetti (1828–88): *Beata Beatrix*, c. 1864–70.
Oil on canvas, 34 × 26 in. (86.4 × 66 cm)

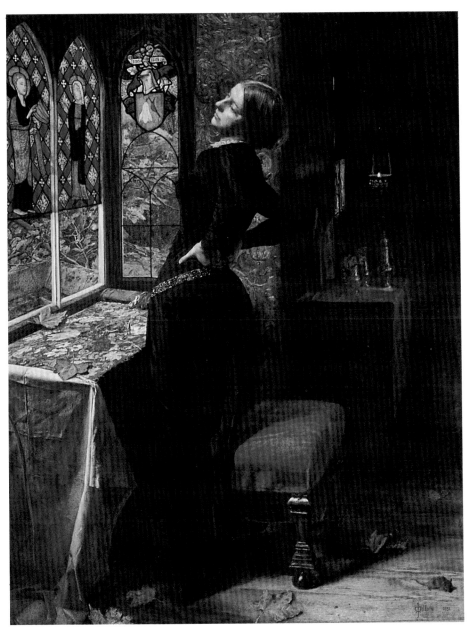

Plate 3 John Everett Millais (1829–96): *Mariana*, 1851.
Oil on panel, 23½ × 19½ in. (59.7 × 49.5 cm)

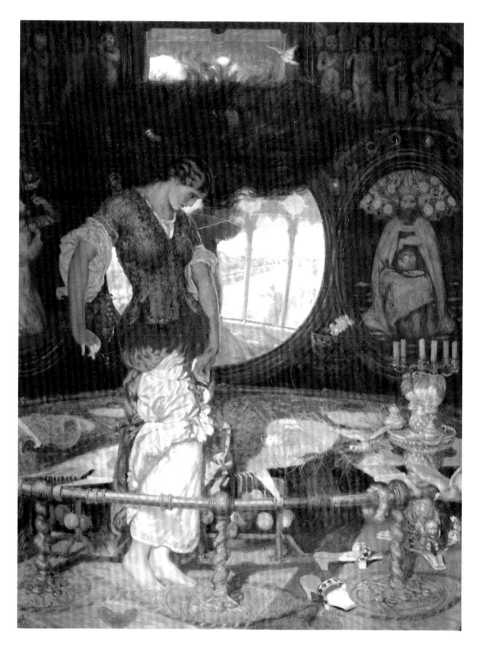

Plate 4 William Holman Hunt (1827–1910): *The Lady of Shalott*, 1886–1905.
Oil on canvas, 17½ × 13⁷⁄₁₆ in. (44.4 × 34.1 cm)

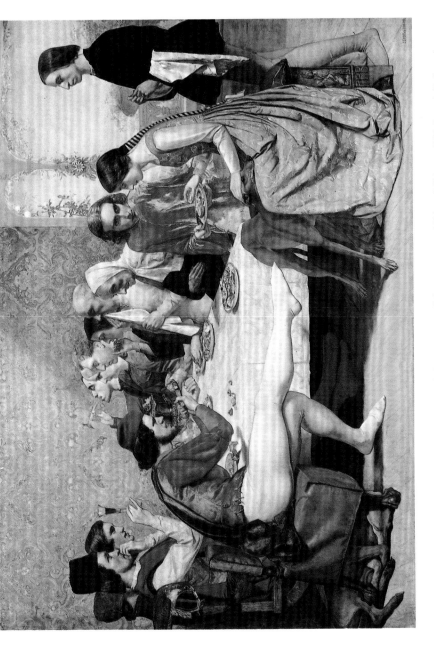

Plate 5 John Everett Millais (1829–96): *Isabella*, 1848–9. Oil on canvas, 40½ × 56¼ in. (102.9 × 142.9 cm)

Plate 6 Arthur Hughes (1830–1915). *The Eve of St Agnes*, 1856. Oil on panel, 17¾ × 27⅝ in. (44.2 × 70.1 cm).

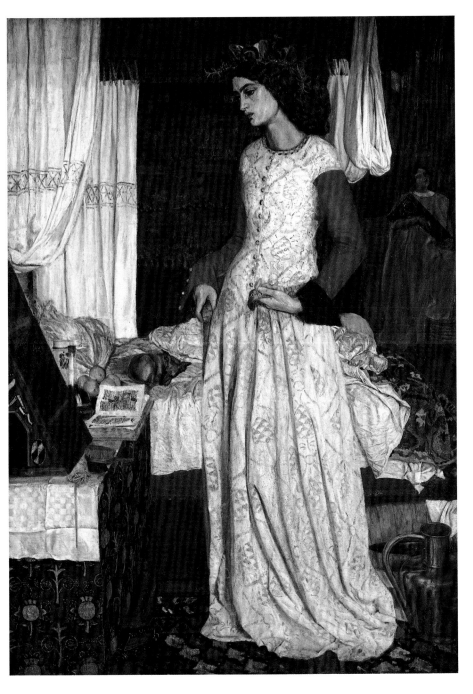

Plate 7 William Morris (1834–96): *Queen Guenevere*, 1858.
Oil on canvas, 28½ × 20 in. (70 × 50 cm)

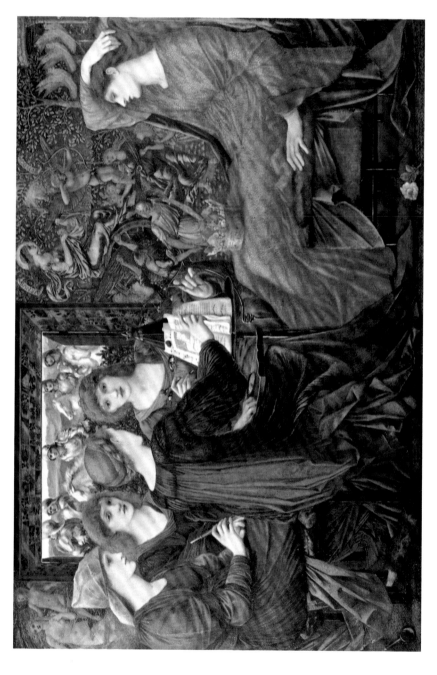

Plate 8 Edward Coley Burne-Jones (1833-98), *Laus Veneris*, in 1873-8 Oil on canvas

between their desperate clutches the 'fairy Lady of Shalott' breaks free and, noisily dragging her chains, smiles in our direction.

Notes

1. 'Ladies of Shalott: A Victorian masterpiece and its contexts'. An exhibition by the Department of Art History, Brown University, Rhode Island, 23 February–23 March 1985. Catalogue produced by the Department of Art, Brown University, 1985. This catalogue includes articles on the following: Elizabeth Nelson, 'Tennyson and the Ladies of Shalott'; Penny A. Fogelman, 'The Moxon Tennyson and Pre-Raphaelite illustration'; Rebecca R. Greenleaf, 'Hunt and Victorian medievalism'; Marc Rolnik, 'Hunt's pictorial unity, 1870–1905'; Timothy R. Rogers, 'The development of William Holman Hunt's "Lady of Shalott" '; Miriam Neuringer, 'The burden of meaning: Hunt's *Lady of Shalott*'; Lisa Norris, 'Hunt and Aestheticism'; Patricia McDonnell, 'Pre-Raphaelitism, Art Nouveau, and Symbolism'. The exhibition featured related subjects (e.g., other paintings and drawings by the PRB, photographs by Julia Margaret Cameron, twentieth-century paintings and drawings) as well as the nineteenth-century key texts: William Holman Hunt's *The Lady of Shalott* (1886–1905) Wadsworth Collection, Hartford, Conn. (together with Hunt's related drawings); John Lafarge's *The Lady of Shalott* (*c.* 1862) New Britain Museum of American Art; Dante Gabriel Rossetti's *The Lady of Shalott*, Moxon Tennyson (1857) and related study; John Byam Shaw's *The Lady of Shalott* (1898), Christian A. Johnson Memorial Gallery; Elizabeth Siddal's *The Lady of Shalott* (1853), Collection Jeremy Maas; John William Waterhouse's *'I am Half Sick of Shadows', said the Lady of Shalott* (1915), Art Gallery of Ontario.

 Other significant representations of the subject not featured in the exhibition include: William Maw Egley, *Lady of Shalott* (1858), Manchester City Art Gallery (reproduced in Jan Marsh, *Pre-Raphaelite Women* (Weidenfeld and Nicolson, London, 1987)); Sidney Harold Meteyard, *The Lady of Shalott: 'I am Half Sick of Shadows'* (1913) The Pre-Raphaelite Trust (reproduced in Christopher Wood, *The Pre-Raphaelites* (Weidenfeld and Nicolson, London, 1981)); John William Waterhouse, *The Lady of Shalott* (1888), Tate Gallery (reproduced in Wood, *The Pre-Raphaelites*); John William Waterhouse, *The Lady of Shalott* (1894), Leeds City Art Gallery. Reproductions of most of these paintings and illustrations are to be found in the following texts: TGC; Marsh, *Pre-Raphaelite Women*; Wood, *The Pre-Raphaelites*.

 In an attempt to explain the mass popularity of the subject, Elizabeth Nelson (Brown University Catalogue) writes:

 > 'The Lady of Shalott' attracted Pre-Raphaelite Artists because the poem emphasized the spiritual nobility and the melancholy of the more sorrowful aspects of love, such as unrequited love, particularly the embowered or isolated and therefore unattainable woman; the woman dying for love; the fallen woman who gives up everything for love; the special 'tainted' or 'cursed' woman; and the dead woman of unique beauty. (p. 6)

2. Both these paintings are blatant representations of 'sexual frustration', in which the Lady is represented in such a way as to emphasise a wasting/wasted sensuality. In both cases, the subject is seated with her embroidery/weaving in front of her,

but is paying little attention to her task. Instead, she gazes dreamingly/wearily/ longingly *elsewhere* (in Meteyard's painting, her eyes are half closed), her arms raised (Waterhouse) or draped (Meteyard) in such a way as to emphasise the fullness of her breasts. In both cases, too, the eroticism of the representation is increased by the claustrophobic confines in which the Lady is placed; her very body gives the impression of bursting out of the pictorial space in which it has been contained.

3. Isobel Armstrong, 'Tennyson's "The Lady of Shalott": Victorian mythography and the politics of narcissicism', in J. B. Bullen (ed.), *The Sun is God: Painting, literature, and mythology in the nineteenth century* (Clarendon, Oxford, 1989), p. 100. Further page references to this article are given after quotations in the text.

4. Nina Auerbach's *Woman and the Demon: The life of a Victorian myth* (Harvard University Press, Cambridge, Mass., 1982). Meanwhile, Deborah Cherry, writing about Elizabeth Siddal's drawing of 'The Lady of Shalott' has also shown the way in which the context of the narrative may be read as an indication of wider ideological oppression. She writes:

> The drawing produces and reproduces the ideology of separate spheres of men and women, and in its representation of an historical past it works over contemporary distinctions between the private indoor world of women and the public outdoor world of men. (TGC, p. 266)

Cherry's feminist 'appropriation' of *The Lady of Shalott* depends very much, however, on a comparative analysis of Siddal's drawing and that of the male artists and illustrators.

5. Andrew Belsey and Catherine Belsey, 'Christina Rossetti: Sister to the Brother-hood', *Textual Practice*, 2, 1 (1988), 30–50. Further references to this article are given after quotations in the text.

6. For discussion of the Lacanian 'Imaginary' see Chris Weedon, *Feminist Practice and Post-Structuralist Theory* (Basil Blackwell, Oxford, 1987), pp. 51–5. The brief definition offered in Sara Mills, Lynne Pearce, Sue Spaull and Elaine Millard (eds) *Feminist Readings/Feminists Reading* (Harvester Wheatsheaf, Hemel Hempstead, 1989) might also be useful:

> Imaginary in Lacanian psychoanalytic theory is a period which roughly corresponds to Freud's pre-oedipal stage. The child experiences an illusory sense of completeness in which there is as yet no separation from the mother. The unity is broken by the introduction of language which, embodying the Law of the Father, introduces a third term and creates a Symbolic Order in which some of the individual experience of the Imaginary cannot be expressed. (p. 243)

7. See Elaine Jordan, *Alfred Tennyson* (Cambridge University Press, Cambridge, 1988), p. 58.

8. Thomas Hardy, *The Woodlanders* (first published 1887), and Wilkie Collins, *The Woman in White* (first published 1860).

9. The metaphor of 'cracking apart' a text derives from Macherey's critical practice, expounded at some length in the Introduction (pp. 9–11). I agree with Isobel Armstrong, however, that *The Lady of Shalott* is a poem which resists systematic decoding. In her essay in *The Sun is God* she writes:

> [James] Joyce rightly intuited that aesthetic and political questions are at stake in 'The Lady of Shalott', but he 'cracked' or decoded Tennyson's poem by assigning a parodic literal content to individual items in it: however, the

generalized and unspecific writing to which Tennyson aspired resists such readings. The problem is to evolve a reading which while it does not 'crack' the poem, nevertheless elicits a complex of (often contradictory) projects. (p. 51)

10. Christopher Ricks (ed.), *The Poems of Tennyson*, vol. 1 (Longman, Harlow, 1987), pp. 390–1. Further page references to this edition will be given after quotations in the text.

11. The 'dereliction of duty' reading of 'The Lady of Shalott' derives from the general interpretation that has been given to Holman Hunt's paintings of 'fallen' women such as *The Hireling Shepherd* (1851–2) and *The Awakening Conscience* (1853–4). Judith Bronkhurst in the TGC writes of Holman Hunt's 1850 drawing of the 'The Lady of Shalott':

> The shawl knotted around her hips adds a touch of sensuality to an otherwise chastely medieval ensemble, and emphasises that part of her nature vulnerable to the dazzling sight of Sir Launcelot. It, together with the lady's reflection in the mirror, looks forward to 'The Awakening Conscience', a work also concerned with the dereliction of duty, for this is how Hunt seems consistently to have interpreted his Tennysonian source (see Hunt, *Pre-Raphaelitism and the Pre-Raphaelite Brotherhood*, vol. 2 (1905) pp. 401–3), (TGC, p. 249)

12. Some of the details referred to in the following discussion occur only in the larger Wordsworth version. The Manchester copy also exchanges mythological figures for Christian in the mirror-roundels and substitutes the samovar with a candelabra.

13. William Holman Hunt, *The Lady of Shalott*, 1850. Black chalk, pen and ink, 9¼ × 5⅝ in. (23.5 × 14.2 cm). National Gallery of Victoria, Melbourne. Reproduced in TGC, p. 249.

14. In 1857 Joseph Moxon published an illustrated edition of Tennyson's poetry which included contributions from Millais, Rossetti and Hunt. The reproduced engravings are very small (c. 3 × 2½ in.) and most critics found the complexity of Rossetti's and Hunt's designs both ugly and inappropriate. Millais's drawings were much simpler, and more in line with mainstream Victorian illustration.

Tennyson himself was most outspoken in his criticism of Holman Hunt's contribution, complaining that since the Lady 'left the web' and 'left the loom', she could not have been entangled in its threads! To this criticism Hunt replied that he had 'only half a page on which to convey the impression of weird fate, whereas you [i.e., Tennyson] use about fifteen pages to give expression to the complete idea' (see William Holman Hunt, *Pre-Raphaelitism and the Pre-Raphaelite Brotherhood*, vol. 2 (Macmillan, London, 1905), p. 125).

In the first drawing of 'The Lady of Shalott' (1850), Hunt's means of overcoming this problem was to surround the main mirror with 'roundels' depicting the different stages of the story.

15. John William Waterhouse, *The Lady of Shalott*, 1888. Oil on canvas, 60¼ × 78⅛ in. (153 × 200 cm). Tate Gallery, London. Reproduced in Wood, *The Pre-Raphaelites*. The painting is an illustration to Part IV of Tennyson's poem and represents the Lady 'loosing the chain' of the boat in which she sits. Dressed in a medieval-style white dress, her most memorable feature is her waist-length red hair.

16. This is part of Rossetti's letter to F. Horner, quoted in Chapter 2 (pp. 52–3).

Chapter 5

Isabella: Sharp Differences

On 3 February 1818, during the period in which he was writing *Isabella*, John Keats declared to his friend Reynolds: 'All I can say is that where there are a throng of delightful images ready drawn simplicity is the only thing.'[1] This statement is quoted by Jack Stillinger in his essay 'The "Reality" of Isabella' to corroborate his argument that this was the moment in Keats's career when the poet began to turn away from the exoticism, fantasy and sentimentality of 'courtly Romance' towards a new, sharp-focused 'realism'.[2]

'Simplicity' and 'realism' were also concepts close to the hearts of the first Pre-Raphaelite Brothers. Their determination to 'study Nature attentively' manifested itself in the obsessive attention to detail and sharp delineation of objects that we have already witnessed in Rossetti's early work, *The Girlhood of Mary Virgin*.[3] While in Rossetti's painting, however, this two-dimensionally inclined 'sharp focus' concurred with a solid, ideological frame, Millais's similar technique in *Isabella* (Plate 5) may be read as a radical register of 'difference': difference which I have chosen to interpret mainly in terms of gender, but which is reinforced in the painting by aesthetic and ideological differences of all kinds. This reading consequently aims to explore the parallels between the symbolic and ideological movement towards 'Simplicity' in Keats's writing and a similar tendency in one of his earliest Pre-Raphaelite interpreters, and to show how the aesthetic urge for 'a simple line' (in both drawings and story-telling) manifested itself ideologically in a sharp-focused realisation of some uncomfortable differences. With 'Isabella' we are thus returning to the surfaces of texts, but to surfaces which exquisitely expose what Mariana's 'thick-moted sunbeam' would conceal.

Keats, as is widely known, was the Pre-Raphaelites' most highly favoured Romantic poet. Various explanations have been put forward for this popularity, not least the 'visual richness' of his poems. However, as in the case of Tennyson, I would rather suggest that these

are texts whose attractions are adjectival rather than graphic. A brief analysis of *The Eve of St. Agnes* reveals to students that what fuels our visual experience of the poem are not *things* (scenes, people, places) but colours, sounds and textures; the 'splendid dyes' and 'snarling trumpets'. Yet notwithstanding this lack of precise contextualisation, Keats's poems did offer his illustrators a structure: the structure of a good story. Both the texts I am dealing with in this and the following chapter are historical narratives; both in the sense that they are located in history (in the historical past), and that they *enact* a history (a story) with a definite beginning, middle and end. In this respect they are very different texts from those considered in the previous chapters. Although 'Mariana' and *The Lady of Shalott* told stories as such, they were stories told from a single point in time. *Isabella* and *St. Agnes*, by contrast, replete with their loquacious third-person narrators, start at the beginning and end at the end. How Keats's illustrators chose to deal with such structuring, in particular, how they chose *the* moment they were to illustrate, is a fascinating problem to which I will return in my discussion of Arthur Hughes's painting in the next chapter. For the moment, however, I want to turn to the beginning, middle and end of 'poor Isabella': Keats's 'simple maid' gone mad.

Although we are not told the exact circumstances afflicting this pair of star-crossed lovers until stanza 14 of the poem, the enforced isolation of Isabella and Lorenzo from each other is dramatically replicated in the syntax of the poem. Here is the first stanza:

> Fair Isabel, poor simple Isabel!
> Lorenzo, a young palmer in Love's eye!
> They could not in the self-same mansion dwell
> Without some stir of heart, some malady;
> They could not sit at meals but feel how well
> It soothed each to be the other by;
> They could not, sure, beneath the same roof sleep
> But to each other dream, and nightly weep.[4]

Enter Isabella; enter Lorenzo. Were this a play, the curtain would rise with hero and heroine entering from opposite sides of the stage. Although united in heart and dwelling in the same mansion, there is something (as yet unspecified) that keeps the two asunder. Yet even without any peculiar complications, their lives are, of course, already divided according to their sex. With a delicate punctuating of 'his' and 'her', the subsequent stanzas reveal the gendered counterpointing of their lives: while Lorenzo attends to his duties around 'house, field, or garden', Isabella plies her embroidery and plucks at her lute. The

separate lives of men and women are brought into the sharpest focus; only at the dinner-table, or in the secret trysts under the cover of night, are the distinctions blurred and the boundaries crossed. But the lines drawn between Lorenzo and Isabella are not merely ones of gender. In Stanza 6 the hero, his voice 'stifled' with fear, admits 'his high conceit of such a bride'; admits, that is, his own lowly social status. Class and economic differentials drive an ugly axe through the old romance, destroying forever our hopes of a happy ending. Keats's narrator is telling his story simply.

In Stanzas 14–15 it is revealed that Isabella's brothers are wealthy industrialists and colonialists; Lorenzo is but one of many 'slaves':

> With her two brothers this fair lady dwelt,
> Enriched from ancestral merchandize,
> And for them many a wary hand did swelt
> In torched mines and noisy factories,
> And many once proud-quiver'd loins did melt
> In blood from stinging whip; – with hollow eyes
> Many all day in dazzling river stood,
> To take the rich-ored driftings of the flood.
>
> For them the Ceylon diver held his breath,
> And went all naked to the hungry shark;
> For them his ears gush'd blood; for them in death
> The seal on the cold ice with piteous bark
> Lay full of darts; for them alone did seethe
> A thousand men in troubles wide and dark:
> Half-ignorant, they turn'd an easy wheel
> That set sharp racks at work, to pinch and peel. (p. 249)

The poem's very precise descriptions of how the wicked brothers made their wealth will certainly interest the Marxist reader and, in terms of the reading I am pursuing here, supports the hypothesis that, with *Isabella* Keats's poetry had, indeed, turned irrevocably towards the material world.[5] It is the ugly details of capitalist exploitation that do more than anything else to undermine the Romance genre. In Romances the bad characters are gratuitously bad; Isabella's brothers are bad for certifiable reasons ('For them alone did seethe / A thousand men in troubles wide and dark'). Yet *so dark* are the differences separating Lorenzo and Isabella from her mercantile brothers that, a few stanzas later, the narrator pauses, incredulous that their two moral/social worlds should ever collide:

> How was it these same ledger-men could spy
> Fair Isabella in her downy nest?
> How could they find out in Lorenzo's eye
> A straying from his toil? How Egypt's pest
> Into their vision covetous and sly!

> How could these money-bags see east and west? –
> Yet so they did – and every dealer fair
> Must see behind, as doth the hunted hare. (p.250)

'Yet so they did', and the material consequences of the difference is Lorenzo's murder and Isabella's death. Such causal simplicity is, indeed, in marked contrast to the mysterious circumstances that surround the death of Tennyson's Lady of Shalott. In that text, it will be remembered, we had to reconstruct actively the differences that caused the mirror to crack; here the same differences are nakedly exposed. It is no wonder, indeed, that Keats's narrator, realising the brutality of telling his story so simply, should ask Boccaccio for forgiveness: 'Of thee we now should ask forgiving boon / . . . For venturing syllables that ill beseem / The quiet glooms of such a piteous theme' (Stanza 19). For even as gender and socio-economics fatally separated Launcelot and the Lady of Shalott, so do they doom Lorenzo and Isabella.

In Keats's story, however, the fatal differences are not silenced by death. Isabella does not die quietly, floating down the river, but becomes mad. Her madness, indeed, and Lorenzo's transformation into a ghostly 'Other', turns the end of the poem into a macabre celebration of the differences that separated them in the material world. First Isabella, through pining for Lorenzo, assumes an unidentifiable shape and form: 'So sweet Isabel / By gradual decay from beauty fell, / Because Lorenzo came not' (Stanzas 35–6). Although yet alive, her transformation is such that it already haunts her brothers with the difference of death. Different, too, is Lorenzo. Appearing as a ghost to Isabella, he is no longer 'he' but 'it'. The boy whose masculinity was, in life, undermined by his socio-economic inferiority, now assumes another androgyny:

> It was a vision. – In the drowsy gloom,
> The dull of midnight, at her couch's foot
> Lorenzo stood, and wept: the forest tomb
> Had marr'd his glossy hair which once could shoot
> Lustre into the sun, and put cold doom
> Upon his lips, and taken the soft lute
> From his lorn voice, and past his loamed ears
> Had made a miry channel for his tears.
>
> Strange sound it was, when the pale shadow spake;
> For there was striving, in its piteous tongue,
> To speak as when on earth it was awake,
> And Isabella on its music hung:
> Languor there was in it, and tremulous shake,
> As in a palsied Druid's harp unstrung;
> And through it moan'd a ghostly under-song,
> Like hoarse night-gusts sepulchral briars among. (p. 253)

For both hero and heroine, then, gender difference is finally undermined; she through the loss of her feminised beauty (all that made her valuable as a woman); he through the loss of his socio-economic identity (all that defined him as a man). Yet because their differences are (excusing the tautology) 'different differences', the two are still divided. In Stanza 39 Lorenzo tragically laments:

> 'I am a shadow now, alas! alas!
> Upon the skirts of human-nature dwelling
> Alone: I chant alone the holy mass,
> While little sounds of life are round me knelling,
> And glossy bees at noon do fieldward pass,
> And many a chapel bell the hour is telling,
> Paining me through: those sounds grow strange to me,
> And thou art distant in Humanity.' (p. 256)

But Isabella's madness takes her further and further from the Humanity in which Lorenzo sees her still inscribed. With her lover's head safely preserved in the basil-pot, Isabella takes full leave of her bodily senses and forfeits recognition of 'the stars, the moon, and sun':

> And she forgot the stars, the moon, and sun,
> And she forgot the blue above the trees,
> And she forgot the dells where waters run,
> And she forgot the chilly autumn breeze;
> She had no knowledge when the day was done,
> And the new morn she saw not; but in peace
> Hung over her sweet basil evermore,
> And moisten'd it with tears unto the core. (p. 260)

Social difference ends for Isabella, as for so many literary heroines, in complete and irrevocable psychic difference. As Foucaultian criticism has shown, madness is the discourse to which we consign those whose differences to/from society's ruling discourses are most noticeably extreme. Isabella, weeping tears into her balmy basil-pot, wore her 'difference' on her sleeve.

On the issue of the representation of female madness it is interesting to compare Isabella's 'derangement' with that which we have already witnessed in Tennyson's Mariana and the Lady of Shalott. The first thing to observe here is that for all three women mental instability results directly from their gendered identity *as women*; their behaviour becomes recognisably 'different' (obsessive/iconoclastic/suicidal) *at the point* where their external/social alienation becomes internalised and they begin to live out their difference. And in every case their social alienation is caused by their inability to marry. By ideological decree they are rendered 'out of bounds'. The only reason why Mariana and

the Lady of Shalott are perceived to be 'less mad' ('different') than Isabella, is because a veil is drawn discreetly over them. We do not know what might happen to Mariana should Angelo fail to appear; we do not know what further peculiarities the Lady of Shalott might have been tempted to commit, should she not have died. Isabella, alone, survives the crisis and her distress is made visible in an extraordinary coda to the narrative. Keats's poem follows the sharp differences of gender and class to their unlovely conclusion.

On this point Stillinger observes that Keats's emphasis on Isabella's 'madness' is one of the aspects of the text to differ most substantially from Boccaccio:

> Still another difference between Keats's source and his poem has to do with the point at which the heroine goes mad. In the old prose [i.e., Boccaccio] it is almost at the end of the story that Isabella's neighbours notice 'incessant weeping' and 'violent oppressions' as she carries the pot of basil around with her. In the poem we see symptoms much earlier. . . . And now in the stanzas following the statement that love was 'dead indeed, but not dethroned', Isabella is depicted as fully deranged. (*Hoodwinking*, p. 42)

John Barnard also comments on this point: 'Where Boccaccio's heroine dies of "an extreme sickness" occasioned by her "ceaseless weeping" and waters her basil plant not only with tears but with "Rose water . . .", Keats makes it entirely clear that Isabella goes mad' (p. 78).

By means of a post-script to this reading it should, perhaps, be said that a positive feminist appropriation of this text is very much 'against the grain' of biographically inscribed criticism which is obliged to read the narrative poems as evidence of Keats's fear and dislike of women on the one hand, and the need to meet the prurient need of his (male) readership on the other. On the pressures of the latter John Barnard has written:

> The difficulty of writing poetry describing erotic and sensual feelings, as Keats knew, was to find a diction and style which could present these ideas of emotional experience satisfactorily avoiding either coyness or coarseness. . . . It is clear that Keats felt there was an unbridgeable divide between poetry's fashionable drawing-room readership and the audience which took poetry seriously. *Isabella* would, he feared, be taken for a 'feminine' poem of 'tenderness and excessive simplicity'. . . . Keats's divided response to *Isabella* and *The Eve of St. Agnes* in September 1809 does, however, reflect a real division in contemporary readers of poetry. The antipathy between Byron's urbanity ('male') and the simplicity and tenderness of feeling sought by Hunt and the early Keats ('female') ran deep, as Keats realised. (pp. 73–4)

Barnard's equation of 'feminine' tenderness with a more general 'simplicity' nevertheless offers an intriguing perspective on the thesis

being pursued here, i.e., that the stark simplicity of the narrative is unwittingly linked to the text's problematisation of gender difference. His biographical analysis of Keats's problem with women during this period of his career also reveals something of the context in which this gender anxiety was formulated. He quotes the letter to Benjamin Bailey of 18 July 1818 in which Keats admits to his confusion:

> I am certain I have not a right feeling towards Women – at this moment I am striving to be just to them but I cannot – Is this because they fall so far beneath my Boyish imagination? When I was a schoolboy I though[t] a fair woman as a pure Goddess. . . . I thought them etherial above Men – I find them [written 'then'] perhaps equal. (*Letters*, p. 341)

Barnard interprets Keats's 'muddle' over women as the classic nineteeth-century 'expression of a morality which idealised women's innocence, purity and beauty at the cost of denying their sexuality' (p. 70). At no point, however, does he suggest that the 'effeminisation' of Lorenzo in *Isabella* might be equated with an (unwitting) attempt to equalise the frightening polarisation of the sexes.

Millais's *Isabella* (see Plate 5) is a narrative interpretation of Keats's poem. Contextually, it refers specifically to the first stanza (quoted above) which describes how the two lovers used to sit together at meals: 'They could not sit at meals but feel how well / It soothed each other to be by.' At the same time, the prefigurative symbolism of the painting ensures that the fate of the lovers is also told: Lorenzo's death (as indicated by the upset salt-cellar and Japolica plate), and Isabella's by the basil-pot which sits innocently on the ledge behind them.[6] Yet beyond this 'official narrative', Millais's painting may be made to enact a much more daring drama of gender and difference. In this early work (the first oil-painting Millais produced as a Pre-Raphaelite member), stylistic and semantic elements combine to provide a rich textual surface for the twentieth-century feminist reader.

The first impression of *Isabella* is one of exquisiteness. It is a painting (not especially large) in which sharpness and delicacy of line combine with subtlety of colour to pique and chasten the viewer's eye as she turns away from the bigger, brighter, bolder specimens of Victorian art which surround it at its home in the Walker Art Gallery, Liverpool. It is a painting whose compositional stillness and balance are ironically at odds with the violence of its subject; even the actual violence being enacted within the frame (one of the 'wicked brothers' is kicking the greyhound) is neutralised. For the flatness, the cleanness, the sharpness of this sparkling canvas cleverly conceals its drama. Visitors walking past who know nothing of the story see only a

dinner table; a scene with its referents in northern Renaissance painting. They see a collection of figures flatly squashed as if against a window-pane. They do not see that what all the sharp lines and clearly defined spaces are revealing are differences.

Let us begin with the formal differences: the differences effected by colour, texture and general composition. Differences, alas, that no colour reproduction will do justice to and which require a visit to the Walker Art Gallery to fully appreciate. The general impression of the picture space, as I noted above, is one of flatness. Various critics have drawn attention to this fact, linking it inevitably to the early Pre-Raphaelite style, their way of preparing canvases, and the general connections with medieval art.[7] This is not to suggest that three-dimensional space has been entirely jettisoned. The presentation of the table and its occupants is spatially feasible, if a little distorted; it is only the dividing wall and the garden beyond, looking rather like a latter-day mural in an Indian restaurant, that really upset the naturalistic illusion. Onto this flattened stage Millais has, however, ranged his characters and their props as though for war. The table itself acts as the principal spatial agent in this respect; a gleaming white triangle that separates one half of the company from the other and which, most significantly, joins the foreground brother and Isabella together in direct opposition. The lighting from the centre-left (observe the shadows cast by the foreground figures, and the corner-triangle on the wall behind) accentuates this divide.

The painting's colouring, meanwhile, unquestionably its chief formal delight, plays a clever game in uniting, dividing and registering difference. Viewed in context, the canvas yields a much wider and more delicate palette than is ever witnessed in reproductions, in which, for example, the foreground brother's doublet and Lorenzo's jacket may appear to be virtually the same colour. In point of fact, the brother's garment is the richest of burnt-oranges and Lorenzo's a delicate salmon-pink. The compositional balance of the picture, however, is held together in the first place by the patterning of black and white. The starkness of these neutrals contributes significantly to the painting's overall sharpness, lending it the proverbial crispness of Dutch art. Two characters, it should be noted, the nurse and the page, are attired principally in black and white; a combination picked up on the other side of the table in the white of the first brother's leggings, and the solid black of the second brother's hat. Together, these colours anchor the corners of the foreground action. The other principal unificatory colours are green and yellow-ochre; the deep

grass-green of the two foreground seats and the dress of the woman (back right) which form another compositional triangle, and the paler greens which harmonise throughout and are present in the background wall-covering and the greenery on the balcony (rose, passion-flower and basil-pot). The yellows, meanwhile, pervade the wall-covering and wooden floor, and have their deepest expression in the mustard of the page's hose.

Against this chromatically wild, if tonally subdued palette, the grey brocade of Isabella's dress might, at first, appear an extraordinary choice. It is a colour repeated nowhere else in the room, save that the gold-brocade details tone with the wall-covering and wooden floor. Its effect, therefore, is one of stunning difference: a difference rendered all the more forceful because it achieves its effect by under-statement. In a room full of richly clad 'Renaissance' figures, Isabella is the woman in grey; a still and luminous figure who relates tonally to only one other person in the room: the 'salmon-pink' Lorenzo.[8] Their unique and isolating colour scheme also has the effect of softening their edges. Although the pair are, in effect, as sharply drawn as the other figures, their lines appear softer. Lorenzo and Isabella are delicately drawn, delicately coloured and, alas, delicately disposed.

But before moving on to draw some ideological conclusions from these formalistic differences, I wish also to mention the textures of the painting. Even more remarkable, perhaps, than the subtle differentiations in colouring is the way in which Millais's painting sets smooth satins against starched linens, cold metal against warm flesh. If we take the foreground group first, we see how exquisitely such textures are balanced: the softness we have already perceived in the colouring of the garments worn by the two lovers is re-emphasised by their materials: in particular, the shining satin sleeves of Isabella's dress, and the soft, plushy velvet of Lorenzo's jacket. Both figures radiate a glowing warmth, as does the smooth-haired, trembling greyhound that rests its head on Isabella's knee. The touch of her hand upon that head is perhaps the most sensitively felt touch in the whole picture. By contrast, Lorenzo and Isabella themselves do not touch, but only share the sensation of a cold, ceramic, plate. The perceptible supersensitivity of their senses nevertheless cuts them off completely from those that surround them.

Outside their charmed space, the juxtaposition of tactile planes is altogether more sinister. The starched linen of the table is the repository of cold ceramic and even colder metal. On close examination we see that two knives feature in the scene: one, possibly

concealed on the far side of the nurse's plate, the other being used by the man dressed in pale green (right-hand side) to peel his apple. The gleaming cold metal of these instruments is also echoed in the silver fruit-stand at the end of the table, and the spilled salt-cellar located in the shadow of the first brother's bent arm. Also cold in their sharp, crystal perfection are the two raised wine-glasses. Everywhere the warm softness of flesh, fur and food is in conflict with the cold hardness of instruments. One particularly sensitive object of tactility, easily missed, unless the painting is viewed *in situ*, is the peach which sits in the middle of the table behind the 'V' of the first brother's raised arms; an item of fleshly vulnerability which teams, most sinisterly, with Lorenzo's pink velvet jacket. But the most violent juxtaposition of surfaces is reserved, predictably, for the arch-villain: the foreground brother whose thick fingers clench the wooden nut-crackers in a murderous grip. The discarded shells of the walnuts he is cracking form an untidy group on the table cloth directly opposite the boy who will share their doom; the pitiful remnants of warm wood against cold linen. This gesture of violence is, moreover, replicated in the activity of the hawk that sits perched on the second brother's chair, its cold, sharp, beak tearing at a white feather; and does the greyhound that sleeps curled under the brothers' chairs know that its slender legs are in peril of being crushed?

It will be seen, then, that even on a purely formal level *Isabella* is a turmoil of difference: differences which conspire principally to separate the two lovers and their fate from the cruel intentions implicit in the rest of the room. If we move now to an assessment of the ideologies that underlie these semiotics we will see how pervasively such difference distinguishes Millais's text.

The formal devices which isolate Lorenzo and Isabella from the rest of the room support a complex hierarchy of class, gender and age. Of the thirteen persons present at the table, only four are recognisably women (I register here some doubt about the last figure on the left-hand side who cannot be seen clearly), and, of these, one is an *old woman*: Isabella's nurse. Spatially isolated from the other younger women at the far end of the table, Isabella's youth and sex are thus rendered especially vulnerable. The soft skin of her hands and neck, for example, are in contrast not only with that of the male members of the group, but also with the worn, weathered flesh of the nurse. Everything about her proclaims the difference of her age and sex; the richness of her brocade dress also signifies the difference of her status: her position at the head of the household. Significantly the person she

resembles most closely is not the other women, but Lorenzo. Lorenzo, whose youth alone equals hers (the other women in the group appear significantly older), and whose face is inflicted with the same tenderness and vulnerability.

Lorenzo's characterisation is, in many ways, the most striking ideological factor in Millais's picture, exposing so blatantly the gender differences at play through his own *relative* androgyny. For not only does Lorenzo's person complement Isabella's femininity, it also highlights the extreme masculinity of the foreground brother. The latter's clenched fist, knotted neck and muscular legs point (quite literally) to everything that the still adolescent Lorenzo is not. It is, indeed, a wonderful enactment of the conspiracy of gender and class that we have already witnessed in Keats's poem. The tragedy of the text depends not only on the heroine's victimisation for being a woman, but the fact that the hero is *not enough of a man*. As Isabella's gender undermines her class, so does Lorenzo's class undermine his gender, exposing them both to the brutal exercise of power constructed *precisely* on those differentials. Here it is also interesting to observe the illusion of conspiracy that exists within the other male members of the group: most viewers, I have discovered, assume that the second brother is exchanging a sinister look with the black-clothed page, while the older men (clothed in green and pale gold respectively on the right-hand side) have their eyes downcast in silent complicity. The man at the far end of the table (right-hand side), said to be a portrait of Rossetti, drains his glass in confident and aggressive manner; a gesture that links suggestively to the raised glass (an ironic toast?) of the second brother. The 'real men', it seems, enjoy a gender-bound comradeship from which the effeminised Lorenzo is excluded. It is the unspoken difference, perhaps, of men and boys; between those weakened by their love for a woman, and those not. It is most certainly the difference of power.

Millais's painting of *Isabella*, then, does much more than retell Boccaccio's story.[9] Wittingly or unwittingly, it replicates the ideological differences implicit in Keats's retelling of that story, and makes them graphic with a startling directness. It is, indeed, as if Keats's own prescription towards 'simpleness' had been translated directly into the clean lines and clear spaces that chart the cool surface of Millais's picture. Both texts, it might be said, are centrally lit and thus yield very little shadow. What drama there is is enacted, quite literally, on the surface, and the 'dark armies' that 'clashed by night' in *Mariana* and *The Lady of Shalott* are brought into the bright light of day.[10]

Notes

1. Hyder E. Rollins (ed.), *The Keats Circle: Letters and papers*, vol. 1 (Harvard University Press, Cambridge, Mass., 1958), vol. 1, pp. 223–5. Further page references will be given after quotations in the text.
2. See Jack Stillinger, 'The "reality" of *Isabella*', in his *The Hoodwinking of Madeline and Other Essays on Keats's Poems* (University of Illinois Press, Chicago and London, 1971). Page references to this volume are given after quotations in the text.

 Louise Z. Smith developed Stillinger's ideas in her 1974 article: 'The material sublime: Keats and *Isabella*' which she concludes thus:

 > In *Isabella* the heart-easing love of Isabella and Lorenzo contends with the jostling world. Ultimately, impassioned sensibility must yield to the damnation of the real world's fierce destruction, and the detachment Keats maintains by means of digression and juxtaposition affords the wisely passive acceptance of the tragically near-equal balance of love and destruction. (*Studies in Romanticism*, 13 (1974), 299–311; reprinted in John Spencer Hill (ed.), *Keats: Narrative Poems* (Macmillan, London, 1983), pp. 105–18.)

 John Barnard (*John Keats* (Cambridge University Press, Cambridge, 1987), p. 73) nevertheless uses biographical evidence to show that Keats continued to worry that this new 'Simplicity' would be read quite differently by the public. In a letter of 1819 he wrote: 'There are very few who would look to the reality.' It is especially interesting that he feared that the 'simplicity' would be interpreted as a species of sentimentality or 'Mawkishness'. Further references to Barnard's volume are given after quotations in the text.
3. The necessity of 'studying nature attentively' was outlined in the 'Pre-Raphaelite manifesto' and recorded some years later by William Michael Rossetti in *Dante Gabriel Rossetti: His Family Letters, with a Memoir* (1895). The Brotherhood were expected to

 > Have genuine ideas to express; to study nature attentively, so as to know how to express them; to sympathise with what is serious and heartfelt in previous art, to the exclusion of what is conventional and self-parading and learned by rote; and most indispensable of all, to produce thoroughly good pictures (reproduced in TGC, p. 11).
4. Jack Stillinger (ed.), *The Poems of John Keats* (Heinemann, London, 1978), pp. 245–63. Further page references will be given after quotations in the text, and stanza references will be supplied in the course of the discussion.
5. I have, however, found little evidence of this aspect of the poem being taken up in recent Keats criticism. John Barnard does present it as one possible interpretation of the poem, but ultimately refuses to privilege it. He writes:

 > The poem's central theme is hard to discern. One of the most important changes Keats made to his source, the introduction of an attack upon capitalist wealth, points to what might have been a possible centre. . . . Keats's reworking of Boccaccio's story depicts the brother's world of commerce and social climbing as actively inimical towards love. The opposition between commercialism and love is, as the reference to 'noisy factories' suggests, one which prevails in the author's own world. . . . But the story's 'piteous theme' (line 152) allows no love fulfilment but in death. (p. 81)

6. A gloss on these symbols is provided by Malcolm Warner in the TGC:

> Isabella and Lorenzo are sharing a blood-orange. The majolica plate in front of them on the table shows a beheading scene. David and Goliath or possibly Judith and Holofernes, a biblical parallel to Isabella's removing the head of Lorenzo. Behind the lovers, on the balcony, are two passion flowers and some ominous garden pots. The hawk tearing at a white feather on the far left is an image of the brothers' rapacity derived from Keats, who calls them "the hawks of ship-mast forests". The bench end carving may show an "Adoration of the Shepherds" or some pilgrims, which would connect them with the image of Lorenzo, "a young palmer in Love's Eye". (pp. 68–9)

7. Malcolm Warner (TGC, p. 69) quotes a review in the Literary Gazette (9 June 1949) which marked the 'absence of perspective and aerial distance' as being 'of a piece with the original school which is imitated'.
8. The painting is especially rich in the palette we associate with northern Renaissance artists such as Jan Van Eyck.
9. Other paintings illustrating Keats's poem include the following: William Holman Hunt, *Isabella and the Pot of Basil* (1866–8), Laing Art Gallery, Newcastle upon Tyne; John Melhuish Strudwick, *Isabella* (n.d.), untraced (reproduced in Percy Bate, *The English Pre-Raphaelite Painters* (1901), p. 110); John William Waterhouse, *Isabella and the Pot of Basil* (1907), private collection; Arthur T. Newell, *Isabella and the Pot of Basil* (1904), untraced (reproduced in Anthony Hobson, *The Art and Life of J. W. Waterhouse R.A.*, 1849–1917 (Studio Vista and Christies, London, 1980)); Henrietta Rae, *Isabella and the Pot of Basil* (n.d.), untraced (reproduced in *The Bookman Memorial Souvenir* (1912)).

I am indebted to Christine Torney for the more obscure of these references. In her MA thesis (St. David's University College, Lampeter, 1983; unpublished), 'Keats through Victorian and Edwardian eyes', Torney comments revealingly on the changing iconography of the 'Isabella' subject. Of the later paintings she writes:

> A dreamy Isabella embracing a pot of basil becomes a stock property around the turn of the century. . . . The poem loses, through these artists, the power to disturb. It is impossible to imagine that these charmingly wispy basil trees grew out of corruption. The introversion of these Isabellas, like their loose-fitting costumes *à la japonnaise*, their masses of cloudy dark hair and sensitive long-fingered hands, is seen merely as an aspect of a fashionable image. (pp. 30–1)

All these later interpretations of the subject may be seen to derive from Holman Hunt's 1866 painting, but with all the horror and obsession of Hunt's painting written out. Hunt's painting, which features Isabella with her arms about a massive ceramic basil pot placed on a home-made shrine, has been compared by Peter Conrad to 'the airless claustrophobia of a Victorian parlour stuffed with bric-à-brac' (Peter Conrad, *The Victorian Treasure House* (Collins, London, 1973)). This indictment, as Torney has pointed out, is 'an unintended tribute to Hunt's achievement' (p. 27) since what is memorable about the painting is the paralleling of Isabella's morbid introspection in the oppressive fabrics and furnishings with which she is surrounded. Focusing on only one moment in the narrative, however, and on Isabella lost to the monomania of her desire, it offers fewer possibilities for productive explication than Millais's startling juxtapositions of form, character and ideology.

10. This metaphor for the catalytic impact of conflicting ideologies found in Tennyson's poem comes courtesy of Matthew Arnold's poem 'Dover Beach' (see *Poetical Works* (Macmillan, London, 1890)).

Chapter 6

Madeline: Ghostly Signifiers

For any society wishing to promote the values of traditional family life, the Pre-Raphaelite heroine is hardly a recommended role model. Of the five women we have considered so far all (allowing for the rather special circumstances surrounding the Virgin) are unmarried, childless women who nevertheless indulge in romantic fantasies about men somehow beyond their station and, for their sins, either go mad or die. With Keats's *Eve of St. Agnes*, however, we come to a text with a happy ending. Although Madeline's romance may not be conducted in a manner of which the stricter moralists would approve, Madeline nevertheless gets her man and is spirited away into a rosy future where she will presumably marry, procreate and live happily ever after.

This, at least, is the popular version of Keats's *Eve of St. Agnes*: the poem 'learned' by generations of A-Level students who can itemise its imagery, recite its verbal felicities by heart and explicate its philosophies of love and beauty at length. For those with better teachers will be able to tell you that this, as well as being a story about another pair of 'star-crossed lovers' (Madeline and Porphyro), is also a poem 'about the Imagination': a poem which celebrates the *power* of the Imagination in the face of Love and Death. According to this line of explication it is the text which is pointed to as the dramatisation of Adam's Dream (as referred to in one of Keats's most famous letters), in which Adam woke from his dream 'to find it Truth'.[1] Likewise, it is argued, Madeline awakens from her St Agnes Eve dream to find Porphyro. In a world of evil forces, death and despair (represented variously as the Baron, the Beadsman and the Bad Weather), the hero appears to spirit Madeline away to a happy future. Thus the Imagination triumphs; the woman is saved; the dream becomes reality. And all this is achieved (if the teacher is careful not to dwell too long on certain stanzas) without even considering exactly what went on in Madeline's bed. It should be acknowledged, moreover,

that this version of the story enjoyed a popularity with the reading public long before its success on the school syllabuses. In the multitudinous editions of Keats's work published in the Victorian and Edwardian periods, it was extensively illustrated and widely circulated.[2] It was also given enthusiastic dissemination by the painters and illustrators of the day: by artists like Arthur Hughes (see Plate 6) who, as we shall see, celebrated its fairy-tale structure as a narrative triptych.

There is, of course, another version of the story. In the early 1970s, Jack Stillinger, as one of a more cynical generation of literary critics, had the temerity to suggest that Keats's text was not all that it seemed. In an essay entitled 'The hoodwinking of Madeline', he proposed that the earlier 'metaphysical' critics of the poem had been rather naive in their conclusions.[3] His own thesis hinges on the modest assumption that people are not always as innocent as they might, at first, appear and that, in matters of love especially, they are often downright devious. Porphyro, he proposes, did not exactly happen upon Madeline's bed-chamber by chance: when we first see him prowling around the castle grounds he knows very well what night it is, what feast is being celebrated, and where Madeline is likely to be. He knows, also, who he must approach if he is likely to find Madeline ('Ah happy chance! The aged creature [Angela] came, / Shuffling along', Stanza XI) and he quickly works out what he is going to do once he has been directed to her chamber ('then doth he propose / A stratagem, that makes the beldame start', Stanza XVI). The crux of Stillinger's argument, however, depends upon the supposition that Porphyro also premeditated what came next. The celebrated stanzas which describe his concealment in the closet are interpreted by Stillinger as evidence that what Porphyro was intent upon was rape:

Awakening up, he took her hollow lute, –
Tumultuous, – and, in chords that tenderest be,
He play'd an ancient ditty, long since mute,
In Provence call'd 'La belle dame sans mercy':
Close to her ear touching the melody; –
Wherewith disturb'd, she utter'd a soft moan:
He ceased – she panted quick – and suddenly
Her blue affrayed eyes wide open shone:
Upon his knees he sank, pale as smooth-sculptured stone.

Her eyes were open, but she still beheld,
Now wide awake, the vision of her sleep:
There was a painful change, that nigh expell'd
The blisses of her dream so pure and deep:
At which fair Madeline began to weep,

And moan forth witless words with many a sigh;
While still her gaze on Porphyro would keep;
Who knelt, with joined hands and piteous eye,
Fearing to move or speak, she look'd so dreamingly.

'Ah, Porphyro!' said she, 'but even now
Thy voice was at sweet tremble in mine ear,
Made tuneable with every sweetest vow;
And those sad eyes were spiritual and clear:
How chang'd thou art! how pallid, chill, and drear!
Give me that voice again, my Porphyro,
Those looks immortal, those complainings dear!
Oh leave me not in this eternal woe,
For if thou diest, my love, I know not where to go.'

Beyond a mortal man impassion'd far
At these voluptuous accents, he arose,
Ethereal, flush'd and like a throbbing star
Seen mid the sapphire heaven's deep repose;
Into her dream he melted, as the rose
Blendeth its odour with the violet, –
Solution sweet: meantime the frost-wind blows
Like Love's alarum pattering the sharp sleet
Against the window-panes; St. Agnes' moon hath set.

'Tis dark: quick pattereth the flaw-blown sleet:
'This is no dream, my bride, my Madeline!'
'Tis dark: the iced gusts still rave and beat:
'No dream, alas! alas! and woe is mine!
Porphyro will leave me here to fade and pine. –
Cruel! what traitor could thee hither bring?
I curse not, for my heart is lost in thine,
Though thou forsakest a deceived thing; –
A dove forlorn and lost with sick unpruned wing.'[4]

'The miracle on which Porphyro congratulates himself', writes Jack Stillinger, 'is in fact a *stratagem* that he has planned and carried out to perfection. . . . The full force of the "stratagem" comes to be felt in the poem – a ruse, an artifice, a trick for deceiving' (pp. 73–4). Stillinger annotates this accusation by cross-reference to other texts which show male protagonists up to similar tricks, and takes us step by step along the insidious route by which Porphyro achieves his conquest:

The second point concerns Porphyro's call for a 'drowsy Morphean amulet' – a sleep-inducing charm to prevent Madeline's awakening when the music bursts forth into the room. Earlier he has wished to win Madeline while 'pale enchantment held her sleepy-eyed' (l.169). Here he would assist 'pale-enchantment' with a 'Morphean amulet'. It may not be amiss to recall Lovelace and the stratagem by which he robbed Clarissa of her maidenhead. 'I know thou wilt blame me for having recourse to *Art*,' writes Lovelace to John Belford, in Richardson's novel. 'But do not physicians prescribe opiates in acute cases'. Besides, 'a Rape, thou knowest, to us Rakes, is far from being an undesirable thing'.[5]

Stillinger's reading of the poem pursues the various 'stratagems' of Porphyro's quest from the moment he enters the castle to the eventual 'consummation of his desire' in Madeline's bed. Besides contemplating the use of drugs to achieve this conquest, Porphyro 'threatens' Angela, gains unlawful access to Madeline's chamber, hides himself in her closet and purposefully 'attempts to melt into her dream' by awakening her with the music of his lute. At no point does he attempt to correct her misapprehension. On this point, Stillinger writes: 'To her request for "that voice again. . . . Those looks immortal" (ll. 312–13), Porphyro offers neither, but rather impassioned action of god-like intensity' (p. 80).

To appreciate the full 'anti-mysticism' of Stillinger's reading one has to place it against earlier 'metaphysical' commentators such as Earl Wasserman, who described the consummation thus:

> Here in the chamber of Maiden Thought the ascent of the scale of intensities is acted out, and Porphyro and Madeline unite in a mystic blending of mortality and immortality, chastity and passion, the moonlight of perfect form and the ruddiness of intense experience.[6]

It is also interesting that John Barnard's more recent reading of the poem has attempted to reinstate something of this mysticism. He writes:

> Missing from Stillinger's analysis is the way the lovers are, at the poem's centre, lost in one another: it describes the youthful experience of the loss of self, of identity, both in being in love and in the act of making love. . . . Their coming together is a *shared* dream, but it is also a consummation. Both discover the unexpected and mysterious: both are unknowing, innocent indeed, but in differing ways. The mingling of the physical and the ideal is central to the meaning. Keats's perception, perhaps felt most strongly in youth, is that in making love we may discover that we are in love. The physical act prefigures the emotional. In that sense, a kiss between lovers is a self-fulfilling prophecy.[7]

Against such eulogy, Stillinger's is detective work of the most sobering kind, and my experience is that students, raised on the other version of the story, do not much care for it. By tainting Romantic Love with the sourness of pragmatic sexuality, the 'magic' of Keats's tale is instantly lost. Not only is the reader dispossessed of her narrative pleasure in the text (i.e., the movement towards a happy ending), but also of the enchanting imagery by which this romance was decorated. By focusing on the end of the poem, it is easy to show that Madeline was far from happy about her experience (see Stanza 37), and to draw their attention to the fact that what the pair of lovers ride away into is not a rosy sunset but an ominous storm.

Once 'cold reality' is admitted, indeed, the text would seem to take

on a wholly different set of 'stage properties': out go the sensuous warmth of stained glass, 'lucent syrops' and 'snarling trumpets', and in come the cold stone of carved angels and the 'sculptured dead'. The images of death and disease which pervade the poem (in particular, in relation to the 'Ancient Beadsman' and the 'palsied Angela') have, of course, been dealt with by less sceptical critics as simple evidence of Keats's temporal contextualisation; a *carpe diem* device that works to enhance the Madeline–Porphyro romance by enshrining it in a legendary past: 'And they are gone: ay, ages long ago / These lovers fled, away into the storm'.[8] In the wake of Stillinger's critical interpretation of events, however, no such easy assimilation is possible. Rather like Catherine Morland in *Northanger Abbey*, we learn that gothic mansions harbour worse things than subterranean passages and ghosts.[9] In Madeline's case, indeed, her closet has harboured a potential rapist.

If Stillinger's polemical exposé of Porphyro is bad news for erstwhile lovers of Keats's poem, it is hardly pleasant reading for the feminist reader who will be only too familiar with the plot. While I would not wish to suggest that *The Eve of St. Agnes* is 'simply' a poem 'about rape', or to deny the ambiguity that surrounds Madeline's desire/ complicity, the *context* of Porphyro's behaviour is certainly that of a rapist. Having forced entry into her bed-chamber, we know that he was *in the position* to rape her should she refuse his advances. For the feminist reader of this text it is thus the politics of the context in which the sexual act takes place, rather than the specifics of the act itself, that will make us reluctant to designate it a mere 'seduction'. The line between a woman being forced to 'have sex against her will' and rape is a notoriously fine one, and the 'degree' to which she has to resist to make the act criminal continues to beset our legal system. Whatever the technicalities of the act itself I would argue that, *textually*, the erotic excitement of this narrative depends upon the male protagonist overpowering the female and achieving consumma-tion. Thus while the degree of Madeline's complicity is contestable (see further discussion of Stillinger below), the narrative subtext of the poem *is the possibility of rape*. If this is not categorically a poem 'about rape', then it is certainly about the chance of one.

This last point leads us directly to the fact that *The Eve of St. Agnes* is also a poem about voyeurism and the objectification of the female body. Before Porphyro attacks his victim, he frames her:

> Full on this casement shone the wintry moon,
> And threw warm gules on Madeline's fair breast,

As down she knelt for heaven's grace and boon;
Rose-bloom fell on her hands, together prest,
And on her silver cross soft amethyst,
And on her hair a glory, like a saint:
She seem'd a splendid angel, newly drest,
Save wings, for heaven: – Porphyro grew faint:
She knelt, so pure a thing, so free from mortal taint.

Anon his heart revives: her vespers done,
Of all its wreathed pearls her hair she frees;
Unclasps her warmed jewels one by one;
Loosens her fragrant bodice; by degrees
Half-hidden, like a mermaid in sea-weed,
Pensive awhile she dreams awake, and sees,
In fancy, fair St. Agnes in her bed,
But dares not look behind, or all the charm is fled. (pp. 309–10)

This classic enactment of male scopophilia is, rather surprisingly, made little of in Stillinger's account of the poem.[10] For the feminist reader, however, this visual ravishment of Madeline is *the* most significant of his preliminaries; the woman he knows (for Madeline, like many rape victims, is already known to Porphyro) has to become something 'other', the mere sum of all her delectable parts, before he can take full possession of her as a sexual object. In a sequence of defamiliarizing adjectives she is described as, at first, 'angel', then 'thing', and finally as a bird 'trembling in her soft and chilly nest' (Stanza 27). As she undresses (see Stanza 25) she is breast, and hands, and hair. With some irony we can observe that if Madeline, through the veils of her dream, did not quite recognise Porphyro, then Porphyro through the voyeuristic objectification of the male gaze, certainly did not recognise Madeline. This, of course, does not excuse him. Most pornographic representations, indeed, *require* the particular sequence of events undertaken by Porphyro.[11] Women have to be defused before they can be abused. That not just Millais, but many other artists and illustrators should have chosen this moment of the narrative to illustrate is hardly surprising; Porphyro's closet is the theatre box reserved for the male reader.

Where such careful positioning leaves the twentieth-century feminist reader is not, at first, easy to see. Were this 1970, we could, like Millett, simply label the text pornographic *in intention* and walk away. Our criticism of the poem need go no further than that already practised; one need only quote the offending passages, spit and run.[12] But this is not 1970, and as post-structuralist readers we are obliged to recognise the multiple reading demands of the text-as-text, the text within its historical context and the text within the post-structuralist

context of the present day. In any of the more sophisticated approaches to Keats's text, the overwhelming problem is Madeline herself. Is she merely the victim of Porphyro's grasp and gaze, or does she, as Jack Stillinger suggests, collude with him in her hoodwinked blindness?

> There are reasons why we ought not entirely to sympathize with Madeline. She is a victim of deception, to be sure, but deception not so much by Porphyro but by herself and the superstition she trusts in. Madeline the self-hoodwinked dreamer is, I think, the main concern of the poem, and I shall spend some time documenting this notion and relating it to Keats's other important poems – all of which, in a sense, are about dreaming. (p. 84)

In the literary-historical context of Keats's writings at this time, it is, indeed, possible to argue for a reading of the poem which presents Madeline as a victim of the doomed Imagination. Duped by her own imaginary desires, she is punished by awakening to an unpleasant reality; Adam's Dream, alas, turns out not quite so happy as she expected. By this interpretative twist Madeline thus changes from an innocent victim into a blameworthy one. Whatever the sexual politics of Porphyro's behaviour, in the realm of the text's 'greater meaning' (i.e., the dangers of the Imagination) it is *she* who is to blame; she, who like Eve, lusts for something that is forbidden her, and is meted the appropriate punishment. Such a reading of events, while confined to the discourse of the Imagination in Keats's poetry may appear innocent. Translated back into the materiality of women's lives, however, it is anything but. Although Madeline may have desired Porphyro in her dream, it is wrong to assume that she desired him in her bed. By presenting Madeline as a dupe of her own imaginary desires, Stillinger returns us to a reading which implies that Madeline was somehow 'asking for it'.

It is perhaps at this interface of these opposing theoretical discourses that we can, as feminist readers, best discover our own viewing-point for this poem. Although Stillinger may have ridiculed the metaphysicals' interpretation of the poem as a naive 'celebration of the imagination', his own proto-deconstruction, while certainly less naive, tends towards the same dematerialisation. Here it is necessary to ask whether a statement of non-existence is any less metaphysical than a statement of existence; whether a reading which focuses the poem's undermining of the Imagination is any more creditable than one which applauds it. For, ingenious as Stillinger's argument is (and a reading of Keats's later poems as discourses on 'the failure of the Imagination' is certainly an interesting one), it inevitably writes

Madeline herself out of the story. It iconises her seduction and rape as a symbol of something that has nothing to do with women, nothing to do with rape.

With the dangers of such metaphorisation in mind, I suggest that feminist readers should retain a baseline reading of the poem that is as materialist as possible. This is, however, far from easy. Unlike *Isabella*, this is not a text that wears its politics on its sleeve. There are no sharp lines alerting us to the socio-economic differences between the lovers; no clear reasons why their relationship should have been denied. For here, despite Stillinger's chronology in which *Isabella* was the crucial turning point, Keats does not choose to tell his story simply.[13] Densely layered and seen through time, this is a fairy-tale in which characters enter and exit unannounced, passing into history 'like phantoms'. It is a story, moreover, which takes place under the cover of darkness, and in which the protagonists are only seen by the light of moon or candle. In such circumstances, it is, indeed, difficult to distinguish who Madeline is; who Porphyro. Pale, 'ethereal' (Stanza 35) and 'azure-lidded' (Stanza 30) as they are, it is all too easy to deny them political substance; cast them to the peril of their own non-referentiality. But Madeline, we must remember, however fictional and fairy-like, is a woman. A woman who is seduced/raped under the cover of darkness and Romance. Her terror upon awakening, in whatever critical context we choose to examine it, is the moment in the story that must be attended to: 'No dream, alas! alas! and woe is mine!' While some readers will continue to insist that these exclamations are themselves ambiguous (the fear Madeline is expressing is the fear of 'abandonment'), I feel that any feminist reading of the text must prioritise the politics of Madeline's compromised circumstances over her hypothesised desires. In the same way that readers of Hardy's *Tess of the d'Urberville's* now acknowledge what happened in the Chase to be a rape despite the fact we are never told if Tess acceded to d'Urberville's demands, so will many of us wish to argue the same for Madeline. Although she may have, indeed, desired Porphyro in her dream and although, after the event, she agrees to elope with him, the *context* in which he possesses her is still that of rape.

With a more popular audience in mind, it is hardly surprising that Keats's painters and illustrators should have preferred the first, 'expurgated' version of the story, and Arthur Hughes's triptych, *The Eve of St. Agnes* (see Plate 6) is pre-eminent among those to defend its Romance. In the following discussion I propose that by a subtle conspiracy of technical measures, Hughes's painting preserves the

innocence of his subject from the grosser realities of sex and 'stratagem'.

Of paramount importance in Hughes's design is his rendition of the narrative via a three-part cartoon. In the chapter on *The Lady of Shalott* I have already noted the problems Holman Hunt encountered when faced with the challenge of representing Tennyson's story in a single composition, including the fact that the cartoon (or variations upon it) is the only means by which the artist can figuratively reproduce the sequential passage of time. By this means Hughes, like other artists before him, effectively privileged narrative in a medium which intrinsically denies it. Through the three gothic arches we see the following:

1. Porphyro spying on the castle where Madeline lives.
2. The moment of Madeline's awakening (Stanzas 33–4).
3. The lovers' elopement (Stanza 41).

By thus concentrating on the sequentiality of the story, in particular its resolution in a 'happy ending', Hughes tempers the strangeness of the subject, its gothicism and its eroticism, and secures the precarious bedroom scene within a fixed point in time. Structurally, the triptych plays some nice tricks around this device. Notice, for example, the way in which the first and third panels give the illusion of a continuous spatial–temporal corridor running behind the centre panel. In this particular time/space zone, we see Porphyro, viewed from the back, approach the castle, disappear and then, in the third frame, re-emerge with his prize. As a witness to this event, the viewer's position is reminiscent of the Edward Thomas poem, 'As the team's head brass', in which a pair of lovers enter and exit some woods in the time it takes for a small square of field to be ploughed.[14] Rather like Thomas's speaker, the viewer to Hughes's painting is frozen in a point of time *outside* these events; a 'meta-time', which like the ending of Keats's poem, has the effect of rewriting the story as 'legend' ('Ay, they are gone: all ages long ago', Stanza 42) and which leaves the witness not quite believing what she has seen. This meta-temporality is further reinforced by the gold frame that contains the triptych; a specially designed pseudo-medieval space that attempts to locate events at least as far back as the fifteenth century, while its ivy-leaved border bespeaks the ephemerality of us all. It is significant, too, that in keeping with this textual overview, the stanza which decorates the frame does not describe a particular moment from the narrative, but is instead the one which gives us the background to the event:

They told her how, upon St. Agnes' Eve
Young virgins might have visions of delight,
And soft adorings from their loves receive
Upon the honey'd middle of the night,
If ceremonies due they did aright;
As, supperless to bed they must retire,
And couch supine their beauties, lily-white;
Nor look behind, nor sideways, but require,
Of heaven for upward eyes for all that they desire. (p. 301)

Against the temporal narrative, then, and against the the greater historical time which surrounds it, the events taking place in Madeline's bed-chamber are held at a proper distance. The central panel of Hughes's painting is framed, quite literally, in more ways than one, and the events described therein rendered safe. It is significant, however, that although anchored in a comforting story-line, the bedroom scene, in both poem and painting, must also be seen to be *outside* time. The reason Madeline can be seduced is because she is temporarily 'out of time'; the same reason, indeed, why Porphyro's rape has never been traditionally recognised as such. The ideological implications of this are clear: cut the strings binding us to a specific time and a specific place and things are known by another name. Within the metaphysical walls of Madeline's dream, as within the gothic arch of Hughes's frame, Porphyro could never rape Madeline. In that rarefied space, his actions exist only as euphemisms: 'Ethereal, flush'd, and like a throbbing star. . . . Into her dream he melted' (Stanza 36).

The ethereality of the lovers in Hughes's painting is further emphasised by their ghostly characterisation. The whole of Keats's drama, as we noted earlier, takes place under the cover of darkness, and Hughes's painting reproduces this fact with a literalness that is beyond good painterly sense. Although much of its visual magic might, indeed, depend upon the 'jewel-like' intensity with which the small areas of bright colour shine out of the darkness, the whole canvas is so dark that it can only be viewed effectively from very close up.[15] In the central panel, where he kneels beside Madeline's bed, we can, with some effort, make out a firm jaw-line and longish red hair. The features are, however, veiled. Madeline, significantly, is desubstantiated in quite a different way. While Porphyro dissolves into the darkness, she is (in the centre panel) lit by coldest moonlight; a light so pale, so blanching of colour, that all who fall beneath its ray become, themselves, ghosts. The skin of Madeline's face, like the vase and delicate, long-stemmed glass on the table behind her, is almost transparent: a membrane as thin as the 'azure-lids' featured in Keats's

poem. Were we not familiar with the details of the story, we may, indeed, be forgiven for thinking that the floating, fairy form of Madeline were the dream, and Porphyro the dreamer. Between two such insubstantial bodies it is, of course, impossible to think that anything carnal should ever occur. Hughes's depiction of this ghostly encounter may certainly be considered erotic, but it is the eroticism of dreams: it is the picture of what goes on inside Madeline's head, not the material reality of what occurs outside it. And although shown with slight colour in her cheeks, the Madeline who tip-toes away from her father's castle on the arm of Porphyro is little more substantial; her form is still frail and fairy-like, even if it has now been shrouded in purple velvet to make her, like Porphyro, melt into the darkness.

Although also placed in a chamber lit only by moonlight, Millais's Madeline (*The Eve of St. Agnes*, 1863) is unquestionably flesh and blood.[16] The ghostly beams which cast a 'grid-iron' over her frozen body, do little to undermine either its substance or its sexuality, despite the fact that the contemporary male audience thought it under-fleshed. As Tom Taylor wrote in a letter to the artist: 'Where on earth did you get that scraggy model, Millais?'[17] Yet the fact that Taylor saw Millais's Madeline as a model, as a figure 'drawn from the life', is itself revealing. Unlike Hughes's fairy-princess, this is a woman with some part of her anatomy in the 'real world'. Whatever role she plays in whatever story, she will always meet her ultimate appraisal *outside of it*. The narrative context which holds Hughes's heroine so firmly in place is here, but an optional extra. This is, first, a picture of a half-dressed woman. It is also, if one reads the labels, an illustration to Keats's poem.

Once identified as the latter, however, we quickly see that Millais's painting is telling a rather different story from Hughes's. This is not the popular 'A'-level version, but a text to which some expurgated elements have evidently been restored. It is the version, indeed, that would be favoured by a certain male audience; the version in which the narrative subtext is always promising rape.

For Millais's Madeline, unlike Hughes's, has not been granted the security of a happy ending. She is frozen both in a particular place and at a particular moment in time, not daring to move or look behind (please refer to Stanza 26 quoted on p. 105). But if Madeline's gaze is frozen, the (male) viewer's most certainly is not. As she stands shivering and exposed with her dress about her knees, he (like a doctor or a visitor to a brothel) is free to examine her from all sides and to pass (like Tom Taylor) his verdict. By looking and

acting slightly stupid, Madeline involuntarily appears all the more vulnerable. This is not sexuality to be feared but to be taken advantage of. It is, moreover, evidence of the gender specificity of certain texts that the majority of my (female) students and friends find this painting absurd, and are unable to imagine how this rigid figure, her dress about her ankles, could ever be considered erotic. While I discussed, in the Introduction, some of the recent explanations that have been put forward to account for women's involvement in male-orientated texts (e.g., Hollywood cinema), a painting like this would seem to deny the female viewer any possibility of entering the narrative. What the male viewer receives as titillation, she perceives to be frankly ridiculous.

But what of Porphyro? If the public viewer is able to take such gratuitous pleasure in Madeline's body, then what of him, the hero? Nowhere visible, it is (in my experience of teaching the text), only by a slow process of elimination that the viewer works out Porphyro's position in the room; realises that we are, in fact, in the closet *with Porphyro*, viewing Madeline through Porphyro's eyes. The politics of this device, well known in twentieth-century cinema, is not only to create a special bonding between the male protagonist and the male viewer, but also to keep his actual body conveniently out of sight.[18] For, unless they are performing some specifically erotic function, men prefer to view their object of desire without the interference of competition. They do not wish to see the hero; they wish to be him.

The ghost of Millais's painting, then, is none other than Porphyro himself; the shadowy figure of Hughes's fairy-tale melted, quite literally, into thin air. Though we see through his eyes, there is no body to which we can attach the blame for what we know is about to happen. Rape, in the end, is as invisible in Millais's text as it is in Hughes's – as it is in Keats's. That we, as feminists, suspect foul play, signifies nothing. The evidence of the 'other stories' is simply too strong. Madeline, alas, is a Pre-Raphaelite heroine who cannot be rescued from her own 'happy ending'.

Notes

1. Hyder E. Rollins (ed.), *The Keats Circle: Letters and papers*, vol. 1 (Harvard University Press, Cambridge, Mass., 1958), pp. 184–5. In this letter to Benjamin Bailey (22 November 1817) Keats writes: 'What the imagination seizes as Beauty must be truth – whether it existed before or not. . . . The Imagination may be compared to Adam's dream – he awoke and found it truth.'
2. See Christine Torney, 'Keats through Victorian and Edwardian eyes' (St. David's

University College, Lampeter, unpublished thesis, 1983). Torney situates the renaissance of interest in Keats's writing at the turn of the century within the context of an expanding 'illustrated' book trade. She observes that this coincided, however, with a new critical appreciation of the poet alongside the 'non-intellectual female readership' for whom prettily illustrated editions were produced throughout the nineteenth century. Significant illustrated editions of Keats's poems during this period included: *The Poetical Works of John Keats*, illus. George Scharf; *The Poetical Works of John Keats* (1872), illus. Thomas Seccombe; *The Poetical Works of John Keats* (1873), illus. William Bell Scott; *The Poetical Works of John Keats*, illus. George Scharf, Jnr; Howard, Edward H. Wehnert, Birkett Foster and Chapman (1987). *The Eve of St. Agnes* was also published in several separate editions: *The Eve of St. Agnes*, illus. Edward H. Wehnert (1856); *The Eve of St. Agnes*, illus. Charles O. Murray (1880); *The Eve of St. Agnes*, illus. Edmund H. Garrett (1885).

3. Jack Stillinger, *The Hoodwinking of Madeline and Other Essays on Keat's Poems* (University of Illinois, Chicago and London, 1971), pp. 67–93. Further page references are given after quotations in the text.

4. Jack Stillinger (ed.), *The Poems of John Keats*, (Heinemann, London, 1978), pp. 313–15. Further page references will be given after quotations in the text, and stanza and line references will be supplied in the course of the discussion.

5. Stillinger's reference is to Samuel Richardson, *Clarissa*, Shakespeare Head edition (1930), v, pp. 339–40.

6. Earl Wasserman, *The Finer Tone: Keats's major poems* (Johns Hopkins Press, Baltimore, Md., 1953), p. 121.

7. See John Barnard, *John Keats* (Cambridge University Press, Cambridge, 1987), pp. 88–9.

8. See for example Wasserman, *The Finer Tone*, p. 125. Wasserman reads the ending of the poem thus:

> The lovers are wholly caught up in timelessness and no longer exist as human actors 'And they are gone': the action of the participle ('gone') belongs to the past, but the adjectival use of the participle here divests it of its verbal quality; it is a description, a quality of being, not an act, and therefore it implies no agency. The lovers' being gone is outside time and activity.

9. See Jane Austen, *Northanger Abbey* (1818). A popular reading of this novel is that the 'evil' in life is not represented by supernatural horrors or heinous crimes but by moral crimes like hypocrisy, snobbery and pride.

10. In many feminist readings of Lacanian psychoanalysis 'specularity' (i.e., relations of 'looking and seeing') has been made central to explanations of subject-acquisition. In an excellent definition of this relationship, Annette Kuhn, in *Women's Pictures: Feminism and cinema* (Routledge and Kegan Paul, London, 1982), writes: 'Specularity is held to govern both the subject–object split built into the language, and also Imaginary relations whereby subjectivity is recognised as unitary' (p. 48). Later in this book, Kuhn introduces the notion of specularity into her readings of Hollywood cinema via Laura Mulvey's earlier work on the 'voyeuristic–scopophilic look' (p. 159) and the way dominant cinema presented its female subjects to the 'male gaze'. She writes:

> Mulvey's analysis of the operations of voyeuristic and fetishistic scopophilia in narrative cinema and the constitution of woman as spectacle suggests that the spectator is male: or perhaps, and this is not quite the same thing, that such a cinema addresses itself to male spectators. (p. 63)

11. See Kate Millett's graphic accounts of Henry Miller and Norman Mailer in *Sexual Politics* (Virago, London, 1977).
12. See my critique of Millett's approach to the reading of literary texts in Sara Mills, Lynne Pearce, Sue Spaull and Elaine Millard (eds), *Feminist Readings/Feminists Reading*, (Harvester Wheatsheaf, Hemel Hempstead, 1989).
13. See the opening paragraph to Chapter 5 and note 2.
14. Edward Thomas, 'As the team's head brass', in R. George Thomas (ed.), *The Collected Poems of Edward Thomas* (Oxford University Press, Oxford, 1978), pp. 108–9.
15. In 'Keats through Victorian and Edwardian eyes' Torney writes:

> It is undoubtedly Hughes's own blend of the erotic and the mystic which is the source of the painting's fascination for the viewer. Its composition embodies the poem's narrative pattern of sacred quest and ritual, while the jewel-like radiance of its colours, like that of the poem's images, has an expressive function. (p. 8)

16. Because Millais's painting belongs to the Royal Collection it is rarely exhibited. Inscribed 'JM 1863' it measures 46½ × 61 in. (118.1 × 154.9 cm) and features a limited blue-grey palette which attests to the artist's discovery that 'the light from even a full moon was not strong enough to throw, through a stained glass window, perceptible colour on any object, as Keats had described and supposed in the poem' (John Guille Millais, *The Life and Letters of Sir John Everett Millais*, 2 vols (Methuen, London, 1899); quoted TGC, p. 199).
17. Tom Taylor, quoted in J. G. Millais, I, p. 373. Meanwhile, it was Frank Grant who made the famous allusion to the 'gridiron': 'I cannot bear that woman with the gridiron.' Both these commentators are cited in Malcolm Warner's account of the painting in the TGC, p. 119.
18. See Annette Kuhn, *Women's Pictures*, on 'The look':

> At moments, of course – and this perhaps constitutes an instance of *discours* in classic cinema – the fictional look of a character may effectively co-incide with the look of the spectator. This is what happens in the (optical) point-of-view shot, which marks a further instance of looking in cinema – the look of the camera. (pp. 57–8)

Chapter 7

Guenevere: Emergent Heroines

With this chapter the format I follow elsewhere in the book alters somewhat in that I deal with two literary texts and one painting. The texts in question are William Morris's *The Defence of Guenevere* (first published 1858) and Tennyson's *Guinevere* from *The Idylls of the King* (first published in 1859). The painting is William Morris's study of Jane Morris from 1858 which has been alternatively identified as *Queen Guenevere* and *La Belle Iseult* (see Plate 7). Since sufficient evidence exists for it to be thought of as the former, it has obviously been in my own interest to make that assumption.[1]

Guenevere's story, as it is retold in these two mid-Victorian texts, is in many ways a reworking of the Lady of Shalott's. Like the latter, Guenevere may be regarded as a woman split apart, and punished for, her interpellation by competing and conflicting ideologies. Like Shalott, indeed, her crisis may be seen to derive from the contradictory demands of Romantic Love, on the one hand, and state-legislated Marriage on the other. The precise nature of these discourses is, however, confused and complicated by our two Victorian texts, which flounder amid a medieval cultural paradigm.

The medieval literary conception of Love and Marriage was manifestly not that shared by the nineteenth- and twentieth-century reader. Between Romantic Love and Marriage there hung the quasi-official institution of Courtly Love; the institution which approved extra-marital relations between lords and ladies of a certain social standing and *expected* the likes of Sir Launcelot to swear eternal love and fidelity to his liege-lady, Queen Guenevere.[2] The problem for commentators on this discourse has been knowing exactly where the boundaries were drawn. If Malory, writing of Launcelot and Guenevere in 1483, was forced to confess: 'And whether they were abed or at any other manner of disports, me list not hereof make no mention, *for love that time was not as is nowadays*' (my italics), it is understandable that the likes of Morris and Tennyson should be

uncertain.[3] Malory's own text, indeed, may be read as an exploration of those precarious moral boundaries: what exactly does Queen Guenevere have to do before the Round Table collapses? Is it that her relationship with Launcelot became carnal (non-carnal relationships were clearly never an issue), or simply that *it was seen to be so* (i.e., that her crime, as queen, was in not being professionally discreet)?

It is this moral confusion at the centre of all representations of Guenevere, from Malory onwards, that has made her such a compelling literary heroine. Her name synonymous with adultery, its sin and its excusability, she has become almost as archetypal as the Virgin or as Eve. Guenevere *is* the Adulterous Woman; the woman who dared ask, in Morris's dramatisation: 'for a little word, / Scarce ever meant at all, must I now prove / Stone cold forever?'.[4]

Amid these moral land-mines, in the perilous no-woman's-land which stretches between duty-to-thine-husband and duty-to-thine-own-heart, our two Victorian texts provide excellent critical sport. Both demonstrate the nineteenth-century conscience at work with its scruples, involuntarily bringing to light complications *vis-à-vis* love, gender and the relationship between the sexes, that were better kept hidden. For the purposes of the theoretical subplot we have been pursuing in these readings, moreover, the two poems can be seen to represent the limits of what the twentieth-century feminist can and cannot do with a nineteenth-century male-produced text. For Morris's *Defence of Guenevere* opens up as many doors as Tennyson's *Guinevere* closes. Together they demonstrate that the success of a feminist intervention depends both upon discovering the appropriate reading strategy and also on the text itself. All texts, as we know, are *liable* to feminist readings; some are simply more enabling than others.

Before embarking on a comparative analysis of how our two texts approach their slippery subject, however, it is first necessary that I offer a brief resumé of the story as it is told in their source text, Malory's *Morte d'Arthur* (Books XVIII–XX). The events which lead to the final collapse of the Round Table begin when Launcelot returns from his quest for the Holy Grail and resumes his relationship with the Queen. During this period he is called upon twice to defend the Queen: first, in a joust to prove the Queen's honour when she is accused of attempting to poison Sir Gawaine; next, to rescue her from Mellyagraunce who has abducted her. Although Mellyagraunce's subsequent attempt to compromise the lovers and impute adultery fails, in Book XX Mordred and Agravain publicise the affair and the Court is divided in its defence/condemnation of the Queen. Shortly

after this, Launcelot is ambushed visiting Guenevere in her bed-chamber; although he flees, the Queen refuses to go with him, and she is subsequently brought to judgement. It is clearly at this point that Morris's (imaginary) *Defence* is inserted into the story. Throughout the trial Guenevere's honour is defended by Sir Gawaine ('For I dare say . . . my lady, your Queen, is to you both good and true' (Malory, p. 469), but to no avail. She is ordered to be burnt at the stake and is rescued only at the last moment by Sir Launcelot, who carries her off to his castle, *Joyous Gard*:[5]

> Then was there but spurring and plucking up of horses, and right so they came to the fire. And who that stood against them, there were they slain; there might none withstand Sir Launcelot, so all that bare arms and withstood them, there were they slain, full many a noble knight. . . . Then when Sir Launcelot had thus done, and slain and put to flight all that would withstand him, then he rode straight unto Dame Guenever, and made a kirtle and gown to be cast upon her, and made her to be set behind him, and prayed her to be of good cheer. (Malory, pp. 471–2).

Some time after her rescue by Launcelot, the Pope decrees that Guenevere should return to King Arthur, which Launcelot eventually persuades her to do. By this time, however, the Round Table is irrevocably split and the country riven by war. When Launcelot returns to his estates in France, Arthur and Gawaine declare war on him and follow him across the Channel. Bloody battles ensue in which Gawaine is, at last, fatally wounded by Launcelot. Meanwhile, in England, Mordred has usurped the throne and abducted the Queen. Imprisoned in the Tower of London, she later escapes and goes to the convent at Amesbury, where Tennyson's narrative is set. On Arthur's return to England, he and Mordred inflict fatal wounds upon one another in a terrible duel and, upon hearing of the King's death, Guenevere takes her vows and becomes a nun. When Launcelot later visits her at Amesbury, she dismisses him: 'For as well as I have loved thee, mine heart will not serve me to see thee, for through thee and me is the flower of kings and knights destroyed' (p. 523). Guenevere dies twelve months later and Launcelot, who goes into extreme mourning, refusing to eat or drink, quickly follows her.

It will be seen, therefore, that both Morris and Tennyson depart from their source to tell their own stories about Guenevere. Both invent scenarios in which the crises surrounding the end of the Round Table may be articulated. In Morris's case, it is to have Guenevere speak her own, final 'defence' in the moments before she is tied to the stake; in Tennyson's, it is to have Arthur pay a last visit to the Queen in the convent at Amesbury. Neither of these events occur in Malory

or any other of the source texts, but the points at which they are inserted in the narrative signify much.[6] Both Morris and Tennyson pluck Guenevere from the impersonal chaos that blows a dust storm over the ending of Malory's text and place her somewhere by herself, with her back against the wall. Both texts demand Guenevere's version of events; it is *her* story that they are interested in.

In common with any defendant taken to a court of law on a charge of adultery, Guenevere is questioned both about her relationship with her husband, and about her relationship with her alleged lover. In Morris's text, this interrogation literally replicates that of the courts: Guenevere is on trial, in the dock, and must speak her own defence. On this point it is important to note that we do not know *to whom* she is defending herself. Her audience is addressed simply as 'O knights and lords' (line 11), but who was included in this gathering of the court (and whether or not it included King Arthur himself) is unclear. In Tennyson's text, in contrast, Guenevere's statement is made in private; her auditors are first the 'prattling' novice, and then the King. Morris's context, then, is the public gallery in which the heroine is expected to prove her innocence; Tennyson's, a private confessional in which she is expected to admit her guilt. The stakes, we see, are loaded right from the start.

Although in a court of law Guenevere would undoubtedly have been expected to begin her defence with a statement of her relations with her husband, it is better for the purposes of my discussion here, to begin with Launcelot whom I posit as a defendant of the 'alternative Ideology' (see Introduction, p. 8, for a discussion of this terminology). In opposition to the dominant ideology which sanctions Marriage and the Family, Launcelot represents the complex hybridisation of Romantic and Courtly Love.

In Morris's text, the Queen, speaking her own defence, describes her falling in love with Launcelot as both natural and inevitable; a causality reflected in her choice of images which likens her transformation to the irrevocable passage of the seasons:

> She stood, and seemed to think, and wrung her hair,
> Spoke out at last with no more trace of shame,
> With passionate twisting of her body there:
>
> It chanced upon a day that Launcelot came
> To dwell at Arthur's court: at Christmas-time
> This happened; when the heralds sung his name,
>
> '"Son of King Ban of Benwick", seemed to chime
> Along with all the bells that rang that day,
> O'er the white roofs, with little change of rhyme.

Christmas and whitened winter passed away,
And over me the April sunshine came,
Made very awful with black hail-clouds, yea

And in the summer I grew white with flame,
And bowed my head down – Autumn, and the sick
Sure knowledge things would never be the same,

However often Spring might be most thick
Of blossoms and buds, smote on me, and I grew
Careless of most things, let the clock, tick, tick

To my unhappy pulse, that beat right through
My eager body;' (p. 168)

In as much as it was a love that fell upon her gratuitously and without
choice, Guenevere, then, was innocent. Her defence is that she *did
not intend* to fall in love with Launcelot; that it 'just happened'. In the
mid-Victorian period in which this text was produced, 'love at first
sight' was a discourse that was gaining popularity. Although undoubt-
edly a dangerous proclivity for the middle and upper classes with
property to consider, romantic love of the type that simply leaps out
and knocks you down, was becoming, in every way, a popular fiction.
One might compare, indeed, Guenevere's lightning strike – 'And over
me the April sunshine came' – with Will Ladislaw's first fateful
glimpse of Dorothea in George Eliot's *Middlemarch*.[7] Both, in an
instant, are stricken forever. Both, too, have chanced upon a truth of
feeling which is outside the truth of the law. So integral, indeed, is
this element of involuntariness to Guenevere's argument that she
returns to it again and again. A few lines after the section previously
quoted, she produces another set of images to describe her helplessness
in the face of love:

So day by day it grew, as if one should

Slip slowly down some path worn smooth and even,
Down to a cool sea on a summer day;
Yet still in slipping was there some small leaven

Of stretched hands catching small stones by the way,
Until one surely reached the sea at last,
And felt strange new joy as the worn head lay

Back, with the hair like sea-weed; yea all past
Sweat of the forehead, dryness of the lips,
Washed utterly out by the dear waves o'ercast

In the lone sea, far off from any ships! (p.169)

Guenevere thus slips down to the cool sea, and keeps on slipping. It
is a suggestive image and an appropriate metaphor; because, as

previous commentators have noted, everything about Morris's Guenevere is slippery.[8] Cast off from 'dry land' (Marriage, King Arthur's Court) and its appropriate behaviour, Guenevere, floating on a 'lone sea' without maps or compass, understandably has great problems in 'telling the truth'. The world seen from the ocean is a very different one from that seen from the land, and Guenevere's language everywhere betrays her confusion and bewilderment. The narrative that Ellen W. Sternberg has described as 'mannered, strained, even self-consciously disjointed' is so for good reason.[9] Guenevere, like the heroine of Margaret Atwood's *Surfacing* is, indeed, 'seeing poorly, translating badly'.[10] In the middle of her supposed defence we find her lapsing into angry rhetorical questions: 'What', she asks, 'was I *supposed* to do?'

In her helplessness and bewilderment, then, Morris's Guenevere inscribes herself as a true 'victim of love'. That this love is 'Romantic' and not 'Courtly' is evinced by the fact that she *is* a victim. In the court etiquette of the medieval texts, it will be remembered, it is the knights and not the ladies who are victims; Malory's Guenevere is entirely the mistress of her actions, and her love for Launcelot is related directly to the services he renders her. At every stage in their relationship he must win her love; she merely accepts it. Not so Morris's Guenevere: she may not suffer guilt like Tennyson's Queen, but love does make her suffer. Like many a Romantic heroine before and after she describes Launcelot's departure from her in the most physical of terms:

> Launcelot went away, then could I tell
>
> Like wisest man how all things would be, moan,
> And roll and hurt myself, and long to die,
> And yet fear much to die for what was sown. (pp. 167–8)

Evidence of her suffering is thus brandished (Sternberg would say physically 'flaunted') by Morris's Queen as evidence of her innocence.[11] She presents her love for Launcelot as a wound which was inflicted upon her involuntarily and for which she has suffered. If I am a victim, she asks, how can I be guilty?

Such reasoning is never a possibility for Tennyson's Queen.[12] For her, her passion for Launcelot is a sign not of her innocence but of her shame. Recalling, as Morris's Guenevere does, the moment she first felt love for Lancelot, she 'grew half-guilty in her thoughts again'. Her love, from the moment of its inception, was her responsibility; was an act of personal betrayal:

And even in saying this,
Her memory from old habit of the mind
Went slipping back upon the golden days
In which she saw him first, when Lancelot came,
Reputed the best knight and goodliest man,
Ambassador, to lead her to his lord
Arthur, and led her forth, and far ahead
Of his and her retine moving, they,
Rapt in sweet talk or lively, all on love
And sport and tilts and pleasure, (for the time
Was maytime, and as yet no sin was dreamed,)
Rode under groves that look'd a paradise
Of blossom . . .
But when the Queen immersed in such a trance,
And moving through the past unconsciously,
Came to that point where first she saw the King
Ride toward her from the city, sighed to find
Her journey done, glanced at him, thought him cold,
High, self-contained, and passionless, not like him,
'Not like my Lancelot' – while she brooded thus
And grew half guilty in her thoughts again . . . (pp. 539–40)

The fatal consequence of this first treacherous act is dramatically underlined in Tennyson's poem by the fact that its remembrance gives rise to the person of Arthur himself, who arrives at Amesbury as a terrifying materialisation of Guinevere's guilt:

. . . while she brooded thus
And grew half-guilty in her thoughts again,
There rode an armèd warrior to the doors.
A murmuring whisper through the nunnery ran,
Then on a sudden a cry, 'The King.' She sat
Stiff-stricken, listening; but when armèd feet
Thro' the long gallery from the outer doors
Rang coming, prone from off her feet she fell,
And grovelled with her face against the floor:
There with her milk-white arms and shadowy hair
She made her face a darkness from the King:
And in the darkness heard his armèd feet
Pause by her; then came silence, then a voice,
Monotonous and hollow like a Ghost's
Denouncing judgement, but tho' changed, the
King's . . . (pp. 540–1)

In Tennyson's text, indeed, Romantic Love is never allowed an autonomous existence; never allowed ideological status – 'alternative' or otherwise. Even syntactically, Love (meaning love for Launcelot) and Guilt are bound together in the same sentence. Silenced by the judicious shadow of Arthur's heavy hand, the circumstances that gave rise to Guinevere's affair are never voiced. The cultural apparatuses

which condoned Romantic Love and Courtly Love might never have existed. Love outside sanctioned Marriage is, and always has been, illicit: a condition not to be wondered at but pitied:

> And all this throve before I wedded thee,
> Believing, 'lo mine helpmate, one to feel
> My purpose and rejoicing in my joy.'
> Then came thy shameful sin with Lancelot;
> Then came the sin of Tristram and Isolt;
> Then others, following these my mightiest knights,
> And drawing foul ensample from fair names,
> Sinned also, till the loathsome opposite
> Of all my heart had destined did obtain,
> And all through thee! (p. 542)

From this initial intervention in the texts, it should already be becoming clear why the one enables and the other frustrates feminist appropriation. Morris's text, through Guenevere's passionate defence, establishes Romantic Love as an ideological possibility; the Queen is 'hailed' by forces which tell her that love for another person is honourable and true, even if it is not legitimate.[13] That she believes such forces to be instinctive and voluntary when they are, in fact, ideologically inscribed, does not matter. What matters is simply that they are allowed to exist, to conflict with the other ideologies informing her behaviour, and thus expose her oppression.

Guenevere's attitude to Marriage, as inscribed by the state apparatuses of Law and Church, is openly critical. Preliminary to the rhetorical question quoted at the beginning of this reading, she makes it plain that her marriage to Arthur was purely one of 'convenience' in which *she* was the merchandise:

> While I was dizzied thus, old thoughts would crowd,
>
> Belonging to the time ere I was bought
> By Arthur's great name and his little love,
> Must I give up forever then, I thought,
>
> That which I deemed would ever round me move
> Glorifying all things; for a little word,
> Scarce ever meant at all, must I now prove
>
> Stone cold forever? Pray you does the Lord
> Will that all folks should be quite happy and good? (p. 169)

It is important to remember that the moral contest between marriage for love and marriage for social status was reaching its crisis in the mid-Victorian period, and the novel played a significant role in circulating the changes taking place in public opinion. In terms of the contemporary socio-literary context, Guenevere's disclosure of the impossible

position she found herself in, torn between one man she truly loved and another she was legally committed to, was no more or less controversial than that admitted by Grace Melbury (Thomas Hardy, *The Woodlanders*) or Lady Percival Glyde (Wilkie Collins, *The Woman in White*). As a female character bound by two contradictory discourses, she was topically enacting a recognised nineteenth-century social problem.[14]

For most commentators, however, it seems to have been difficult to believe that Morris's Guenevere 'merely' did anything. If Guenevere really wanted to expose the injustice/corruption of loveless marriage, then why did she have to lie? Why deny, as in her oft-repeated refrain, that there was ever anything between herself and Launcelot?

> Nevertheless you, O Sir Gawaine, lie,
> Whatever may have happen'd these long years,
> God knows I speak truth, saying that you lie! (p. 174)

Frederick Kirchhoff reads these apparent capitulations as indecisiveness on Morris's part:

> This ambiguity can be blamed on Morris. His Guenevere is confusing because he was unable to sort out his conflicting attitudes towards her. Attracted by her egotistical vitality, he nevertheless cannot wholly absolve her guilt. But the confusions of the poem also mirror the unresolved complexities of Guenevere herself. She, like Morris, is not sure whether to be proud or ashamed, to ask for sympathy or to give defiance. (p. 411)

Unable to find any *reason* for Guenevere's indeterminacy, Kirchhoff can only assume that she and her literary creator were 'confused' and reads this as a sign of the text's aesthetic failure. Ellen Sternberg discloses much more by proposing that the Queen's oscillations signal not confusion but consummate 'craftsmanship': Morris's Guenevere is a self-conscious actress and brilliant rhetorician who stuns her spellbound audience with her verbal artistry:

> Guenevere does oscillate between logic and illogic, but she also succeeds in keeping her audience off-balance, precisely by putting forth her puzzling and contradictory statements. It is her style, not her substance, that is seductive; it is her rhetoric, not her logic, that illustrates her consummate craftsmanship. (p. 49)

This portrait of Guenevere as a slippery wordsmith is an attractive possibility for the feminist reader and I shall not dispute it. The imputation, however, that in her manipulations Guenevere is, on occasion, 'economical with the truth', needs, I think, to be cast differently. On the issue of Guenevere's honesty, Sternberg states elsewhere in the same article that 'while some of Guenevere's

arguments are merely capricious or disingenuous others are forensically hollow' (p. 47). Such an indictment fails to allow that a woman capable of rhetoric might also be capable of irony. The ambiguous refrain, for example, quoted earlier, has been read by some critics as an outright denial of guilt, by others as a veiled admission of that guilt, and by others again as an admission of adultery, but a denial of other imputed crimes.[15] The point here, surely, is that without knowing exactly with what Guenevere has been charged, it is impossible to interpret her reply in any way at all. Within the textual context in which it is read, the refrain is wholly rhetorical. Attached to an allegation inscribed somewhere *outside* the text it merely symbolises the ideological 'Catch-22' in which Guenevere is held. For, according to the two contending discourses we have disclosed here, she will have sinned *either way*. To deny her love for Launcelot was, according to the demands of Romantic Love, as much a sin as betraying her husband would be according to the laws of Marriage. With the official discourse thus undermined, upturned and effectively blasted apart, *anything* Gawaine accused Guenevere of, or defended her from, would, of course, be 'a lie'. When a ruling ideology hits an alternative, or oppositional ideology, the superstructure cracks open and 'truth' is drowned.[16] Sometimes a new ideology emerges as a result.

For Tennyson's Guinevere, alas, the world never has a chance to split open. Romantic Love is not in opposition to Married Love; it is completely subsumed by it. Thus Guinevere, berated into an acknowledgement that her transgression has caused the downfall of the Round Table, is compelled to penitentially eulogise the husband she has lost:

> Ah great and gentle lord,
> Who wast, as is the conscience of a saint
> Among his warring senses, to thy knights –
> To whom my false voluptuous pride, that took
> Full easily all impressions from below,
> Would not look up, or half-despised the height
> To which I would not or I could not climb –
> I thought I could not breathe in that fine air
> That pure severity of perfect light –
> I yearned for warmth and colour which I found
> In Lancelot – now I see what thou art,
> Thou art the highest and most human too,
> Not Lancelot, not another. (p. 546)

Launcelot who is (let us not forget) the cause of her infidelity becomes, at last, but a 'polluting shadow'; an infatuation who temporarily (but fatefully) deflected Guinevere from the 'pure light' of her husband's love. Launcelot, at the end of Tennyson's text, exists

only as a chain of negatives: he is 'not Lancelot', which means he is 'not Arthur'. The love by which the Queen was seduced is ultimately proven to have been no love at all.

On this point I will conclude my reading of the literary texts by observing that while it is Morris's Guenevere who has consistently been accused of 'illogic' (Sternberg writes that she has 'no consistent line of argument'; that her speech is a 'disjointed harangue, weak both in substance and structure', p. 48), it is actually Tennyson who betrays the most serious confusion by forgetting *how* and *why* she succumbed to adultery. Brainwashed as to the imputed grossness of her error and its historic consequence ('Well is it that no child is born of thee / The children that are born of thee are sword and fire / red ruin, and the breaking up of laws', lines 421–3), Launcelot is remembered only as a fleeting 'warmth and colour'. Arthur and the combined weight of the Ideological State Apparatuses have done their job effectively: Guinevere can find no *reason* for what she has done.

In a text of such totalitarian didacticism (readers not familiar with the text should also refer to Arthur's rallying cry to husbands whose wives have gone astray, lines 508–52), there is thus very little opportunity for the feminist to intervene. At the point, indeed, where a text becomes political propoganda 'deconstructive' readings become unprofitable and unwise. There are few gaps and inconsistencies, alas, via which the problematic of Guinevere's case may be examined. Unlike the case of the Lady of Shalott, this is a trial at which the plaintiff is allowed no questions.

It is perhaps something to their credit that no Pre-Raphaelite artist ever attempted to illustrate Tennyson's *Guinevere*. Despite their evident penchant for passivity, sickness and dementia, the humiliation Guinevere suffers as she grovels at Arthur's feet – though graphic, has elicited no visual response of which I am aware. Women debased thus far evidently disjoined remorse from sexuality. Morris's *Queen Guenevere* grovels to no-one (see Plate 7). The full-length study of Jane Morris (the only oil-painting by Morris known to have survived) depicts a woman tall, proud and inscrutable, who is mistress of her private space (a richly furnished bed-chamber) even if her kingdom is in demise. To what extent this is, indeed, a painting about Guenevere will depend upon how much external narrative we bring to bear upon it. Its literary contextualisation is certainly more tenuous than in any of the other paintings considered in these essays, and those who have claimed it to be, first and foremost, a portrait of Jane Burden, must be allowed their point (see note 1, below). Whatever its precise textual

associations, however, Morris's painting is certainly given a full historical contextualisation. In anticipation of his career in design and furnishings, the details of Guenevere's room are minutely observed.[17] Much of the picture's visual pleasure, indeed, derives from the luxurious clash of patterned fabrics: the embroidered cloth which covers the dressing table as it meets the richly woven carpet; the pink and whites of Guenevere's heavy brocade dress offset against the deep-blue wall hangings, yet complementing the patterns which decorate the curtains on her bed. Although here the draperies, carpets, the heavy wooden furniture and brass jug (bottom right-hand corner) perform an essentially decorative function, they concur to give a special historical (i.e., medieval) specificity to Morris's interior that is lacking in the work of most of his contemporaries. A significant comparison can be drawn, for example, between this room and the one which Burne-Jones's Venus inhabits in the painting discussed in the next chapter.

Morris's Guenevere, then, is mistress not only of a domestic space but also an historical one. Her appearance of command and authority derive both from the signifiers which tell us that this *is* Queen Guenevere (i.e., the title inscribed upon the frame, the golden crown she wears on her head), and from her actions. For this woman, if we consider, exhibits a quality rare among Pre-Raphaelite female subjects. Although her attention is directed merely to the apparently trivial action of fastening her belt, she is nevertheless *in control* of what she does. If the reader quickly looks back through the other plates she will see that, in this, Guenevere is depressingly exceptional. Crouched in corners, floating down rivers, or in the painful process of being 'visibly rapt towards heaven', the Pre-Raphaelite woman is usually seated, invariably inactive. The gestures of the only other standing figures considered in this book, Millais's *Mariana* and Holman Hunt's *The Lady of Shalott*, merely give expression to their demise. Passivity, ranging from boredom to sheer frustrated helplessness, is the order of the day. In fastening her belt, in looking in the mirror (placed on the dressing-table) Morris's Guenevere demonstrates none of these neuroses. As Deborah Cherry has written of Elizabeth Siddal's drawing of 'The Lady of Shalott', this is a woman depicted 'at the moment of *her* look'; she is not simply a passive victim of the male gaze.[18]

If we then move from the fact that Guenevere is fastening her belt, to the question of *why* she is fastening it, we may start supposing that she is also in control of other things. Reading the portrait as 'Queen

Guenevere' our attention is inevitably drawn to the bed, the crumpled linen, and the accusations of adultery. Once pointed in this direction we may also, for the first time, experience the overwhelming eroticism of Guenevere's chamber. The gorgeous fabrics which drape furniture and bed are luxuriant not only in their patterns but also in their textures. The fine, ivory-coloured linen which covers the bed is not only crumpled but still warm (notice the small dog that lies curled up in its midst), and the softness of this and the other fabrics are evoked in subtle contrast to the other objects that litter the room: the waxy skin of the oranges, the crisp vellum of the prayer book, the sharp coldness of the brass-jug. Alerted to its sensual specificities, Guenevere's room becomes not only a domestic and historical space, but also a sexual one. To fasten one's belt in these circumstances means that one is in control of more than one's wardrobe arrangements. This woman, whatever her feelings for the lover who has just left her bed (and here we presume that it was Launcelot) is clearly not assuming the role of passive victim. Her gestures, as she looks in the mirror and fastens her belt, indicate that she is *taking possession of herself*; that she is assuming responsibility for what she has done. Such emphasis on so slight an action may appear pedantic, but if we are attempting to read the text as a representation of the Guenevere who speaks Morris's *Defence*, it is essentially all we have; all the evidence we have to propose that, in the painting as well as in the poem, Morris produced a female subject *with the potential* for heroism. For there is nothing in Guenevere's face, in her expression, that can be read as confusion, or defiance, or irony or any of the things we brought to the printed page. Her painted face, despite the imaginative attempts of students to guess otherwise, is essentially a mask; we may suggest its sentiments, but we cannot prove them.[19] In her look, however, and in the fastening of her belt, we can, if we wish, invest this Queen with the same defiance as her literary counterpart. We can hear her, as she looks into the mirror and sees reflected the impossibility of her situation, saying, 'Nevertheless you, O Sir Gawaine, lie.'

From the stumbling rhetoric of Morris's poem, then, and from a single gesture of his painting, the twentieth-century feminist is able to re-create, for herself, a satisfactory Pre-Raphaelite heroine. Amidst the gaps and silences we, like Guenevere, are allowed to answer our own rhetorical questions; to fasten our own belts. It is, alas, a rare opportunity.

Notes

1. John Christian in the TGC accounts for the mixed attribution of this painting thus:

 > The records speak of three oil paintings that Morris worked on, and they have often been confused. In addition to no. 94 [*Guenevere*] there were two stories inspired by the story of Tristram and Iseult. . . . He chose another incident from it for his contribution to the famous murals illustrating Malory's *Morte D'Arthur* that Rossetti and his followers painted in the Oxford Union in 1857; and in fact no. 94 has sometimes been called 'La Belle Iseult', thereby adding to the confusion between Morris's easel paintings. All the earlier records, however, refer to the subject as 'Guenevere', King Arthur's Queen whose adultery is one of the central themes of the *Morte d'Arthur*. (p. 169)

 Christian adds: 'In a sense the title of the picture is unimportant since it is essentially a portrait in medieval dress of Jane Burden, whom Morris married in 1859' (p. 170). I have already noted, however, the problems of regarding *any* of the Pre-Raphaelite studies of women as 'portraits' (see Griselda Pollock's observation quoted in Chapter 2, p. 52, and also Lewis Johnson's chapter, 'Pre-Raphaelitism, personification, portraiture', in Marcia Pointon (ed.), *Pre-Raphaelites Re-viewed* (Manchester University Press, Manchester, 1989)).

2. 'Courtly Love' is defined by M. H. Abrahms (*A Glossary of Literary Terms*, (Holt, Rinehart and Winston, New York, 1971) thus:

 > A philosophy of love, including an elaborate code governing the relations of aristocratic lovers, which was widely represented in the lyric poems and *chivalric romances* of western Europe during the Middle Ages. The development of the convention of courtly love is usually attributed to the troubadours (poets of Provence, in Southern France), in the period from the latter eleventh century through the twelfth century. Love is regarded as the noblest passion this side of heaven. The courtly lover idealizes his beloved, and subjects himself entirely to her every whim. (This love is usually that of a bachelor knight for another man's wife, as in the stories of Tristram and Isolde or of Launcelot and Guinevere; it must be remembered that marriage among the medieval upper classes was usually a kind of business contract, for utilitarian and political purposes.) The lover suffers agonies and sickness of body and spirit at the caprices of his imperious sweetheart, but remains devoted to her, and manifests his honour by his unswerving fidelity and his adherence to a vigorous code of behaviour, both in knightly battles and in the complex ceremonies of courtly speech and conduct. (pp. 34–5)

 It is important to remember that 'courtly love' was primarily a literary convention; to what extent it was a fact of actual medieval society has been much disputed. For contending views on the nature of Courtly Love see C. S. Lewis, *The Allegory of Love* (Oxford University Press, Oxford, 1936), and Peter Dronke, *Medieval Latin and the Rise of the European Love Lyric*, 2 vols (Clarendon, Oxford, 1965).

3. See Sir Thomas Malory, *Le Morte D'Arthur*, vol. 2 (Penguin, Harmondsworth, 1969), p. 460. Subsequent references to this edition will be given after quotations in the text.

4. 'The Defence of Guenevere', reproduced with notes in N. P. Messenger and J. R.

Watson (eds), *Victorian Poetry: City of the dreadful night and other poems*, (Dent, London, 1974), p. 169. Further page references will be given after quotations in the text, and line references to the poem will be supplied in the course of the discussion.

5. 'Joyous Gard' is named after the castle inhabited by the earlier pair of adulterous lovers, Tristram and Iseult.

6. Most of Malory's narrative derives from three French source texts: the prose *Tristram*, the Vulgate Cycle, and the *Roman du Grael*, together with two English works: the alliterative *Morte Arthure* and the stanzaic *Morte Arthur* (see the Introduction to the Penguin edition for further details).

7. See *Middlemarch*, Chapter XIX (1874) (Oxford University Press edition, Oxford, 1988). Eliot describes the lightning strike of first love thus:

> Why was he making any fuss about Mrs Casaubon? And yet he felt as if something had happened to him with regard to her. There are characters which are continually creating collisions and nodes for themselves in dramas which nobody is prepared to act with them. Their susceptibilities will clash against objects that remain innocently quiet. (p. 157)

8. See for example Frederick Kirchhoff, *William Morris* (Twayne, Boston, Mass., 1979) and Ellen W. Sternberg, 'Verbal and visual seduction in "The defence of Guenevere"', *Journal of Pre-Raphaelite Studies*, 6, 2, 1986, 45–52. Further page references to both items are given after quotations in the text. Apropos of this imagery Sternberg writes: 'Embellishing slippery words with sexual overtones, Guenevere paradoxically but most successfully uses the very sensuality of which she has been accused with Launcelot to win over her audience of accusers' (p. 51).

9. Sternberg 'Verbal and visual seduction', (p. 50):

> Though her narrative may seem at times mannered, strained, even self-consciously disjointed, it is seductive by its very quality of surprise; her oscillation between sound and silence, humility and pride, logic and illogic, merely adds to Guenevere's intrigue.

10. For discussion of the 'translation problem' suffered by the heroine of *Surfacing*, see my reading of the text in Sara Mills *et al.* (eds), *Feminist Readings/Feminists Reading* (Harvester Wheatsheaf, Hemel Hempstead, 1989). As the nameless heroine of Atwood's novel 'travels back' to the Lacanian 'Imaginary', the dissonances between her own perception of the world and that of her (male) companions, securely 'fixed' in the Symbolic realm, become acute: 'I was seeing poorly, translating badly, a dialect problem, I should have used my own' (Margaret Atwood, *Surfacing* (Virago, London, 1979, p. 70.)

11. See Sternberg ('Verbal and visual seduction', p. 49): 'Guenevere punctuates both her words and her silences with gestures and body movements, always aware of herself as a sensuous being.'

12. Christopher Ricks (ed.), *The Poems of Tennyson*, vol. 3 (Longman, Harlow, 1987). Page references are given after quotations in the text. Readers should also be aware of the variable spelling of 'Guenevere', which is spelt 'Guinevere' in Tennyson's text.

13. 'Hailing' is the concept used by Althusser to describe the way in which individuals are 'recruited' by ideology (see the discussion in the Introduction, pp. 6–7).

14. See Thomas Hardy, *The Woodlanders* (1887) and Wilkie Collins, *The Woman in White* (1860) (also discussed in the notes to Chapter 4).

The publication of Hardy's novel was extremely sensitive politically since it commented directly on the 1867 Divorce Act which gave women limited opportunity for divorce for the first time. As the law stood at this time, however, a man might still divorce his wife for adultery, whereas a woman could divorce her husband only if the adultery were accompanied by cruelty, desertion or 'unnatural offences'.

15. Sternberg summarises some of the interpretations of the refrain in her article. Lawrence Perrine posited that Guenevere *is* guilty of adultery, but not of the specific charge of which she is accused, while John Hollow suggested that she was not denying adultery so much as Gawaine's claim to know God's judgement of her. Sternberg herself favours the latter explanation: 'She [Guenevere] does not deny her adultery, but only Gawaine's right, or ability, to judge her justly' (p. 48).

Messenger and Watson (*Victorian Poetry*, p. 232), meanwhile, propose that Guenevere is in fact saying *exactly the opposite* of what she appears to be, since her statement, 'You, O Sir Gawaine, lie' must be read as direct contradiction of Gawaine's testimony in the *Morte D'Arthur*:

> Then spake Sir Gawaine, and said, 'My lord Arthur, I would counsel you not to be over-hasty, but that ye would put in respite, this judgement of my lady the queen, for many causes. . . . For I dare say,' said Sir Gawain, 'my lady, your queen, is to you both good and true'. (p. 469)

According to this twist, Guenevere's defence is a 'defiant admission of her love for Launcelot'.

16. See Introduction, page 8, for discussion of the theoretical assumptions implicit here.

17. For an account of William Morris's career as artist, writer, designer and politician see J. W. Mackaill, *The Life of William Morris* (Longmans, Green, London, 1920); E. P. Thompson, *William Morris: Romantic to revolutionary* (Lawrence and Wishart, London, 1955); and Ray Watkinson, *Pre-Raphaelite Art and Design* (Studio Vista, London, 1970).

Morris's career as a designer began in 1861 when the original 'Morris, Marshall, Faulkner & Co.' was launched. In 1875 the firm (which had expanded phenomenally in the previous decade) was reformed as 'Morris & Co.' with Morris as the principal share-holder. In the early twentieth century Morris's designs for wallpapers and furnishings were bought up by Sandersons, and they continue to be sold extensively throughout the world.

18. Deborah Cherry (TGC, p. 266): 'The Lady of Shalott is represented at the moment of *her* look. She is not offered as a spectacle for the masculine gaze, nor does she attain visibility within its relays of power.'

19. It has been suggested that the face of Morris's Guenevere was actually painted by D. G. Rossetti or Ford Madox Brown. See John Christian (TGC, p. 170): 'Whether Rossetti or Brown in fact worked on the picture it is impossible to say.'

Chapter 8

Venus: Pyrrhic Victory

It was with some disappointment that I found myself ending this book with a reading that constitutes what I have described as a 'pyrrhic victory'. Following immediately on from the radical possibilities offered by Morris's representations of Guenevere, this intervention into two *fin-de-siècle* texts by Swinburne and Burne-Jones presents new and depressing obstacles to the reader wishing to recruit more texts 'on behalf of feminism'.

It is disappointing precisely because the magnificent *femmes fatales* which throng the late canvases of the Pre-Raphaelite group, and which trouble Swinburne's poems, promise so much. We feel that surely here, at last, are representations of women so radically over-determined that they must, of necessity, undermine the discourses out of which they were produced; must escape the 'intentions' of the men who produced them. Our first encounter with Burne-Jones's huge, glowing, gold-embossed painting certainly promotes such expectation (see Plate 8); anyone searching for a proto-feminist Pre-Raphaelite heroine might certainly feel she had found her in this spectacular representation of Venus. The power implicit in this giant female form is, indeed, unrivalled in Pre-Raphaelite art, with the possible exception of Rossetti's *Astarte Syriaca* which has been discussed in terms of similar potency by Griselda Pollock (see Introduction).[1]

The problem, as this reading will subsequently reveal, is, again, one of politics. The ideological complexities which allowed the feminist reader to produce such a positive reading of Morris's texts are here constrained by discourses I felt it was impossible to silence. In the same way that I found myself unable to ignore the fact that Keats's *Eve of St. Agnes* included what, at the very least, was a 'potential' rape, so here did I find it impossible to escape the fact that the *femme fatale*'s power is habitually circumscribed by death. No matter how much *fear* such representations might reveal in the men who created them (this is Pollock's argument *vis-à-vis Astarte Syriaca*), they are also graphic

indexes of the misogyny which has its ultimate expression in murder. Although as feminists we may, indeed, appropriate such represen-tations and inscribe them in discourses of our own, we do so at the risk of making invisible the sinister narrative to which they belong. Thus while there are texts in which the originating discourses may be productively discarded, I would argue that there are others in which they are simply too dangerous to ignore.

Such reasoning is, admittedly, at odds with much of the critical practice undertaken in this book, but I feel its 'common-sense' awkwardness to be one of the salutary conclusions of the project as a whole. Despite the fact that, as feminists, we *ought* (theoretically) to make all texts work for us, we repeatedly find we cannot. This is one of the issues I will return to in more detail in the Conclusion.

To support my hypothesis *vis-à-vis* the politics of power/death in representations of the Pre-Raphaelite *femme fatale*, I open my discus-sion of Swinburne's *Laus Veneris* with an extract from another poem by the same author. This is a grim tale of lesbian passion spoken by Sappho to her lover, Anactoria. Although the sexual politics of the relationship are necessarily different from those existing between a *femme fatale* and her male lover, the text is typical of Swinburne's rhetoric of annihilation:

> I would my love could kill thee; I am satiated
> With seeing thee live, and fain would have thee dead.
> I would earth had thy body as fruit to eat,
> And no mouth but some serpent's found thee sweet.
> I would find grievous ways to have thee slain,
> Intense device, and superflux of pain;
> Vex thee with amorous agonies, and shake
> Life at thy lips, and leave it there to ache;
> Strain out thy soul with pangs too soft to kill,
> Intolerable interludes, and infinite ill;
> Relapse and reluctation of the breath,
> Dumb tunes and shuddering semitones of death.[2]

Evidently overwhelmed by the insatiability of her own desire, Sappho, it seems, can find emotional relief only in the prospect of murdering the thing she most loves. Elsewhere in the same poem she defends her sadistic tendencies thus: 'Cruel? but love makes all that love him well / As wise as heaven and crueller than hell' (p. 61). Such behaviour, the text invites us to believe, is simply par for the course. The only satisfactory cure for desire is death.

The protagonist of Swinburne's *Laus Veneris*, the hapless knight lured from his 'manly duties' to the depraved pleasures of Venus's 'horsel' (i.e., her bower), is perhaps comforted by similar pos-

sibilities.[3] In his opening description of Venus he, like Sappho, appears to have a peculiar interest in his lover's neck:

> Asleep or waking is it? for her neck,
> Kissed over close, wears yet a purple speck
> Wherein the pained blood falters and goes out;
> Soft, and stung softly – fairer for a fleck.
>
> But though my lips shut sucking on the place,
> There is no vein at work upon her face;
> Her eyelids are so peaceable, no doubt
> Deep sleep has warmed her blood through all its ways.[4]

This, again, is flesh 'good to bruise or bite' (see *Anactoria*) or, one feels, to wrap one's fingers around and quietly strangle.

At this point I would ask readers to turn briefly to Burne-Jones's painting; Venus's neck, from which she obligingly holds back her long hair, may be seen to be of similar fetishistic interest.[5] Yes, this woman is alive: but for how long?

It is significant that neither the Venus of Burne-Jones's painting nor Swinburne's poem exist as identifiable 'characters'. They are not, like the majority of women we have been considering, literary subjects belonging to a particular narrative. On the contrary, Venus, like the Virgin, who opened these readings, is an archetype, and as an archetype she is without a personal history. No ideologies clash in Venus's heart and soul, because her heart and soul belong exclusively to the men who worship her. She herself, like Rossetti's Beatrice, is but a 'hazy outline'; a bodily manifestation of her master's soul:

> Behold, my Venus, my soul's body, lies
> With my love laid upon her garment-wise,
> Feeling my love in all her limbs and hair
> And shed between her eyelids through her eyes
>
> She holds my heart in her sweet open hands
> Hanging asleep (p. 12)

But before proceeding to consider what festering neuroses inhabit the 'soul' of the text's hero, let us first pause to consider the representation of its 'mirror': Venus herself. In line with the codes of fetishisation, we note that Venus is never seen in her entirety. Instead, her various bewitching parts are itemised and catalogued. Along with the white column of neck cited in the first two stanzas, we are variously shown her mouth ('lovelier than Christ's'), her hands, her 'wonderfully woven hair'. In another section, when the Knight recounts his first arrival at the horsel, she is glimpsed 'Naked, with hair shed over to the knee', but despite this, the sum total of her parts refuses to add up to a physical

entity. Like Burne-Jones's female prototype, Swinburne's Venus is an effectual photo-fit reconstruction of the 'ideal' sexual woman; an artful configuration of all the desirable elements. Her sexuality – that is, her sexual potency – is expressed not through visual description, but through *metaphor*. In common with many of Swinburne's most deadly lovers, Venus's flesh is experienced as fire:

> And I forgot fear and all weary things,
> All ended prayers and perished thanksgivings,
> Feeling her face with all her eager hair
> Cleave to me, clinging as a fire that clings
>
> To the body and to the raiment, burning them;
> As after death I know that such-like flame
> Shall cleave to me forever; yea, what care,
> Albeit I burn then, having felt the same? (p. 26)

Throughout the text, indeed, her touch is described repeatedly as a burn: 'I dare not touch her, lest the kiss / Leave my lips charred'; imagery which invites a suggestive cross-reference to the Venus of Burne-Jones's painting, sheathed as she is in a gown of flame-like red.

Her body thus dismembered, Venus's 'presence' is more readily felt in the rooms she inhabits, where her own burning heat has transferred itself into the suffocating atmosphere of the horsel:

> Inside the horsel here the air is hot;
> Right little peace one hath for it, God wot;
> The scented dusty daylight burns the air,
> And my heart chokes me till I hear it not. (p. 12)

Meanwhile the speaker is repeatedly seen choking for the cool, fresh air of the great outdoors, available to him now only as a lost memory:

> Outside it must be winter among men;
> For at the gold bars of the gates again
> I heard all night and all the hours of it
> The wind's wet wings and fingers drip with rain.
>
> Knights gather, riding sharp for cold;
> I know the ways and woods are strangled with the snow. (p. 14)

So what of this speaker, then? What of the man who has *become* the soul of Venus? His story, as we might expect, is a tragic one. Before being fatefully lured off course, he was a truly *manly* hero. In the section of the poem recounting his honourable past, he describes himself thus:

> For I was of Christ's choosing, I God's knight,
> No blinkard heathen stumbling for scant light;
> I can see well, for the dusty days
> Gone past, the clean great time of goodly fight.

> I smell the breathing battle sharp with blows,
> With shriek of shafts and snapping short of bows;
> The fair pure sword smites out in subtle ways,
> Sounds and long lights are shed between the rows
>
> Of beautiful mailed men. (pp. 18–19)

As a warrior–knight of the highest standing, there is therefore no reason to think that the protagonist of Swinburne's text was in any way temperamentally inclined to the wantonness of Venus's court. Like many a great public figure before and after, his fall proves only the ancient power of the female temptress. His conquest, like that of Adonis and all the other saints 'that were / Slain in the old time' was, at once, inevitable and gratuitous:

> Their blood runs round the roots of time like rain:
> She casts them forth and gathers them again;
> With nerve and bone she weaves and multiplies
> Exceeding pleasure out of extreme pain.
>
> Her little chambers drip with flower-like red,
> Her girdles, and the chaplets of her head,
> Her armlets and her anklets; with her feet
> She tramples all that winepress of the dead.
>
> Her gateways smoke with fume of flowers and fires,
> With loves burnt out and unassuaged desires;
> Between her lips the stream of them is sweet,
> The languor in her arms of many lyres. (p. 15)

Although evoked as a mistress of death, however ('with her feet / She tramples all that winepress of the dead'), the more immediate threat Venus presents to her victims undoubtedly concerns their masculinity. In the stultifying languor of the horsel, the hero of 'the battle sharp' is reduced to wanton sensuality. Shut up for ten years in the company of women, his own gender identity is evidently under threat. Hence, when he describes Venus as 'my soul's beauty' he does so with good reason: the day she becomes his mirror, he ceases to be a 'real man'. Recalling his fateful arrival at the horsel he laments:

> I knew the beauty of her, *what she was,*
> The beauty of her body and her sin,
> And in my flesh the sin of hers, alas! (p. 22)
> [my italics]

The knight's act of recognition, in fact, presupposes his own feminisation. The erstwhile manly hero is brought face to face with his own desire in the form of a woman. The final section of Swinburne's poem, indeed, shows the knight, newly returned from his audience with the Pope in Rome, fatefully surrendering himself to this androgynous

destiny. Venus and he melt into a single flesh from which he no longer attempts to extricate himself:

> For till the thunder in the trumpet be,
> Soul may divide from body, but not we
> One from another; I hold thee with my hand,
> I let mine eyes have all their will of thee,
>
> I seal myself upon me with my might,
> Abiding alway out of all men's sight
> Until God loosen over sea and land
> The thunder of the trumpets of the night. (p. 26)

In this conclusion, however, as in the poem's beginning, there sounds the warning that this is not the end of the matter. Venus may have triumphed temporarily, concealing her victim 'out of all *men's* sight' (my italics), but God, the Heavenly Father who reigns over all (and who is interlocutor to long sections of the poem), waits in the wings to direct the revenge. 'Over sea and land' the armies of God and men are gathering, and the swords of patriarchy hover at Venus's throat.

This throat, as we have already observed, is a highly prominent aspect of Venus's anatomy in Burne-Jones's painting (see Plate 8).[6] Although long, swan-like necks became part of the standard Pre-Raphaelite iconography from the 1860s onwards, Burne-Jones's Venus is endowed to an unprecedented degree.[7] Merely compare it to the necks of her four companions, indeed, and the difference is established: Venus's head rests on a trunk at least twelve inches long. It is true, of course, that every other limb of her extraordinary body is likewise mannered. Her upper thighs and out-stretched legs extend into what is virtually half the total picture space; her hands, from wrist to finger-tip, are almost half a chair-seat in length. Should she stand, only her lower legs would be visible within the frame. What we are looking at, indeed, is a veritable giant; Burne-Jones's Venus is most certainly one of the largest Pre-Raphaelite women on canvas.

It is not only her size, however, that threatens. The 'masculine quality' which has caused all Burne-Jones's women to be labelled androgynous, is here manifest to a new degree. Venus's body may be long and languid, but it is also hard and muscular. Beneath the semi-transparency of her gown, the sharp leanness of her outline is revealed. Against this muscularity, her breasts are virtually insignificant. The things which signal Venus to be a woman are the trappings; her glowing dress, her flowing hair. As with the particulars of her anatomy, the gendered difference of Venus's body is further emphasised by her juxtaposition to the other female subjects. Their manner of

dress, as well as their more decorous poses, contribute to the illusion that they are, underneath, softer and more feminine. Their faces (which virtually clone one another) are paler and more delicate; although still characteristically prominent, the jaw-line has been softened.

These 'differences' did not go unobserved among Burne-Jones's contemporaries who registered them with some distaste. In his review of 1878 Henry James wrote:

> She has the face and aspect of a person who has what the French call an 'intimate acquaintance' with life; her companions, on the other hand, though pale, sickly, and wan, in the manner of all Burne-Jones's young people, have a more innocent and vacant expression, and seem to have derived their languor chiefly from contact and sympathy.[8]

Frederick Wedmore went one step further by implying that the 'sexual familiarity' registered by Venus's body also suggested perversity. He described the figure as 'stricken with disease of the soul' and concluded: 'The very body is unpleasant and uncomely, and the soul behind it . . . ghastly.'[9] Although unvoiced, the suspicion behind all such reviews is inevitably that of lesbianism. This woman, tall and strong enough to match a man in strength, might also be strong enough to decline his favours. The overt androgyny of her figure, meanwhile, denies and disguises her reproductive 'purpose'. This woman, like Tennyson's Princess Ida, threatens to make a sport of men and to reserve her affections for her female companions. Symbolically cloistered with such a company as here, she threatens to dispense with men altogether.

For the nineteenth-century male viewer Burne-Jones's Venus begins to add up into a monstrous threat. Large enough to eat men whole, she might also choose to *reject* them; indeed, to laugh at them.[10] With such a stunning victory in sight, it sadly remains the feminist critic's job to understand why it never happened. Burne-Jones's mighty Venus *ought* to terrify men, but the fact is she does not. Despite her size, her androgyny, her apparent self-sufficiency, she remains in the annals of art history merely another Pre-Raphaelite woman whose challenging 'difference' most viewers and commentators are happy to overlook.

The reason why she fails in her threat may be explained as a condition of her representation; because, that is, Burne-Jones's painting fails to satisfy the criteria necessary for the representational 'illusion of realism'. Apart from the fetishisation of her body (the emphasis on her neck, her hair, her hands) which replicates the devices at work in Swinburne's poem, virtually every formal element

in Burne-Jones's painting works against her realisation as a material presence.

If we begin with the composition of the painting, it will be seen that the two-dimensional frieze-like arrangement of the figures, popular throughout Burne-Jones's work, is here meticulously observed. Even standing directly in front of the painting in the Laing Gallery (Newcastle), it is hard to feel that any of the picture's three planes is necessarily more 'real' than any other. Indeed, in many ways, the second plane, represented by the elaborate wall-hangings gives a greater illusion of naturalistic space than the static foreground figures. And the knights on horseback glimpsed through the open shutters only escape appearing ridiculous because, as a painting within a painting, they have no more pretensions to three-dimensional reality than anything else. Returning to the foreground plane, we may also note the central role *colour* plays in reducing the mighty Venus to a mere decorative function. The stunning orange–red brilliance of her gown which threatens, like Venus herself, to overwhelm the picture, is neutralised by its decorative repetition. Its precise shade, although not its material (the gown itself is textured, significantly, like fine snake-skin) recurs in the head-scarf of the foreground figure with her back to us, and slight variations on its hue are played out in the ruddy draperies of the other figures, and in the wings of the angel (left) and the cupid (right) on the hangings behind.[11] The visual pleasure of the whole painting, indeed, depends, as in so much of Burne-Jones's work (including the tapestries), on the fine, rhythmic balance with which the limited palette is distributed.[12] Another instance is the way in which the purple lining to the sleeves of Venus's dress is echoed in the bodice of the gown worn by the woman directly opposite her. The peacock's feather, moreover, which lies casually to the side of this figure's chair, contains, in its mottled hues, the spectrum of the principal colours which unite the painting: blue, green, ochre and pale brown. The total effect of this 'patterning' is to dematerialise both the figures and the context in which they are represented. A comparison between this room and that in which Morris's Guenevere stands reveals the difference between an attempt at authentic historical reconstruction and the late Pre-Raphaelite tendency to abstract its trappings. The pink rose which lies on the floor at Venus's side not only reifies herself and the other figures into symbols, but also (like the horn and peacock feather in the left-hand corner) militate against spatial realism, and translate the room into an elegant still-life.

If we now move on to the second plane of the composition, we find

a tableau that in every way competes with the foreground of the picture for our attention. Not only is there more action here, but there is also a narrative element denied the ahistorical figures of the foreground space. The embroidered Venus, indeed, does not sit languorously, but flies through the heavens on a winged chariot drawn by three white doves. At the same time, Cupid is busy shooting new victims for her, while a bevy of Botticelli-like angels offer her up succulent pink hearts. The depiction of this Venus, moreover, is hardly less three-dimensional than that of her opposite number, and the overall effect is certainly not to emphasise the differences between the 'real' and the 'legendary' but to collapse them. Her name, carefully scripted in a gold scroll floating behind her head, is reminiscent of Rossetti's *The Girlhood of Mary Virgin*. The third plane, represented by the five knights on horseback, performs a similar function, although the knights' particular connection is not with Venus herself, but with her four attendants. These women, who, as I noted before, are virtual clones of one another, are no more or less 'real' than the men who appear framed in the window behind them; their sexuality no more nor less realisable than if they themselves were a painting on the wall.

By this set of particular formalistic devices, then, which is typical of Burne-Jones's *oeuvres* and late Pre-Raphaelite art in general, any challenge *Laus Veneris* might have presented to its male audience, contemporary or otherwise, is effectively neutralised. Cold, bloodless, stylised – suspended out of historical time and three-dimensional space – the mighty Venus and her hand-maidens may live out whatever strange fantasies they choose in a place that is remoter than Lesbos. Framed and positioned behind glass they can interest, even perhaps titillate, without ever threatening the viewer who looks up at them. These are mythical women; goddesses who tantalised the bewildered sexual psyche of men but never challenged their manhood. These are legendary women; women who belonged to a history that never really happened.

It may be argued, of course, that the devices I have just described are a feature of all painting; that the whole politics of visual representation depends on the fact that it stands in an ambivalent relationship to the 'real world' (see Lynda Nead's observations on this quoted in the Introduction).[13] There is, moreover, the correlative danger for Marxist–feminist readers of falling back into the trap of evaluating art in terms of its 'social realism'. My own use of the adjective 'authentic' to describe the depiction of the bed-chamber in Morris's painting of Guenevere, is illustrative of such a tendency. It

therefore becomes important for the viewer of Pre-Raphaelite art, belonging as it does to the tradition of nineteenth-century realism, to remain as alert to the 'conventionality' of this art form as to any other. With this proviso in mind, I would still argue, however, that the way in which a painting articulates its relationship to the material world *is* of political significance. While it is by no means a simple question of 'authenticity' of representation, the ostensible ahistoricity of certain texts (like those dealt with in this chapter) are very obviously of a different order to others we have considered. By self-consciously disclaiming any relationship to an *a priori* historical reality, Burne-Jones's art is qualitively different to the work of the early Pre-Raphaelite Brotherhood. While all the representations of women we have considered in this book are *always only* representations, it nevertheless seems important that we should mark the *relativity* of their relationship to a social and material context; to a 'political reality'. *Fin-de-siècle* art very consciously militates against such 'realities', though in a way that is, in itself, highly political.

For the feminist reader, therefore, the Venus of Burne-Jones's painting, as of Swinburne's poem, can yield only a pyrrhic victory. The power which is the *femme-fatale's raison d'être* is circumscribed by discourses of mythicality and death. Through covert narrative and representational strategies the threat she represents is effectively contained. Denied a correlative in the material world, her power is self-reflexively textual. She is the site on which a male reader/viewer can indulge his fantasies of female domination without ever risking their actuality. Thus, while it is entirely possible for the feminist reader to reclaim such images 'against the grain', this reading has been made on the assumption that such 'liberation' is ethically undesirable. Powerful as the Pre-Raphaelite *femme fatale* may, at first, appear, she is contained by narrative and formal devices that foreshadow her 'death', deny her existence. Victories won by women on such terms (and here I include *women readers*), can only ever be considered pyrrhic victories.

Notes

1. Griselda Pollock, 'Woman as sign: Psychoanalytic readings', in *Vision and Difference: Femininity, feminism and the history of art* (Routledge, London, 1988).

2. *The Poems of Algernon Charles Swinburne*, vol. 1: *Poems and Ballads* (Chatto and Windus, London, 1912), p. 58. Further page references to this edition are provided after quotations in the text.

3. The story of Swinburne's *Laus Veneris* is based on various nineteenth-century sources deriving from the German legend of the Tannhaüser. These sources

include Tieck's *The Trusty Eckbert* (translated by Carlyle in 1827), Neville Temple and Edward Trevor's *Tannhaüser; or, The Battle of the Bards* (1861) (see John Christian, TGC, p. 229). Christian summarises the story thus:

> The conception is based on the German legend of the Tannhaüser, the wandering knight who comes to the Venusberg and abandons himself to a life of sensual pleasure. Overcome by remorse, he goes to Rome to seek absolution from the Pope, who tells him it is as impossible as that his personal staff should blossom. In despair Tannhaüser returns to the arms of Venus, but in three days' time the Pope's staff miraculously puts forth flowers. Emissaries are sent far and wide to find the sinner, but he is never heard of again. (TGC, p. 229)

4. *Laus Veneris*, in *The Poems of Algernon Charles Swinburne*, vol. 1, p.11. Further page references will be given after quotations in the text.
5. In Freudian psychology a fetish is something (often a part of the body) that functions as a phallic substitute. Another Pre-Raphaelite instance of the female neck being treated in this way is William Morris's 'Golden wings'. This poem, which tells the story of Jehane du Castel (a woman who, Mariana-like, awaits the return of her lover) includes many broken-phallus images, including that of her own neck:

> Her long throat, stretch'd to its full length,
> Rose up and fell right brokenly;
> As though the unhappy heart was nigh
> Striving to break with all its strength.

(lines 163–6, p. 129, *The Defence of Guenevere, The Death of Jason and Other Poems* (World Classics, Oxford, 1920)).
6. This poem–painting combination is the only one in this book in which the visual text predates the literary one. Although the Laing Art Gallery oil is dated 1873–8 (thus postdating Swinburne's poem, which was first published in *Poems and Ballads* in 1866), an earlier watercolour of the same composition was painted in 1861. In the TGC John Christian speculates on the chronology thus:

> Since the first stanzas of the poem were written on 14 June 1862, by which time the watercolour was apparently complete, it may seem that Swinburne was simply influenced by Burne-Jones. But Burne-Jones's choice of subject is so Swinburnian that poem and picture were clearly twin-expressions of shared ideas; this was, after all, the moment when the two men were particularly close, a fact reflected in the dedication of *Poems and Ballads* to Burne-Jones. (p. 230)

7. The increasingly goiterous necks of Rossetti's female subjects from the 1860s onwards have been noted and ridiculed by generations of critics, the most celebrated of whom is probably Henry James. In a frequently quoted letter, he describes the Pre-Raphaelite woman thus:

> She is a wonder . . . a tall, lean woman . . . with a mass of crisp black hair heaped into wavy projections on each side of her temples, a thin pale face, a pair of strange, sad, deep, dark Swinburnian eyes, with great thick black oblique brows, joined in the middle and tucking themselves away under her hair, a mouth like the Oriana in our illustrated Tennyson, a long neck. (*Letters of Henry James*, 1920; quoted by John Dixon-Hunt, *The Pre-Raphaelite Imagination* (Routledge and Kegan Paul, London, 1968), p. 177)

In Rossetti's case, it may, indeed, be argued that this mannerism intensifies throughout his later career until by the time of the Lady Lever Art Gallery *Pandora* (1874) and *Astarte Syriaca* (Manchester City Art Gallery, 1875–7) the neck has assumed the thickness and muscularity of a limb.

8. Henry James, *The Nation* (1878). Quoted by John Christian (TGC, p. 230).

9. Frank Wedmore, 'Some tendencies in recent painting', *Temple Bar Magazine* (July 1878). Quoted by John Christian (TGC, p. 229).

10. In numerous interviews Margaret Atwood has made the point that while the worst thing a man can do to a woman is to murder her, the worst thing she can do to a man is laugh at him.

11. Burne-Jones uses this snakeskin material again in his representation of another 'evil woman': Queen Eleanor, in *Fair Rosamund and Queen Eleanor* (Yale Center for British Art, Gouache, 1861).

12. A similar rhythmic distribution of a limited palette is, of course, to be found in Burne-Jones's textile designs. See, for example, the 'Holy Grail tapestries' (Birmingham City Art Gallery).

13. Lynda Nead, *Myths of Sexuality* (Basil Blackwell, Oxford, 1988). Nead's critical observations on 'reflection theory' are quoted in the Introduction, page 13.

Conclusion

Gendered Reading in Practice

> With the house image we are in possession of a veritable principle of psychological integration. . . . On whatever theoretical horizon we examine it, the house image would appear to have become the topography of our intimate being. (Gaston Bachelard, *The Poetics of Space*, p. xxxii)[1]

Descriptions of houses, or rather their individual rooms, have featured widely in these readings. Both in the poems and the paintings, all except two of the female subjects I have discussed have been analysed *in the context* of their rooms.

The significance of the room in literary analysis, its profound symbolic and metaphoric *reverberations*, was first brought to attention in the 1960s with the publication of Gaston Bachelard's *Poetics of Space*.[2] I referred to this text, in passing, in the chapter on 'Mariana', but wish now to put its metaphors to a more demanding use: namely, a retrospective appraisal of gendered reading in practice. It is, indeed, the burden of this Conclusion to assess the significance of the various theoretical reading strategies presented in the Introduction in the light of the actual readings which followed, and Bachelard's conceptualisation of 'intimate space' has, I hope, furnished me with a metaphor that will make this task somewhat easier.[3]

Bachelard's work, as I explained in Chapter 3 is primarily concerned with images of what he has described as 'felicitous space' (p. xxxi); with the house, nest, drawer, wardrobe, etc., as figures of intimate being. The reader of this book will immediately register that few of the female subjects we have been considering occupy their space in a 'felicitous' way, and the disjuncture between Bachelard's perception of domestic space and the one that has emerged here is the spring-board for the discussion which follows. Put simply, I am proposing that the discord between the female subject and the room which she inhabits is a symbolic index of her unhappy relationship with her own social/historical/psychological position. *For various reasons* (and it is important to avoid monolithic inclusivity in pursuing

this metaphor), the women of these poems and paintings are not happy in their space. Where they should be owners, they are tenants; where they should be willing occupants they are, in fact, prisoners. Instead of being a symbol of what Bachelard has called 'psychological integration' (p. xxxii), the houses/rooms represented in these texts signal (with just one clear exception) alienation, oppression, and danger. They constitute what Bachelard has described as 'hostile space' (p. xxxii).

Before pursuing the implications of this hypothesis *vis-à-vis* the individual chapters, however, I wish to extend the significance of the metaphor to the theoretical quest of this Conclusion: an appraisal of the possibilities and limitations of 'reading as a woman'. My trope here is that if we regard the houses/rooms the female subjects inhabit as symbolic representations of their ideological/psychological *context*, then our activity as Marxist–feminist readers, may be thought of as an endeavour to *enter those rooms*; to take possession of that context. The great significance of the room for the materialist–feminist is, indeed, the context it supplies. If the reader reflects upon the analyses undertaken in these pages, she will quickly realise that most of the ideological 'deconstruction' of the texts concerned focused not on the representations of the women themselves, but on the rooms in which they were placed. An image of a female form, in itself, tells us very little, yet even the simplest portrait betrays much by the existence/non-existence of its 'trappings' (situation, dress, background 'props'). The room also often supplies the *narrative context* of a painting, and for this reason is a crucial element in the translation of verbal into visual texts. One recalls, for example, how much William Holman Hunt was tormented by the difficulty of translating the narrative of *The Lady of Shalott* into a single frame; his partial solution, as for several of the texts we have looked at here, was to make the room 'tell the story'.[4] According to a Marxist–feminist formulation, then, the context in which a female subject is placed is necessarily integral to any analysis we may make of her. To attempt to read the subject without the context is both impracticable and, as I will propose later, politically undesirable.

By extending Bachelard's metaphor to include critical activity we have arrived, then, at a trope of 'breaking and entering'. Such an imagery relates to Macherey's account of literary activity which, it will be remembered, depends upon the notion of the reader inserting him/herself into the 'margins' of texts and in exposing their 'gaps' and 'absences' (see Introduction pp. 9–11). On this point it is interesting

that Bachelard associates the 'mystery' of intimate space with locks
and keys. Writing about drawers, chests and wardrobes, he exclaims:
'What psychology lies behind their locks and keys! They bear within
them a kind of esthetics of hidden things . . . an empty drawer is
unimaginable . . . all wardrobes are full' (p. xxxiii–iv). Bachelard's
realisation that all locked, intimate spaces contain for us some secret
is, indeed, in line with the spirit of contemporary post-structuralist
textual analysis. We now believe, as readers, that *all texts* will contain
something of interest; that it is impossible for them, like Bachelard's
wardrobes, to be empty. While, following Macherey, we may be aware
of the dangers of searching for some 'hidden truth' (see Introduction),
we nevertheless believe that we must be able to 'steal' something.

One of the findings of this book, however, has undoubtedly been to
call such presumptions into question. In the retrospective which
follows, I propose that what these readings have revealed is the
profound relativity of the text–reader relationship. As I observed in
my conclusion to Chapter 8 the fact that all texts ought, *theoretically*,
to be liable to feminist appropriation is not borne out in practice.
Some texts (again, for *various* reasons) are supremely resistant to
intervention of any kind; they are, as it were, rooms we cannot enter.
There are, again, others which we can enter but which we cannot do
much with once we have got there; rooms so tidy, so luxurious or so
over-decorated, that all clues to their inhabitant's social being are
effectively silenced. In the final analysis, there are, indeed, very few
rooms/texts whose entry yields significant reward: rooms at whose
doors the inhabitant invites us in, and *welcomes us* to share the chaos
of her domestic space.

The texts (both poems and paintings) which seem to me, in
retrospect, to have been the most resistant to feminist intervention
are 'The Virgin', 'Beatrice', 'Mariana' and 'Venus'. In every case it is, I
would propose, a complex of textual and political factors that frustrate
us entering the rooms in which these women are contained.

By subtitling the chapter dealing with Rossetti's poem–painting
tribute to the Virgin 'Solid Frames', I was indicating what I perceive to
be the incontrovertible didacticism of this text; the way in which the
sonnets nailed to the frame must inevitably direct and limit the
viewer's apprehension of the visual image. Although I conceded that
the Victorian penchant for appending descriptive texts/titles to
canvases was, in itself, a register of the anxiety felt over the
slipperiness of all signification, I nevertheless felt that this particular
visual–verbal composite was particularly 'solid' in its resistance, and

that its ideological fixity corresponded significantly to its two-dimensional static form.

'Mariana' presented similar obstacles. Both Tennyson's poem and Millais's painting dazzle the reader/viewer with the sensuousness of their surfaces, and although it was possible to enter the room in which Mariana was immured and note its contents in some detail, the things found there were so attractive in themselves that their reverberations remained elusive. I argued, indeed, that Millais's painting (and, to a lesser extent, Tennyson's poem) presents itself to the viewer as a representation of Bachelard's 'felicitous space'. Although we know Mariana's story to be tragic, we perceive her circumstances (literally, her room) to be comfortable. We are positioned to enjoy the romance of her situation and therefore to suspend its wider social and political implications. For the Marxist–feminist, there is, with Mariana, the further problem that in both poem and painting she appears to be inscribed by only one ideological discourse; that of Romantic Love. There are none of the contradictions which we find, for example, in the Lady of Shalott's circumstances, and which allow us to engage in a more complex political intervention. Mariana's room, though full of interesting details, tells only one story.

The carefully realised domestic space which Mariana inhabits is also in significant contrast to that in which Rossetti's *Beata Beatrix* is situated. Although in subtitling this chapter 'Hazy Outlines' I was referring to the formal/ideological representation of Beatrice herself, the 'haziness' also applies to the indeterminacy of her context. The Beatrice of Rossetti's painting, it will be remembered, occupies nothing more than a shadowy foreground space, beyond which float symbolic/allegorical reepresentations of Dante, 'Love' and the city of Florence. The feminist reader, denied a material context in which to locate her subject may thus feel impossibly handicapped. Although, in the chapter itself, I ended with the rather perverse conclusion that Beatrice's 'non-referentiality' reflects back upon the essential impotence of her male producer, I acknowledge that, by the same token, she evades significant materialist–feminist critique. For this reason, I would not wish to propose Beatrice as Pre-Raphaelite heroine; despite the fact that her 'rapt' beauty has 'fascinated' many generations of women viewers, her lack of a recognisable social–political context makes her a problematic feminist investment.

It was the lack of such a context that also presented problems for the readings of the two 'Laus Veneris' texts. It will be remembered that I opened this chapter by expressing regret that this potential

heroine should, in practice, yield the feminist reader nothing more than pyrrhic victory; that the power *implicit* in the *femme fatale* of Swinburne's poem and Burne-Jones's painting was made politically redundant by the wider discourses in which she was inscribed. On this point, it should be made clear that we are dealing not only with the problematic discourses contained in the texts themselves (principally the discourse of misogyny), but also those which surround the text's production and consumption. The chapter on Venus is, perhaps, this book's most graphic demonstration of the text–context debate raised in the Introduction: an instance of the dilemma in which the feminist reader/viewer is invited to read the text 'against the grain' and claim an apparently powerful female image for her own purposes, but who realises that to do so is to ignore the context in which that image was originally produced/consumed. Desire as we may to release Burne-Jones's Venus from the tight, two-dimensional and mythical space in which she has been imprisoned, we ultimately discover that she is inseparable from it. This text, like all the others, insists that the women come with their rooms attached.

With respect to the four chapters just described, then, I concede that feminist intervention is, for the most part, limited to a fairly basic sexual political critique. By different means, the texts concerned have suppressed and silenced the complexities and contradictions necessary for a more productive intervention; have allowed, according to Macherey's model, few 'gaps' into which we can insert ourselves.

By contrast, the two chapters featuring the poems by Keats revealed several black holes. Through the vulnerablity of their female protagonists, both *Isabella* and *The Eve of St. Agnes* offer disturbing glimpses into the dangerous abuse of patriarchal power; show that in 'felicitous' domestic space (Isabella's dining-room and Madeline's bed-chamber) lurks the threat of rape and murder. The *means* by which these two texts (and, indeed, their companion paintings) reveal this information are, however, strikingly different. Keats's *Isabella*, as I noted in Chapter 5, is an extraordinarily 'simple' text in many ways. The ideological contradictions with which it is concerned (principally the 'differences' revolving around class and gender) are presented directly, by the poem's narrator. This 'simplicity' is reproduced, moreover, in the painting by Millais, whose clear, sharp lines and dynamic composition symbolically encode these differences. On Millais's canvas, indeed, every inch of domestic space reverberates with narrative tension; the smallest details (from salt-cellar to walnut) are part of the text's total binary opposition.

The 'politics' of *The Eve of St. Agnes* are, by contrast, distinctly murky. In the same way that Hughes's dark, 'jewel-like' canvas contrasts with Millais's brightly-lit one, so can the two poems be distinguished. By subtitling this chapter 'Ghostly Signifiers' I was alluding to the way in which the romantic insubstantiality of hero and heroine (wonderfully re-created in the luminous, moonlit flesh of Arthur Hughes's painting), have allowed generations of readers/ viewers to ignore the grosser sexual politics of the narrative; that is, the *threat* of Madeline's rape. To return to the metaphor of the room, I would suggest that the feminist reader is disadvantaged by its poor lighting: although we, like Porphyro, have easy access to Madeline's bed-chamber, it is not easy to make out the idiosyncrasies lurking in its corners (least of all the presence of Porphyro himself!).

I turn, finally, to the two chapters which I believe yielded most to the feminist reader: namely, 'The Lady of Shalott' and 'Guenevere'. These chapters featured texts (specified below) in which the female subject may be seen actively to invite the woman reader/viewer to enter her rooms and *join with her* in the chaos and confusion of her social/psychological oppression. The women of these texts are thus distinguished from those of Keats's poems by their *resistance*. By refusing to be victims, they offer the feminist reader/viewer not only the possibility of critique, but also legitimate 'fascination' (see Introduction pp. 21–2, for discussion of this last term).

Tennyson's *Lady of Shalott* is a narrative structured around a room, and a room's secret. The curse which prevents the Lady looking out of the window turns all our attention inwards, and we do so in a supreme effort to understand the *reason* for her incarceration, punishment and death. Although the poem itself furnishes us with few domestic details, the paintings and illustrations by Holman Hunt and others make us instantly and startlingly aware of the ideological *dynamics* of the Lady's tragedy; of the fact that her whole domestic space resonates with the fantasy of Romantic Love and Marriage while being circum-scribed by walls (the discourse of Celibacy) that she dare not look beyond. On this last point, a note must finally be said about Waterhouse's painting, which is the only visual image in this book to feature a woman *out of doors*. Considering the hostile nature of most of the interior spaces we have looked at, one might, supposedly, turn with relief to a representation which offers the Lady a breath of outside air. The problem is, of course, that Waterhouse's Lady has simply exchanged one hostile space for another and, in boarding the boat that will bear her to her death, is once again dispossessed of power.

William Morris's Guenevere is the only female subject featured in these readings that is in significant control of her space. Although in the poem she is, supposedly, about to be bound at the stake, she nevertheless uses her words to claim the place of her 'defence' for her own.[5] The painting, meanwhile, is the only one included in these pages which depicts a woman in calm possession of her domestic space. Thwarted as she might be in other respects, Morris's Guenevere has the unique distinction of 'owning' the space in which she stands. Neither tenant nor prisoner, Guenevere occupies the site of her recent adultery with total self-possession. Thus, although various items in the room point to an ideological turmoil no less acute than the Lady of Shalott's (the juxtaposition of bed and prayer book, for example), Guenevere's own social and economic status (as Queen) places her in a different relation to the laws by which she, too, is oppressed.

In retrospect, I would propose, then, that the chapters on Shalott and Guenevere offered the possibility of a different type of gendered reading; a reading which allowed us not only to 'deconstruct' the multiple ideological forces by which the female subjects had been constrained, but also to 'reconstruct' their own defiance. Such possibilities do not necessarily constitute a radical consciousness on the part of the texts' producers, although I concede that it is the basic *complexity* of the texts concerned that makes the more 'sophisticated' readings possible. By taking possession of their rooms in different ways, both Shalott and Guenevere make them newly available to the feminist reader.

The objective of this metaphorical overview was not, however, to exult in the fascinations of two rooms, but to demonstrate the inescapable significance of all of them. While I began this project with an open mind as to the extent to which the twentieth-century feminist reader could legitimately undermine the conditions of a text's production/consumption, could 'renegotiate' the discourses which that text contained, in practice I was repeatedly restrained from doing so. It is now my opinion that 'reading against the grain' of a text cannot ever legitimate reading against its *contexts*, and that while our principal activity as feminist readers and viewers might be to prolifer-ate the discourses which surround a text in order to generate new 'meanings', we cannot ever over-ride the hierarchy of those discourses (i.e., ignore the 'dominant ideology' present in a text). In our search for feminist heroines, then, or for readings of texts that in some way go beyond a simple critique of the patriarchy by which they are inscribed, it is no good simply being seduced by what appears to be a 'powerful

woman'; it is only *the context of her being*, the room in which she has been placed, that can offer a satisfactory feminist account of her identity.

Notes

1. Gaston Bachelard, *The Poetics of Space*, trans. Maria Jolas (Orion Press, New York, 1964). Page references are given after quotations in the text.
2. Bachelard uses the concept of 'reverberation' to suggest the 'trans-subjectivity' of his poetic image (see *The Poetics of Space*, p. xii).
3. I am indebted to Tony Pinkney for pointing out the relevance of Bachelard's text to this project.
4. See note 13 to Chapter 4 for discussion of Hunt's problem.
5. Morris's poem ends with a reference to Launcelot galloping to Guenevere's rescue, and in Malory's text he literally saves her from the fire (*Le Morte d'Arthur* (Penguin, Harmondsworth, 1969), Book xx, Ch. 8).

Bibliography

This Bibliography includes references for all the principal items cited in the text, plus selected additional background reading.

Abel, Elizabeth (ed.), *The Signs Reader: Women, gender and scholarship* (University of Chicago Press, Chicago and London, 1983).

Abrahms, M. H., *A Glossary of Literary Terms* (Holt, Rinehart and Winston, New York, 1971).

Althusser, Louis, 'Ideology and ideological state apparatuses', in *Lenin and Philosophy and Other Essays*, trans. Ben Brewster (New Left Books, London, 1971).

Armstrong, Isobel, 'Christina Rossetti: Diary of a feminist reading', in Sue Roe (ed.), *Women Reading Women's Writing* (Harvester Wheatsheaf, Hemel Hempstead, 1987).

Atwood, Margaret, *Surfacing* (Virago, London, 1979).

Auerbach, Nina, *Woman and Demon: The life of a Victorian myth* (Harvard University Press, Cambridge, Mass., 1982)

Bachelard, Gaston, *The Poetics of Space*, trans. Maria Jolas (Orion Press, New York, 1964).

Baker, E. C., and Thomas B. Hess, *Art and Sexual Politics* (Macmillan, New York, 1973).

Barker, Francis (ed.), *1848: The sociology of literature* (University of Essex Papers, Colchester, 1978).

Barnard, John, *John Keats* (Cambridge University Press, Cambridge, 1987).

Barrett, Michele, *Women's Oppression Today* (Verso, London, 1985).

Beauvoir, Simone de, *The Second Sex*, translated H. M. Parshley, second English edition, (Penguin, Harmondsworth, 1972).

Beegel, Susan, 'Rossetti's sonnets and paintings on Mary's girlhood: A case study in reciprocal illustration', *Journal of Pre-Raphaelite Studies*, 2, 2 (1981), 1–6.

Belsey, Andrew, and Catherine Belsey, 'Christina Rossetti: Sister to the Brotherhood', *Textual Practice*, 2, 1 (1988), 30–50.

Belsey, Catherine, *Critical Practice* (Methuen, London, 1980).

Belsey, Catherine, *John Milton: Language, gender, power* (Basil Blackwell, Oxford, 1988).

Benton, Ted, *The Rise and Fall of Structural Marxism: Althusser and his influence* (Macmillan, London, 1974).

Berger, John, *Ways of Seeing* (Penguin, Harmondsworth, 1972).

Betterton, Rosemary, *Looking On: Images of femininity in the visual arts and media* (Pandora, London, 1987).

Bock, Carol A., 'D. G. Rossetti's *Found* and *The Blessed Damozel* as explorations in Victorian psychosexuality', *Journal of Pre-Raphaelite Studies*, 1, 2 (1980), 83–90.

Boos, Florence, 'Dislocation of personal identity in the narratives of William Morris', *Journal of Pre- Raphaelite Studies*, 1, 1 (1980), 1–13.

Boumelha, Penny, *Thomas Hardy: Sexual ideology and narrative form* (Harvester Wheatsheaf, Hemel Hempstead, 1982).

Brown University, *Ladies of Shalott: A Victorian masterpiece and its contexts* (Brown University Art Department, Rhode Island, 1985).

Brunt, Rosalind, and Caroline Rowan, *Feminism, Culture and Politics* (Lawrence and Wishart, London, 1982).

Bullen, J. B., *The Sun is God: Painting, literature, and mythology in the nineteenth century* (Clarendon, Oxford, 1989).

Bürger, Peter, *Theory of the Avant-Garde*, trans. Michael Shaw (Manchester University Press, Manchester; University of Minnesota Press, Minneapolis, 1984).

Calder, Jenni, *Women and Marriage in Victorian Fiction* (Thames and Hudson, London, 1976).

Cameron, Deborah, *Feminism and Linguistic Theory* (Macmillan, London, 1985).

Casteras, Susan, *Images of Victorian Womanhood in English Art* (Farleigh Dickinson, Rutherford, NJ, 1987).

Caudwell, Christopher, *Illusion and Reality*, 2nd edition (Lawrence and Wishart, London, 1946).

Caws, Mary Ann, *The Art of Interference: Stressed readings in verbal and visual texts* (Polity Press, Oxford, 1989).

Cherry, Deborah, *Painting Women: Victorian women painters* (Rochdale Art Gallery Exhibition Catalogue, 1986).

Cherry, Deborah, and Griselda Pollock, 'Patriarchal power and the Pre-Raphaelites', *Art History*, 7, 4 (1984), 480–95.

Clark, Kenneth, *The Nude* (John Murray, London, 1956).

Clément, Catherine, *Opera, or the Undoing of Women* (University of Minnesota Press, Minneapolis, 1988).

Collins, Wilkie, *The Woman in White* (Oxford University Press, Oxford, 1975).

Coward, Rosalind, *Female Desire: Women's sexuality today* (Paladin, London, 1984).

Culler, Jonathan, *On Deconstruction: Theory and criticism after structuralism* (Routledge and Kegan Paul, London, 1982).

Dante, *La vita nuova*, trans. Barbara Reynolds (Penguin, Harmondsworth, 1969).

Dixon-Hunt, John, *The Pre-Raphaelite Imagination* (Routledge and Kegan Paul, London, 1968).

Dixon-Hunt, John, *Encounters: Essays on literature and the visual arts* (Studio Vista, London, 1971).

Doan, Laura L., 'Narrativity and transformative iconography in Dante Gabriel Rossetti's earliest paintings', *Soundings*, 71, 4 (1988), 471–83.

Doane, Mary Ann, *The Desire to Desire: The woman's film in the 1940s* (Indiana University Press, Bloomington, 1987).

Draper, Ellen, 'Zombie women: when the gaze is male', *Wide Angle* 10, 3(1988) 52–62.

Dronke, Peter, *Medieval Latin and the Rise of the European Love Lyric*, 2 vols (Clarendon, Oxford, 1965).

Dworkin, Andrea, *Pornography: Men possessing women* (Women's Press, London, 1981).

Eagleton, Mary, *Feminist Literary Theory: A reader* (Basil Blackwell, Oxford, 1986).

Eagleton, Terry, *Against the Grain: Essays 1975–1985* (Verso, London, 1986).

Eagleton, Terry, *Literary Theory: An introduction* (Basil Blackwell, Oxford, 1983).

Eagleton, Terry, *Marxism and Literary Criticism* (Methuen, London, 1986).

Eagleton, Terry, *The Rape of Clarissa: Writing, sexuality and class struggle in Samuel Richardson* (Basil Blackwell, Oxford, 1986).

Ecker, Gisela, *Feminist Aesthetics* (Women's Press, London, 1985).

Edmond, Rod, *Affairs of the Hearth: Victorian poetry and domestic narrative* (Routledge, London, 1988).

Eliot, George, *Middlemarch* (1874) (Oxford University Press edition, Oxford, 1988).

Ellis, Steve, *Dante and English Poetry: Shelley to T. S. Eliot* (Cambridge University Press, Cambridge, 1983).

Faderman, Lillian, *Surpassing the Love of Men: Romantic friendship and love between women from the Renaissance to the present* (Women's Press, London, 1985).

Felski, Rita, *Beyond Feminist Aesthetics: Feminist literature and social change* (Hutchinson Radius, London, 1989).

Fetterley, Judith, *The Resisting Reader: A feminist approach to American fiction* (Indiana University Press, Bloomington, 1978).

Fisch, Marilyn Woroner, 'Swinburne's divine bitches: Agents of destruction and synthesis', *Journal of Pre-Raphaelite Studies* 7, 2 (1987) 1–11.

Flaxman, Rhoda L., *Victorian Word-Painting and Narrative: Towards the blending of genres* (UMI Research Press, Ann Arbor, Mich., 1987).

Foucault, Michel, *The History of Sexuality* vol. 1 (Penguin, Harmondsworth, 1984).

Foucault, Michel, *The Order of Things: An archeology of the human sciences* (Vintage/Random, New York, 1973).

Fredeman, William E. (ed.), *The Pre-Raphaelite Brotherhood Journal: William Michael Rossetti's diary of the Pre-Raphaelite Brotherhood 1849–1853* (Oxford University Press, Oxford, 1975).

Gamman, Lorraine, and Margaret Marshment, *The Female Gaze: Women as viewers of popular culture* (Women's Press, London, 1988).

Gledhill, Christine, 'Pleasurable negotiations', in Deidre Pribram (ed.), *Female Spectators: Looking at film and TV* (Verso, New York and London, 1988).

Goff, Barbara Munson, 'Dante's *La vita nuova* and two Pre-Raphaelite Beatrices', *Journal of Pre-Raphaelite Studies*, 4, 2 (1983), 100–16.

Golby, J. M. (ed.), *Culture and Society in Britain 1850–90* (Oxford University Press, Oxford, 1986).

Golden, Catherine, 'Dante Gabriel Rossetti's two-sided art', *Victorian Poetry* 26 (1988), 395–402.

Gombrich, E. H., *Art and Illusion* (Phaidon, Oxford, 1960).

Greene, Gayle, and Coppélia Kahn, *Making a Difference* (Methuen, London, 1986).

Greer, Germaine, *The Female Eunuch* (Paladin, London, 1971).

Greer, Germaine, *The Obstacle Race* (Secker and Warburg, London, 1979).

Gribble, Jennifer, *The Lady of Shalott in the Victorian Novel* (Macmillan, London, 1983).

Griffin, Susan, *Pornography and Silence* (Women's Press, London, 1981).

Hagstrum, Jean, *The Sister Arts: the tradition of literary pictorialism and English poetry* (University of Chicago Press, Chicago, Ill., 1958).

Hardy, Thomas, *The Woodlanders* (Macmillan, London, 1974).

Harris, D. A., 'Dante Gabriel Rossetti's "Jenny": Sex, money, and the interior monologue', *Victorian Poetry*, vol. 22 (1984), pp. 197–215.

Harris, Jack T., 'I have never seen a naked "Lady of Shalott"', *Journal of Pre-Raphaelite Studies*, 5, 1 (1985), 76–87.

Harris, Jack T., 'The Pre-Raphaelites and the Moxon *Tennyson*', *Journal of Pre-Raphaelite Studies* 3, 2 (1983), 26–37.

Harrison, Antony H., *Swinburne's Medievalism: A Study in Victorian love poetry* (Louisiana State University Press, Baton Rouge and London, 1988).

Heffner, David Todd, 'Additional typological symbolism in D. G. Rossetti's *The Girlhood of Mary Virgin*', *Journal of Pre-Raphaelite Studies*, 5, 2 (1985), 68–80.

Hersey, George, 'Hunt, Millais, and *Measure for Measure*', *Journal of Pre-Raphaelite and Aesthetic Studies*, 1:1 (Part 1) (1987) 83–90.

Hill, John Spencer, *Keats: Narrative poems* (Macmillan, London, 1983).

Hönnighausen, Lothar, *The Symbolist Tradition in English Literature: A study in Pre-Raphaelitism and fin-de-siècle* (Cambridge University Press, Cambridge, 1988).

Houghton, Walter E., *The Victorian Frame of Mind* (Yale University Press, New Haven, Conn., and London, 1957).

Hunt, William Holman, *Pre-Raphaelitism and the Pre-Raphaelite Brotherhood*, 2 vols (Macmillan, London, 1905).

Ironside, Robin, and Jeffrey Gere, *Pre-Raphaelite Painters* (Phaidon, London, 1948).

Jefferson, Ann, and David Robey, Modern Literary Theory: A comparative introduction (Batsford Academic, London, 1982).

Jordan, Elaine, Alfred Tennyson (Cambridge University Press, Cambridge, 1988).

Kaplan, Cora, Sea Changes: Culture and feminism (Verso, London, 1986).

Kaplan, E. Ann, Women and Film: Both sides of the camera (Methuen, New York and London, 1983).

Keane, Robert N., 'Ut Pictura Poesis: Rossetti and Morris: Paintings into Poetry', Journal of Pre-Raphaelite Studies 7, 2 (1987), 75–9.

Killham, John (ed.), Critical Essays on the Poetry of Tennyson (Routledge and Kegan Paul, London, 1979).

Kirchhoff, Frederick, William Morris (Twayne, Boston, Mass., 1979).

Kotzin, Michael C., 'Tennyson and Pre-Raphaelitism: Symbolism and point of view in "Mariana" and "The awakening conscience"', Pre-Raphaelite Review 1, 2 (1977), 91–101.

Kuhn, Annette, Women's Pictures: Feminism and cinema (Routledge and Kegan Paul, London, 1982).

Lauretis, Teresa de, Alice Doesn't: Feminism, semiotics, cinema (Macmillan, London, 1984).

Leng, Andrew, 'Millais's Mariana: Literary painting, the Pre-Raphaelite gothic and the iconology of the Marian artist', Journal of Pre-Raphaelite and Aesthetic Studies, 1:1 (Part 2) (1988), 63–72.

Lessing, Gotthold, Laocoön: An essay on the limits of painting and poetry, trans. Edward A. McCormick (Johns Hopkins University Press, Baltimore, London, 1984).

Lewis, C. S., The Allegory of Love (Oxford University Press, Oxford, 1936).

Lovell, Terry, Consuming Fiction (Verso, London, 1987).

Lovell, Terry, Pictures of Reality: Aesthetics, politics, pleasure (British Film Institute, London, 1980).

Lukács, Georg, Studies in European Romanticism (Grosset and Dunlap, New York, 1964).

Macdonnell, Diane, Theories of Discourse (Basil Blackwell, London, 1986).

McGann, Jerome, 'Dante Gabriel Rossetti and the betrayal of truth', Victorian Poetry, 26, 4 (1988), 339–62.

Macherey, Pierre, A Theory of Literary Production, trans. Geoffrey Wall (Routledge, London, 1978) (first published Librairie François Maspero, 1966).

Mackaill, J. W., The Life of William Morris, 2 vols (Longmans, Green, London, 1920).

MacKay, Kenneth M., Many Glancing Colours (University of Toronto Press, Toronto, 1988).

Malory, Thomas, Le Morte d'Arthur, 2 vols (Penguin, Harmondsworth, 1969).

Mancoff, Debra N., 'A vision of Beatrice: Dante Gabriel Rossetti and the Beata Beatrix', Journal of Pre-Raphaelite Studies, 6, 1 (1986), 76–87.

Marcus, Steven, The Other Victorians: A study in sexuality and pornography in mid-nineteenth century England (Bantam, London, 1966).

Marsh, Jan, Jane and May Morris (Pandora, London, 1986).

Marsh, Jan, *The Legend of Elizabeth Siddal* (Quartet, London, 1989).

Marsh, Jan, *The Pre-Raphaelite Sisterhood* (Quartet, London, 1985).

Marsh, Jan, *Pre-Raphaelite Women* (Weidenfeld and Nicolson, London, 1987).

Messenger, N. P., and J. R. Watson, *Victorian Poetry: City of the dreadful night and other poems* (Dent, London, 1974).

Meyers, Jeffrey, *Painting and the Novel* (Manchester University Press, Manchester, 1975).

Millais, John Guille, *The Life and Letters of Sir John Everett Millais*, 2 vols (Methuen, London, 1899).

Millett, Kate, *Sexual Politics* (first published Doubleday, New York, 1969; Virago, London, 1977).

Mills, Sara, 'Knowing your place: Marxist feminist contextualised stylistics' in M. Toolan (ed.), *Contextualised Stylistics* (Routledge, London, 1991).

Mills, Sara, Lynne Pearce, Sue Spaull and Elaine Mitchell (eds) *Feminist Readings/Feminists Reading* (Harvester Wheatsheaf, Hemel Hempstead, 1989).

Mitchell, Judith, *Psychoanalysis and Feminism* (Penguin, Harmondsworth, 1975).

Mitchell, Judith, and Ann Oakley (eds), *The Rights and Wrongs of Woman* (Penguin, Harmondsworth, 1976).

Modleski, Tania, *Loving with a Vengeance: Mass-produced fantasies for women* (Routledge, London, 1982).

Moi, Toril, *Sexual/Textual Politics* (Methuen, London, 1985).

Morris, William, *Collected Works*, ed. May Morris (Longmans, Green, London, 1911).

Morris, William, *The Defence of Guenevere, the Death of Jason and Other Poems* (The World's Classics, Oxford, 1920).

Mullins, Edwin, *The Painted Witch* (Secker and Warburg, London, 1985).

Mulvey, Laura, *Visual and Other Pleasures* (Macmillan, London, 1989).

Mulvey, Laura, 'Visual pleasure and narrative cinema', *Screen*, 16, 3 (1975), 6–18.

Nead, Lynda, *Myths of Sexuality* (Basil Blackwell, Oxford, 1988).

Nochlin, Linda, and Thomas B. Hess, *Woman as Sex Object: Studies in erotic art 1730–1970* (Art News Annual, New York, 1972).

Nunn, Pamela Gerrish (ed.), *Canvassing: Recollections by six Victorian women artists* (Camden Press, London, 1986).

Open University Arts Foundation Course (A102), *Religion: Conformity and controversy* (Units 18–19) and *Moral Values and the Social Order* (Units 20–1) plus *Illustration Booklet* (Open University Press, Milton Keynes, 1987).

Parker, Roszika, and Griselda Pollock (eds), *Old Mistresses: Woman, art and ideology* (Routledge and Kegan Paul, London, 1981).

Patmore, Coventry, *Poems*, ed. F. Page (Oxford University Press, London and New York, 1949).

Pearce, Lynne, Sara Mills, Sue Spaull and Elaine Millard, *Feminist Readings/Feminists Reading* (Harvester Wheatsheaf, Hemel Hempstead, 1989).

Pointon, Marcia (ed.), *Pre-Raphaelites Re-viewed* (Manchester University Press, Manchester, 1989).

Pollock, Griselda, *Vision and Difference: Femininity, feminism and the history of art* (Routledge, London, 1988).

Rice, Philip, and Patricia Waugh, *Modern Literary Theory: A reader* (Edward Arnold, London, 1989).

Ricks, Christopher (ed.), *The Poems of Tennyson*, 3 vols, 2nd edn (Longman, Harlow, 1987).

Ricks, Christopher, *Tennyson* (Macmillan, New York, 1972).

Roberts, Helene E., 'Marriage, redundancy, or sin: The painter's view of women in the first twenty-five years of Victoria's reign' in Martha Vicinus (ed.), *Suffer and Be Still: Women in the Victorian age* (Indiana University Press, Bloomington, 1972; Methuen, London, 1980).

Roe, Sue (ed.), *Women Reading Women's Writing* (Harvester Wheatsheaf, Hemel Hempstead, 1987).

Rollins, Hyder E., *The Keats Circle: Letters and papers* (Harvard University Press, Cambridge, Mass., 1958).

Rose, Andrea, *The Pre-Raphaelites* (Phaidon, Oxford, 1977).

Rossetti, William Michael (ed.), *The Works of Dante Gabriel Rossetti* (Ellis, London, 1911).

Ruskin, John, *The Works of John Ruskin*, ed. Edward T. Cook and Alexander Wedderburn (George Allen, London, 1903–12).

Sargent, Lydia (ed.), *Women and Revolution: The unhappy marriage of Marxism and feminism* (Pluto, London, 1981).

Selden, Raman, *A Reader's Guide to Contemporary Literary Theory* (Harvester Wheatsheaf, Hemel Hempstead, 1985).

Shaw, Marion, *Alfred Lord Tennyson* (Harvester Wheatsheaf, Hemel Hempstead, 1988).

Sheets, Robin, 'Pornography and art: the case of "Jenny"', *Critical Inquiry*, 14 (1988), 315–34.

Shefer, Elaine, 'The woman at the window in Victorian art and Christina Rossetti as the subject of Millais's *Mariana*', *Journal of Pre-Raphaelite Studies*, 4, 1 (1983), 14–25.

Showalter, Elaine, *The New Feminist Criticism* (Virago, London, 1977).

Smith, Steven B., *Reading Althusser: An essay in structural Marxism* (Cornell University Press, Ithaca, N.Y., and London, 1984).

Staley, Allen, *The Pre-Raphaelite Landscape* (Clarendon, Oxford, 1973).

Stanford, D (ed.), *Pre-Raphaelite Writing* (Dent, London, 1973).

Sternberg, Ellen, 'Verbal and visual seduction in "The defence of Guenevere"', *Journal of Pre-Raphaelite Studies*, 6, 2 (1986), 45–52.

Stillinger, Jack, *The Hoodwinking of Madeline and Other Essays on Keats's Poems* (University of Illinois Press, Chicago and London, 1971).

Stillinger, Jack (ed.), *The Poems of John Keats* (Heinemann, London, 1978).

Surtees, Virginia, *The Paintings and Drawings of D. G. Rossetti: A catalogue raisonné*, 2 vols (Clarendon, Oxford, 1971).

Swinburne, Algernon Charles, *The Poems of Algernon Charles Swinburne*, vol. 1: *Poems and Ballads* (Chatto and Windus, London, 1912).

Tallack, Douglas (ed.), *Literary Theory at Work: Three texts* (Batsford, London, 1986).

Tate Gallery Exhibition Catalogue, *The Pre-Raphaelites* (Tate Gallery Publications/Penguin, London, 1984).

Thomas, Edward, *The Collected Poems of Edward Thomas*, ed. R. George Thomas (Oxford University Press, Oxford, 1978).

Thompson, E. P., *The Poverty of Theory and other essays* (Merlin Press, London, 1978).

Thompson, E. P., *William Morris: Romantic to revolutionary* (Lawrence and Wishart, London, 1955).

Vaughan, William, 'Incongruous disciplines: The Pre-Raphaelites and the Moxon Tennyson', in Joachim Möller (ed.), *The Imagination of a Long Rein* (Jonas, Marburg, 1988).

Vicinus, Martha (ed.), *Suffer and Be Still: Women in the Victorian Age* (Indiana University Press, Bloomington, 1972; Methuen, London, 1980).

Vicinus, Martha (ed.), *The Widening Sphere: Changing roles of Victorian women* (Indiana University Press, Bloomington, 1977; Methuen, London, 1980).

Warner, Marina, *Monuments and Maidens: the allegory of the female form* (Weidenfeld and Nicolson, London, 1985).

Warner, Marina, *She Alone of all her Sex: The myth and cult of the Virgin Mary* (Random, New York, 1983).

Wasserman, Earl, *The Finer Tone: Keats's major poems* (Johns Hopkins University Press, Baltimore, Md., 1953).

Watkinson, Ray, *Pre-Raphaelite Art and Design* (Studio Vista, London, 1970).

Watt, George, *The Fallen Woman in the Nineteenth-Century Novel* (Croom Helm, Brighton, 1984).

Weedon, Chris, *Feminist Practice and Post-Structuralist Theory* (Basil Blackwell, Oxford, 1987).

Widdowson, Peter (ed.), *Re-reading English* (Methuen, London, 1982).

Williams, Raymond, *Marxism and Literature* (Oxford University Press, Oxford, 1977).

Williams, Raymond, *Problems in Materialism and Culture* (Verso, London, 1980).

Wolff, Janet, *The Social Production of Art* (Macmillan, London, 1981).

Wood, Christopher, *The Pre-Raphaelites* (Weidenfeld and Nicolson, London, 1981).

Wright, Elizabeth, *Psychoanalytic Criticism: Theory in practice* (Methuen, London, 1984).

Index